TRAVELS WITH VAN GOGH
Discovering the Connections
AND THE IMPRESSIONISTS

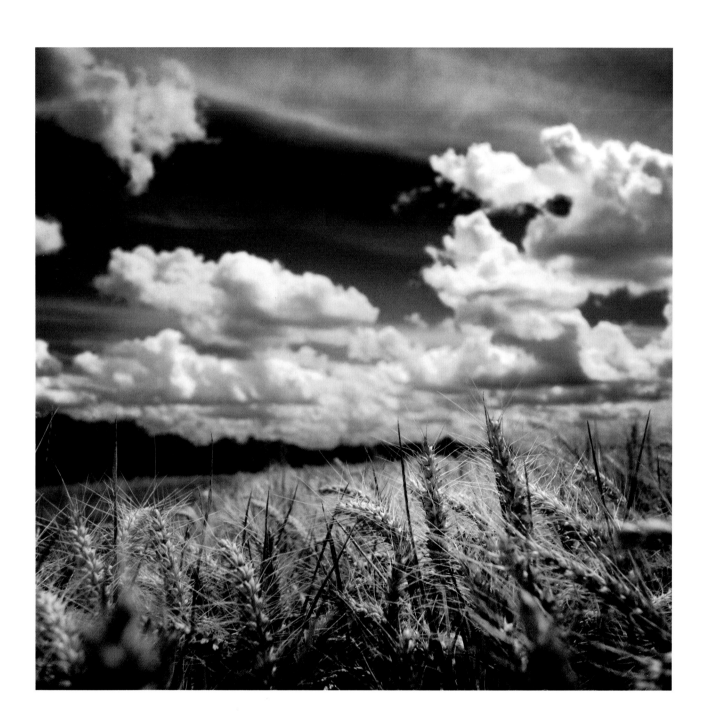

TRAVELS WITH VAN GOGH

Discovering the Connections

AND THE IMPRESSIONISTS

LIN ARISON ~ NEIL FOLBERG

ABBEVILLE PRESS PUBLISHERS • NEW YORK • LONDON

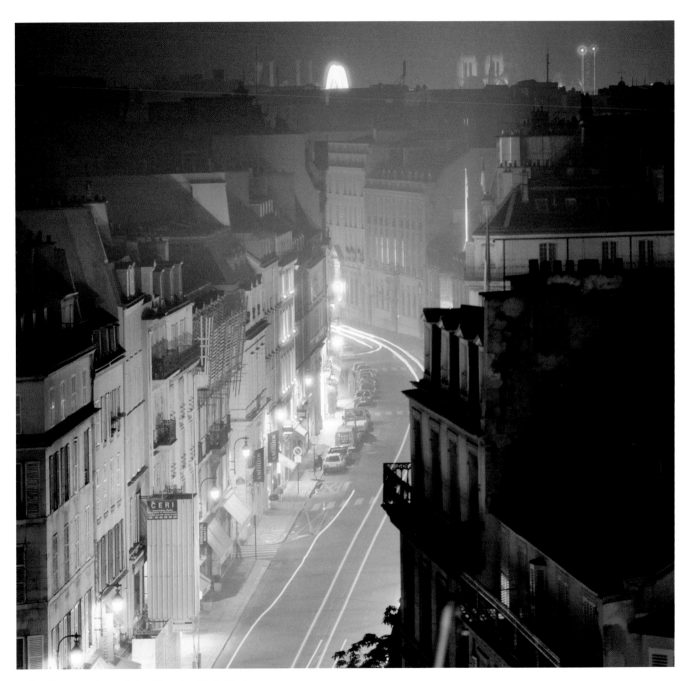

Neil Folberg, *Faubourg Saint-Honoré at Night*, Paris, 2001

FOR TED ARISON

—L.A. and N.F.

Contents

Neil Folberg, *Arabesque*, Paris, 2002

ENGLAND

BELGIUM

GERMANY

LUXEMBOURG

English Channel

Fécamp
Le Havre • • Etretat • Rouen
Trouville • • Honfleur
Deauville

Oise

Aisne

NORMANDY

Meulan
Paris • • La Varenne-
ÎLE DE FRANCE • Saint-Hilaire

Marne

Fontainebleau

Seine

BRITTANY

• Pont-Aven

Belle Isle

Loire

F R A N C E

SWITZERLAND

L. Léman

Rhône

N

Bay of

Biscay

Charente

ITALY

Garonne

PROVENCE Nice
Saint-Rémy-de-Provence
Arles • Aix-en-Provence Cagnes-
• Mont Sainte- sur-Mer
L'Estaque Victoire
Marseille • Les Calanques

Mediterranean Sea

0 20 40 60 80
miles
0 20 40 60 80
km

SPAIN

Giverny • Eragny-sur-Epte *Oise* • Chantilly
Gisors
Vétheuil
Pontoise • Auvers-sur-Oise
L'Hermitage • • Saint-Ouen-l'Aumône
Juziers • Mézy

Seine

Argenteuil
• Gennevilliers
• Asnières
Chatou •
Louveciennes • Paris
Bougival

THE ENVIRONS

OF PARIS

Introduction

LIN ARISON

NEIL FOLBERG

I am naturally curious. When my teenage granddaughter, Sarah, and I arrived in the French village of Auvers-sur-Oise, only to discover that the studio of Charles Daubigny was closed that day, we casually strolled around the corner to the Auberge Ravoux, the inn where Van Gogh had died. In such innocence my story begins.

I have always loved to travel: to encounter, to explore, and to learn. The travels described in this book, however, were unusual for me, in that they were motivated by loss and the unease that accompanies mourning. Sarah and I began our trip to France six months after the death of my beloved husband, Ted Arison. During our thirty-one years of marriage, Ted's dynamism and creativity had shaped so much of my life; consequently, his death in 1999 left me uncertain as to my own future. Together we had created very special projects to help young people develop their talents: the New World Symphony orchestra, and youngARTS (also known as the National Foundation for Advancement in the Arts, NFAA). But when he and I moved from the States to Israel, we loosened our ties to both of these ventures. And certainly while in France, at such a geographical distance and immersed in sorrow, I was in no position to advance them at all. Ironically and very unexpectedly, my travels with Van Gogh and

the Impressionists—in particular the discovery of their connections with each other—led me to reconnect with both the orchestra and the foundation dedicated to the nurturing of young artists. Even more unexpected, and equally pleasing, was the metamorphosis Sarah experienced. She began our journey a fifteen-year-old girl with no interest in art or artists, and today she is a dedicated advocate of emerging artists, as a board member of both youngARTS and the New World Symphony, as well as the president of the Arison Arts Foundation. Ted, no doubt, would be pleased and proud that Sarah has discovered the art of contributing. In a sense, our travels became a family odyssey that brought us home.

It was that experience of seeing Van Gogh's small death chamber at the Auberge Ravoux that first caught my interest and pulled me into his life. As I investigated the artist's story, I saw that there is a widely held misconception about him. Van Gogh's reputation as a "madman" often supersedes the truth that is so clear in his letters to his brother, Theo. He was troubled, yes, and plagued by fits of epilepsy, and inspired by colorful reveries—but he was no lunatic. On the contrary, he was supremely lucid, and without that lucidity, he could never have worked as he did. As I delved into the tale of his last

days, I felt that the record had to be set straight on Van Gogh, and that is one thing I have attempted to do in these pages.

Curators and critics have recently come to see that it is impossible to understand the work and life of one artist without understanding the work and lives of his or her contemporaries. Recent years have witnessed such stunning exhibitions as 2002's *Van Gogh and Gauguin* (at Amsterdam's Van Gogh Museum and the Art Institute of Chicago), 2003's *Matisse and Picasso*, and 2005's *Cézanne and Pissarro* (both at New York's Museum of Modern Art). My research into Van Gogh led me to Gauguin, and back to Pissarro and Cézanne, who brought me to Degas, Manet, Renoir, Monet, and Morisot.

Berthe Morisot was, I soon realized, a far more difficult subject to research than the other painters. Van Gogh's tiny death chamber is now a much-visited memorial; hordes of tourists flock to Monet's Giverny each year—yet Morisot's family home in Passy was recently demolished to make way for a Jesuit school. I wanted to find out all I could about her, and about the balancing act she pulled off with such grace: playing the part of the demure and well-behaved beauty, while underneath she was hard as nails and driven to accomplish what was nearly impossible for a woman of her day—to become a painter in a circle of male *bohèmes*. This "double life" that I explore here is an aspect of Morisot that few critics have addressed.

Happily, my investigations did not keep me entirely in the nineteenth century. In researching the ever-astonishing Morisot, I had the good fortune to develop friendships with members of her living family, Jean-Marie Rouart, Yves Rouart, and Yves's daughter, Lucie. It is Lucie's lovely face that graces the cover of this volume,

while her great-great-grandmother Berthe's portrait is on the back cover. I also had the opportunity to become acquainted with Joachim Pissarro, Camille's great-grandson, curator of painting and sculpture at New York's Museum of Modern Art, and the creator of the museum's 2005 *Cézanne and Pissarro* exhibition that resonates so clearly with my own work and research.

And now to Neil Folberg, whose images are such an important and powerful part of this story. My first meeting with Neil was by no means a matter of chance. I had seen his stunning photographs of synagogues—images that truly convey the beauty and spirituality of the structures—and I was compelled to track him down. Who was this man who could make me thirst for synagogues? I found him at his studio in Jerusalem and promptly invited him to collaborate with me on a book about Israel. The process proved so fruitful that soon after that project was finished, I was eager to work with him again. Little did I know what a wondrous experience the Impressionist collaboration would be, for both of us.

In the course of working on this book, Neil underwent something of an artistic transformation. His career had up to that point been largely based on his images of landscapes, places of worship, and starry skies. Now, I believe that he has discovered the spirit that resides in the human countenance and form as well. The photographs that he has created for this project seem to capture the very essence of the Impressionists' paintings, in a truly uncanny way. Neil entered into the world of each painter, both literally (by visiting their living places, their studios, the streets where they walked) and aesthetically (by coming to understand their colors, their forms, their visual obsessions). Some

of the resulting photographs are dispersed throughout my text, in fluid counterpoint with artworks and stories of the Impressionists. And Neil's images convey their own extraordinary visual narrative in the photo-plate section that follows my essay. There, the photographer also discusses his approach to the project—an approach that sometimes paralleled mine, but is more often uniquely his own. Watching Neil work on site in France with his colleague Max Richardson was, indeed, a source of awe for me. I am proud and honored to have this remarkable body of work alongside my words in this volume.

My own artistic transformation was no less radical than Neil's. Before my marriage to Ted, I had begun a career as a journalist. It is a natural profession for me, because I love to write and I am propelled by the delight of discovery. Through Neil, I met the wonderful writer, editor, and professor of creative writing Allen Hoffman, who taught me most of what I now know about how to tell a story in prose, and who urged me to follow my intuition as an author. Allen encouraged me to move forward with my first book, my memoir about Israel, as well as with this project about the Impressionists. I am grateful, and I remain slightly amazed at all of the relationships that have contributed to the writing of this book. But I am most deeply thankful for Van Gogh and the Impressionists, whose connections—along with my curiosity—inspired this narrative.

—*L.A.*

I first met Lin Arison in Israel in 1996, when she found her way to my studio in Jerusalem. She had been given a copy of my book on synagogues, and had sought me out to propose that we collaborate on a book project about Israel. Lin and I worked together for a number of months on that project, traveling together, exploring, photographing. We discovered in the process that we were two very different personalities with surprisingly different ways of living—but we also recognized that each of us had the ability to enhance the other's vision and creativity. That book was our first attempt at working together, and it opened the door to another, more artistically developed collaboration: the volume you hold in your hands.

The concept for *Travels with Van Gogh and the Impressionists* was born of Lin's experiences in France during the periods she spent there with her husband, Ted, and with her granddaughter Sarah. Lin has always been an explorer, and she had developed a particular fascination with Impressionist paintings and their sources in the scenery—both human and natural—that lay before her. She was also very struck by the personal stories and relationships among the Impressionist artists.

Lin came to me with the idea of creating a book together about the lives and works of these artists. The approach was to be very personal, in every sense: it would touch on our view of the painters, as well as their own views of one another and their world. She proposed that we take a trip to France together with my wife, Anna, and our friends Allen and Stephanie Hoffman, during which Lin would show us all firsthand the world of the Impressionists as she had been discovering it.

During that trip, I saw that the subject was overwhelming; I wondered how one could possibly create a photographic body of work around painters who had departed this world so many years ago, leaving behind a visual legacy that was unrivaled for its color, richness, boldness, and depth of vision. How could one

enter their minds and eyes and say something relevant and fresh about their vision through the medium of photography? I would have had to be crazy to take on a project of this scale, but of course even crazier to turn it down (an artistic challenge is something I have never been able to resist!).

From the start of this venture, Lin and I agreed that we would pursue our separate parts of the project independently. She would tell her story in writing and I would tell mine in photographs, but we would have the same parameters, and both of us would remain within their boundaries. She would supply me with the benefits of her research, and I would share with her new visual discoveries and revelations. I was not to see her text until it was finished, and I was under no obligation to show her my work until I felt it was ready to be seen. We had learned that working in this way allows both of us a kind of artistic freedom in our endeavors—but, as we understood a common premise, there are many places of convergence between our two bodies of work.

Each of us found our way through the complexities of this subject and emerged with a surprise for the other. Lin's text and my photographs seem to "converse" about Van Gogh and the Impressionists, just as Lin and I have conversed about them so often. We hope you will enjoy the interplay of our joint efforts as much as we have. You may be surprised as well.

As soon as I became involved with this project, I immersed myself in French history and language, but most of all, I looked at the original artworks, and I continued to look at them over and over and over again, until each artist's paintings merged into a kind of collective picture in my mind of that artist's oeuvre.

As my understanding of the work deepened, I began to feel that I might indeed have something to offer.

I decided to begin in the simplest way possible by exploring and documenting the places where the Impressionists lived and worked. From there, I hoped, I would find an inspired way to continue. Soon I realized that if I wished to move beyond documentation, I would have to begin photographing modern France under the influence of the *vision* of the artists. This would mean, in many instances, staging scenes, posing models, and creating a light for these photographs to match, or at least echo, the brilliance of theirs. The important job of lighting fell to my friend and colleague Max Richardson, who had worked with me on the synagogues book, and whose eye is wonderfully attuned to the nuances of light, shadow, and color.

As I became more and more engrossed in the nineteenth century, I found it interesting to consider that the medium of photography was coming into its own just as the Impressionists were making their mark on the world. In France, Nadar, Gustave Le Gray, Hippolyte Bayard, and Edouard Baldus were some of the early proponents of the new medium. Le Gray in particular had a visual sensibility that was related to that of the Impressionists; interestingly, he started out as a painter and exhibited work at the Paris Salons of 1848 and 1853 before turning his attention to photography. Could such photographic visions have inspired some of the Impressionist artists?

The idea of capturing transient phenomena certainly fascinated these painters—and this idea was of course the great promise of photography. We see this interest very clearly in Monet's work: think, for example, of his 1872 painting *Impression, Sunrise*, the piece that gave the

Impressionist movement its name. But the new visual approach was not confined to obviously poetic effects of winter, twilight, and grand landscape; it extended in both painting and photography to everyday life on the streets, in the cafés and *guinguettes*, in the train stations and countryside. It was, in fact, a sociological change as well as an aesthetic one.

Still, despite its inspiring potential, photography in the 1880s was a cumbersome process: emulsions and prints were handmade, and cameras were large and difficult to handle, demanding skilled operators willing to suffer a fair amount of discomfort to make images. Emulsions were slow and required long exposures of static subjects, denying the instantaneous vision of contemporary life that the medium would later offer. So although some of the Impressionist painters might have been conceptually attracted to the medium, they would likely have found it lacking in spontaneity (and color, which was a central interest of these artists). Degas experimented with the medium for a couple of years—with very interesting and beautiful results—but eventually lost interest in it, perhaps because of its technical awkwardness.

If the Impressionist painters were resurrected today, they would naturally be turning their attentions to modes, subjects, and media far different from those they utilized in the mid- and late nineteenth century.

For this series of images, I was working in the world of contemporary France, with elements of the Impressionist aesthetic in my mind, but advanced photographic tools in my hands. I have tried to channel the Impressionists' approaches through my own, and to make photographs that reflect their individual interests and perspectives.

When I showed my Impressionists series to Weston Naef, curator of photographs at the J. Paul Getty Museum, he posed a question: "You have so many identities and voices in these photographs—which one of them is you?" There is a genre in contemporary photography in which the artist poses him- or herself in different vestments and situations; I have chosen instead to try on other artistic identities—identities of creators whom I admire greatly. It has been an amusing and challenging process, and inevitably my shortcomings as an artist may show through these costumes. To Mr. Naef's inquiry about my identity within this body of work, I was tempted to respond, like the Wizard of Oz: "Pay no attention to that man behind the curtain!" But I held my tongue.

I always try to keep a sharp critical eye on my own efforts, and this project presented the distinctly uncomfortable proposition that I engage with giants. This engagement led me occasionally to construct images with a kind of wryness, or a sly sense of humor, which is evident from time to time in these photographs. I'm afraid that humor will have to be my substitute for humility! My larger purpose in this series is to bring the Impressionist *concept* to the contemporary viewer in a new way, and to invite you to revel in their works, which remain as fresh, relevant, and compelling today as they were at the time of their creation.

—*N.F.*

Opening the Door

It was quite by chance that I found myself in the tiny garret in Auvers-sur-Oise where Vincent van Gogh died.

A week before, in Paris, my fifteen-year-old granddaughter, Sarah, and I had been feasting our eyes on the luminous Impressionist paintings in the Musée d'Orsay, when a guide casually mentioned that Charles-François Daubigny, a forerunner of the Impressionists in plein-air work, used to paint on the walls of his atelier on rainy days. That atelier, she added, was open to the public. Although I found Daubigny's work somewhat old-fashioned and bitumen-dark when compared with the vivid colors of the Impressionists, the idea of seeing such intimately conceived paintings piqued my curiosity. These elusive treasures simply *had* to be tracked down while I was in the neighborhood—no one would ever see them displayed in a museum.

It was the summer of 2000, and Sarah and I had been in France for a month. Her immersion in French was helping her to overcome her inhibition about speaking the language. As I don't speak French, she had been forced to get us out of jams, which she did admirably well. What I did not yet know was that my granddaughter had a curious antipathy toward art—a stance she had taken, I realize, partly because her mother is an artist (and Sarah was in adolescent mode), and also because her mind has a scientific bent that had drawn her away from the artistic world; she was at the time considering a career as a microbiologist. In my ignorance, I had planned visits to artists' ateliers and museums, because that is my own habit when traveling. Visiting these places has always been a great pleasure for me, and I took it for granted that it would be for Sarah as well. At the beginning of our trip, it hadn't dawned on me that she might not be interested. Sarah went along with my artistic forays amiably, not wanting to hurt my feelings.

And so, several days after our Musée d'Orsay visit, we drove out of Paris to Claude Monet's Giverny, and on the way back stopped at Auvers-sur-Oise to see the rainy-day paintings on the walls of Daubigny's atelier.

Auvers is a quaint and lovely village twenty miles northwest of Paris, with a rustic main street flanked by a few shops, a marketplace, and an inn with white lace curtains in

the windows, situated across from a *place* with a small white town hall. Beside the inn to the left is a narrow winding street, which comes abruptly to an end at the foot of a stone stairway leading up a hill.

Nearby is Daubigny's atelier, in front of which Sarah and I encountered a locked gate. The sign in front of the studio informed us that the atelier was not open on Mondays or Tuesdays. Having traveled all this way, we were disappointed and didn't want to head all the way back to Paris. As we retraced our steps toward the main road, I noticed the entrance to the Auberge Ravoux, the last home of Vincent van Gogh. I had a vague recollection that Auvers was somehow connected with Van Gogh.

Sarah and I paid our admission at the Auberge Ravoux and were given a booklet of information about the world of Van Gogh and Auvers. She stood quietly reading the artist's history outlined on panels outside the museum, while gentle music played in the background. I could see Sarah becoming thoughtful as Van Gogh's life spread before her, and when she read of his suicide at the age of thirty-seven—shooting himself in the nearby wheat fields and then dragging himself back to this very inn to die—she had tears in her eyes.

We entered the inn and climbed a winding flight of creaky stairs to the artist's death chamber, empty except for a simple wooden chair with a straw seat. This was Van Gogh's tiny bedroom. The sense of sadness and bereavement in that little room was reinforced by a weak light filtering in from a small window in the slanted ceiling. On the wall, protected by glass, was an empty picture frame, in which were inscribed Van Gogh's words to his younger brother, Theo: "One day or another, I believe that I will find a way to have an exhibition of my own in a café." He wrote this just over a month before his suicide.

Sarah and I silently left the desolate chamber to enter a larger room, where we watched a documentary film chronicling the ten years of Van Gogh's artistic life. In a final frenzy, he completed an oil painting every day on each of the seventy days he lived in Auvers. The intense colors of his paintings present a striking contrast to the sense of loss we had just encountered in the room where he died.

Sarah and I shared a moment of deep and bewildering mourning, as we sensed both the sheer energy of Van Gogh's paintings and the desperate loneliness of his death chamber. Our emotional response was profoundly charged, as my husband, Ted— Sarah's grandfather—had died less than a year before. Our trip through France was, among other things, an attempt to help us come to terms with our loss.

I was struck by the power of that moment, all the more because Sarah—although she is a perceptive and intelligent young woman—had not had a serious involvement with art up to that point. I could tell that Van Gogh's art and the understanding of his death had deeply touched her. Earlier that day, at Claude Monet's house and lily ponds in nearby Giverny, Sarah had also surprised me by musing about what her mother would have painted if she had been with us. For the first time, Sarah was beginning to connect to her mother's artistic world.

The emotional moment Sarah and I experienced in Auvers would have far-reaching repercussions. As beautiful as Monet's gardens are, when I revisited this area of France, I was drawn first to Auvers. The locked gate of Daubigny's atelier had yet to be opened. And I strongly wished to contemplate Van Gogh's final days by waking up in the morning to walk in his landscapes and to smell the dew on the grass.

Although our sojourn together was almost over, and Sarah would soon return to high school in the United States, my own long journey was just beginning.

Several months later, I returned to Auvers, and went directly to Daubigny's atelier-home, which he dubbed the "Villa des Vallées." After wandering the paths of his lush and peaceful garden, I entered the house and studio to see the fabled rainy-day paintings, which, it turned out, were well worth the anticipation.

The atelier holds visual treasures both by Daubigny and by members of his extraordinary circle of friends. Camille Corot transposed Lake Como from Italy to the north wall of the large space. Since the white-haired Corot was too old to climb ladders, he sketched out the paintings on small canvases, and Daubigny's eighteen-year-old son, Karl, working with the architect Achille Oudinot, transferred them to the floor-to-ceiling canvases that are permanently affixed to the walls. On the entire south wall of the studio, Daubigny painted a grand landscape populated with herons. The huge scene was made after Daubigny's mural of the same landscape (at Paris's Hôtel de Ville) was destroyed in 1871 during the chaotic insurrection of the Paris Commune.

Looking at the beauty, color, and warmth that emanate from so many of the paintings of this period, it would be easy to conclude that the artists must have lived in an idyllic world. That is, of course, far from the truth: theirs was a period of great political turmoil, and many artists subsisted in dire poverty. It is also important to recall that—as familiar and soothing as many of these paintings seem to our contemporary eyes—the work of the Impressionists was seen as shockingly avant-garde in its time:

the artists were shunned by the established art community as pariahs, but they forged ahead with singular vision despite all obstacles.

Daubigny was a great champion of the Impressionists in their struggle for recognition. His generosity, so clearly expressed toward the younger artists of his time, seems also to be manifest in the spirit of his home.

I couldn't help feeling a deep respect for this impulse to help younger artists. My late husband and I were driven by a similar mission to seek out creative young people, to support them and foster their work. Ted was a profoundly innovative and creative person. He was extremely gifted in the arts—as both a musician and a painter—but his talents were never encouraged or supported, and so had not flowered as they might have otherwise. As fulfilling as my husband's business career was for him, I believe he lived with a sense of having been thwarted as an artist—and that sense intensified his determination to support other artists. Certainly, he understood the many obstacles faced by anyone who thinks outside the proverbial "box": like many artists, he refused throughout his life to fit neatly into a conventional mold. He saw, as I do, a great integrity in original thinking, and this was an important factor in our decision to found both youngARTS (the National Foundation for Advancement in the Arts, NFAA) and the New World Symphony orchestra, as well as other programs and foundations to help artists find and maintain their footing in the world.

There in Daubigny's studio, I felt a surge of pride at what we had accomplished in our ventures. But my pride was tinged by sadness, remembering who Ted was behind the larger-than-life figure so many people knew, his personal dreams and passions. My involvement with the projects we'd begun together had languished for some time—and in fact it would be a few years still before I could bring my energies back to them fully. But this encounter with Daubigny and his circle was a first rekindling of my interest in returning to the work of helping and encouraging artists.

Daubigny's camaraderie with other artists had begun well before his time at Auvers. The collective creations at this atelier were preceded by a great *bonhomie* at leg-of-mutton dinners at Daubigny's Paris studio, attended by Corot and Honoré Daumier, among many others. These must have been wonderful gatherings. (Surely recalling those Paris feasts, when Daubigny first bought the land in Auvers, he wrote to Corot that there was a garden here—but he planned to pull up the flowers and plant legs of mutton instead!)

Many significant artists have been drawn to this beautiful village over the years. Daubigny's artist friends—enchanted by Auvers and the Villa des Vallées—came often to visit and to paint. Corot was sometimes accompanied by the young Berthe Morisot, whom he brought along to meet Daubigny and Daumier. As I wandered Auvers's quiet lanes, I came upon reproductions of paintings placed before the corresponding landscapes, views that have not changed in more than a century. The artists stayed either in the village or nearby, and walked to these locations, sometimes alone, sometimes with a friend, with their canvases, collapsible easels, and campstools on their backs, carrying their color-boxes—often painting side by side and encouraging each other. Discovering the stories of their close and mutually supportive relationships within this intimate space was as surprising to me as it was intriguing.

Over the next years, I revisited Auvers frequently, using the village as a kind of home base, sometimes staying for weeks at a stretch, finding out as much as I could about these artists and the many others who were inspired here.

The starting point and trajectory of my path were determined by Vincent van Gogh, beginning with his death chamber and moving back through his life and the months leading up to his demise.

The French, Van Gogh once noted, had trouble pronouncing his Dutch surname—and so he took up the habit of signing his paintings simply "Vincent." Also, as he wrote to Theo: "I want to give the wretched a brotherly message. When I sign 'Vincent,' it is as one of them." "Vincent" is the name by which he is known in Auvers; it is the name by which I think of him. Nonetheless, in these pages, for the sake of convention, I will call him by his surname, Van Gogh.

Vincent van Gogh

Vincent van Gogh

BEAUTY AND SORROW IN AUVERS

The morning was bright and sunny with a touch of fall in the air when I began to follow Van Gogh's trail from the time of his arrival in Auvers, in May 1890.

The artist awoke early in his little room at the Auberge Ravoux, and took a Spartan breakfast of bread and coffee, and his regular pipe. Then, with painting gear strapped to his back, he would leave the inn and head outdoors. Van Gogh painted almost every aspect of Auvers during the short time he was there; the first reproduction I encountered in the village was his 1890 *Stairway at Auvers*, in which he used his characteristic thick brushstrokes, here white and verdant green, to depict blossoming chestnut trees. The trees were not in bloom when I later returned to Auvers, but I climbed that very stairway at the end of the road beside the Auberge Ravoux, as if I had become one of the figures in the painting. The lane at the top led me past the terracotta-roofed villas with green shutters that appear in the painting. Van Gogh must have taken to this village easily: its paths are unpretentious and accessible.

I soon arrived at the village church, which is rendered in orange and violet against a cobalt-blue sky in Van Gogh's 1890 *The Church at Auvers* at the Musée d'Orsay. In that wondrous work, he invests the building with a supernatural aura: the walls are distorted to shimmering waves, infused with powerful energy. In today's bright sunlight, however, the structure, though handsome, seems to me solid and nondescript—not much different from any number of historic churches in the area. The clock in its tower is stopped, as if the church were benevolently trying to halt the march of time.

At the top of the hill, amid the wheat fields, in the small village cemetery lie the bodies of Van Gogh and his younger brother, Theo. They died within months of each other: Vincent by his own hand, Theo of illness compounded by grief. The black crows, arrogantly feeding in the surrounding fields that stretch toward the horizon, seemed well aware of their role in the fatal drama that played itself out in Auvers. In one of his final paintings, the 1890 *Wheat Field with Crows*, Van Gogh depicted them hovering over this land, under a menacing deep-blue sky.

Vincent van Gogh, *The Church at Auvers*, June 1890

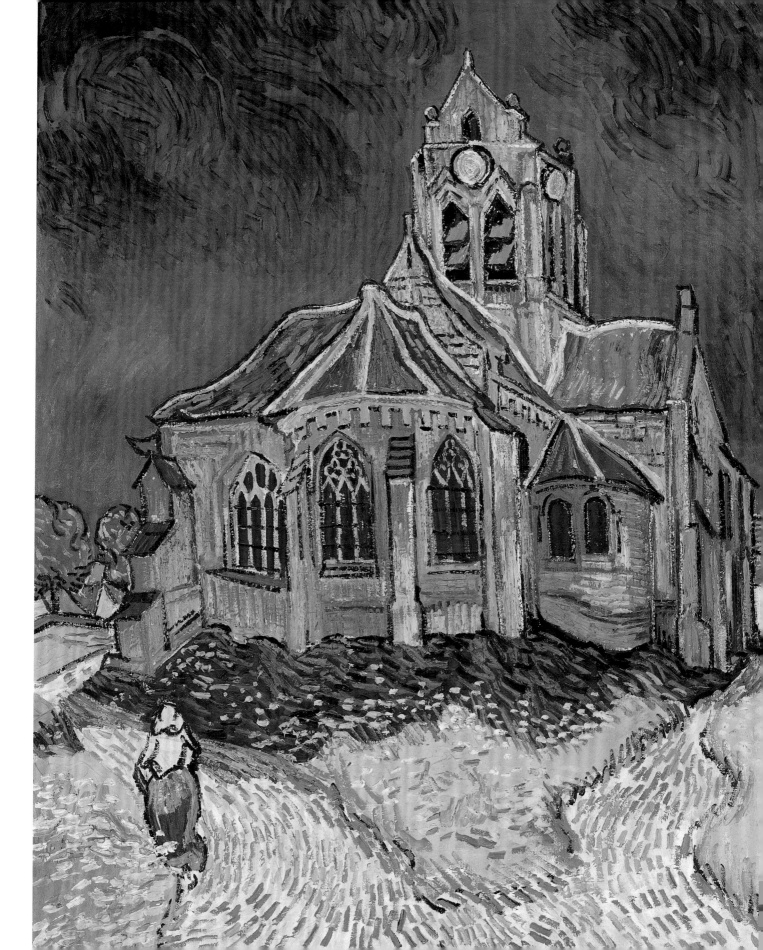

Neil Folberg, *Wheat Fields*, Valmandois, 2001

I climbed the hill to look over the wheat fields, which had been recently harvested; they were not as I remembered them from the summer's visit with Sarah—golden as in Van Gogh's paintings—but were now a stubbly amber. I knew the village lay hidden below the slope, but there is no suggestion in this view of anything more than an expansive plain. The plateau contains an entire world: his art, his death, his final resting place beside his brother. I considered the scene before me, and then turned back to the town that sheltered him in those final hours.

Exploring Auvers over the next days, I often found that if I stood in one place, I could see only what surrounded me. This allowed me to focus calmly on what was at hand; with no all-encompassing view, I was able to examine the immediate in discrete segments. Because so little has changed in the village in more than a century, one can become connected to its timelessness, even while experiencing its daily rhythms. In my strolls down narrow lanes, I caught glimpses of miniature gardens tucked behind houses—wisps of roses and hollyhocks. From my window at the town's Hostellerie du Nord, I could see tiny terraces of flowers and vegetables rising up with precision toward the old village houses at the foot of the famous church. At night, the town church is lit dramatically, but nothing in the building's reality compares with Van Gogh's psychedelic rendition of it.

Auvers's beauties are scaled to toy-like perfection: everything here seems slightly smaller than life. The exceptional dining room at the Hostellerie overlooks the railroad tracks that run along the banks of the Oise River—those tracks that were such an important artery in Van Gogh's life.

The railway allowed Van Gogh to escape the noise and bustle of Paris: enveloped in Auvers's peaceful countryside, he was still within easy reach of his beloved brother, yet he did not have to endure the life that he found so difficult in the city. The tracks parallel the Oise, which, with its dark-green water and the colorful rowboats tethered to its shore, was a lively source of inspiration for the artist.

Halfway up the limestone cliffs beside the river, Dr. Paul Gachet's house still nestles on a scenic lane, a short walk from the Auberge Ravoux. Gachet was, of course, to play a crucial role in the last few months of Van Gogh's life.

The artist had just lived through a most difficult period in Provence—including a year at an asylum—after which he strongly felt the need to return to Paris to see his artist friends, who recognized and appreciated his genius. But that long-anticipated reunion with his artistic comrades had turned out to be too taxing on Van Gogh's nerves, especially after living in seclusion for so long. Irritable and overwhelmed by the intensity of the city, he had abruptly left Paris after just three days.

Auvers was not Van Gogh's first choice of towns to escape to; he had originally hoped to move to the more rural countryside of Eragny-sur-Epte, near the medieval town of Gisors in Normandy, to live with Camille Pissarro. He and Pissarro had become friends four years earlier, when Van Gogh had first come from the Netherlands to stay with Theo in Paris. Van Gogh had taken the train to Gisors, where Pissarro had met him, and the two artists had spent a few days painting together. Pissarro's wife, Julie, had felt at the time that Van Gogh seemed scarred, as though life had treated him harshly. Yet he was gentle with the children, teaching them to draw and telling them stories of the Netherlands.

Now, however, after Van Gogh's breakdown and incarceration, Julie was very uncertain of his mental stability. At this particularly vulnerable point, Van Gogh was in great need of the eminent Pissarro's encouragement and support. While the warm, avuncular master was sympathetic, his wife was unwilling to have the troubled Van Gogh under the same roof with her five children.

At Pissarro's suggestion, Theo contacted Dr. Gachet to ask if he would look after Vincent in Auvers. Having just signed himself out of the mental asylum, Van Gogh knew that, although he was faring better, he still needed supervision; he feared a recurrence of his dreadful attacks, which had been diagnosed as epilepsy. Gachet's practice was in Paris, but as an enthusiastic patron of the arts, he was interested in Van Gogh, and willing to care for him in Auvers. The doctor's home had long been a haven for many of the Impressionist painters—among them Pissarro, Renoir, Monet, and Cézanne; a number of them had painted in Gachet's home, and made use of his printing press to make engravings. Edgar Degas and Frédéric Bazille, too, had been enticed to visit Auvers by Gachet's neighbor, Eugène Murer, another collector of the new art.

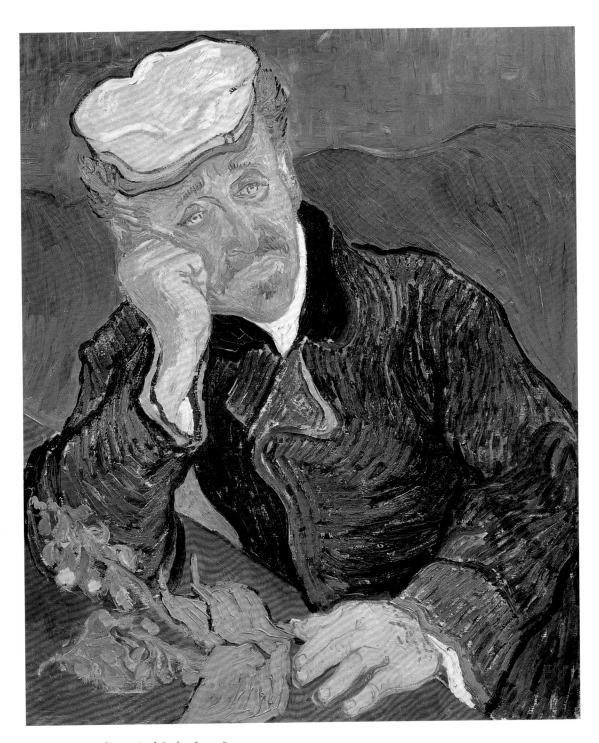

Vincent van Gogh, *Dr. Paul Gachet*, June 1890

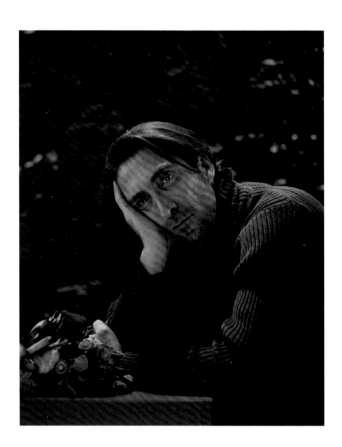

Neil Folberg, *Dr. Gachet,
after the Loss of His Friend
and Patient* (after Van Gogh),
Paris, 2002

Van Gogh was thus partaking in a distinguished
tradition in moving to Auvers and being befriended
by Gachet, but he unfortunately arrived too late
to participate in the creative camaraderie that had
established the town as a meeting point for artists. The
encouraging artistic interactions in Auvers had preceded
him by several years. The great artistic revolutionaries—
Degas, Pissarro, Cézanne, Renoir, Monet, Sisley,
and Morisot—had by now all dispersed to distant
destinations.

Vincent wrote to Theo that Gachet seemed like a
brother. The doctor's dyed reddish hair and nervous
afflictions were so familiar that Van Gogh felt when
he looked at Gachet that he was looking in a mirror.
Although he did not have the inspired artistic sensibilities
of Van Gogh's artist friends Henri de Toulouse-Lautrec,
Emile Bernard, or Paul Gauguin, Gachet understood and
appreciated Van Gogh's paintings.

In Van Gogh's portrait of Gachet, which he
painted shortly after his arrival in Auvers, on May 20,
1890, despair clouds the doctor's expressive eyes; his body is portrayed as shrunken
and depressed. Van Gogh wrote to Gauguin that he depicted Gachet with the
"heartbroken expression of our time." The doctor repaid the insightful compliment;
when Gachet examined *L'Arlésienne*, his comment was: "It is so difficult to be simple."

Van Gogh was glad of the presence of Impressionist paintings on the walls of
Gachet's home for more than simply aesthetic reasons; they made it clear that he would
be able to pay his medical bills with artworks (as had Pissarro and Cézanne before
him). Once or twice a week, Van Gogh would appear at Gachet's house for an ample
lunch or dinner, enjoying the friendly company of the doctor, who was a widower, and
of his teenage children Marguerite and Paul. Gachet—like the doctors in the South—
believed that good nutrition was an important part of Van Gogh's therapy.

In addition, Gachet told Van Gogh that *work* was the best thing for the painter, in
order to maintain his mental equilibrium. At the asylum in Saint-Rémy-de-Provence,
the artist had seized his periods of clarity and painted even more rapidly than was his

wont. In one letter to his mother, he wrote: "I must work, otherwise I have abnormal thoughts. During the last fortnight or three weeks which I spent in Saint-Rémy I worked from morning till night without stopping." Gachet further spurred the artist's remarkable creative drive, and as Van Gogh's sole emotional support while in Auvers, the doctor was to have a powerful influence upon the final phase of his art.

Van Gogh often used his new friends as models for his portraits. He wrote to his sister, Wilhelmina, shortly after he arrived in Auvers: "What impassions me most—much, much more than all the rest of my métier—is the portrait, the modern portrait." Van Gogh painted Gachet's daughter, Marguerite, playing the piano, her dress a pale red, with striking dots of green in the background; and Marguerite again, a vision in white, in the garden surrounded by deep green shrubs, trees, and bits of red roof adding highlight. Van Gogh also painted a portrait of Adeline Ravoux, the thirteen-year-old daughter of his landlord, and several peasant women in the fields. He produced a sweet painting of the small son of the local cabinetmaker holding an orange. (Ironically, just days after receiving the painting as a gift, the child's father constructed Van Gogh's coffin.)

Spending time pleasurably in Gachet's comfortable home, Van Gogh painted the aloe trees and bushes in the doctor's garden. Theo and his family visited shortly after Van Gogh's arrival in Auvers, and that garden—filled with animals and birds—was a wonderland for the artist's four-month-old nephew and godson, Vincent.

At this point, Van Gogh's professional reputation was improving dramatically, but news of the warm response to his paintings in Paris and Brussels exhibitions failed to encourage him. Both Pissarro and Monet said that Van Gogh's paintings were the best in the exhibitions—but even his peers' admiration brought little comfort. Just months before Van Gogh arrived in Auvers, the critic Albert Aurier had written an enthusiastic review that served only to upset the artist. He wrote to his mother: "As soon as I heard that my work was having some success, and read the article in question, I feared at once that I should be punished for it; this is how things nearly always go in a painter's life: success is about the worst thing that can happen." Van Gogh was concerned that he was not strong enough to handle triumph and public adulation; he requested that Aurier write no further about him. Finally, the first of Van Gogh's paintings was sold in an exhibition in Belgium to Anna Boch (a scion of the porcelain firm of Villeroy and Boch). Still, Van Gogh could not muster any optimism; he truly feared these successes, which indeed foreshadowed the tragic events that were soon to follow.

During this productive period in Auvers, it was Van Gogh's habit to take his dinner at the inn's restaurant with the Ravoux family or with Tommy Hirschig, a young Dutch painter who was staying in the attic room adjacent to his own. The *auberge* has today been faithfully restored to its state in Van Gogh's day, down to the white lace curtains in the window, the zinc-topped wooden bar, and the black-and-white quarry-tiled floor—the setting for the final events of the artist's life.

On Sunday, July 27, 1890, instead of returning to the Auberge Ravoux at six o'clock as usual, Van Gogh came in at nine and silently dragged himself up the two flights of stairs to sink into his bed. Soon, Monsieur Ravoux, hearing Van Gogh's moaning, became alarmed, and ran upstairs to find the artist critically wounded by the shot he had inflicted upon himself. Ravoux called the local practitioner as well as Dr. Gachet. Both doctors agreed that Van Gogh could not be moved to the hospital in Pontoise, and that they could do nothing to help him. Theo was sent for and arrived by train at noon the next day. He sat with the beleaguered Vincent, who, smoking his pipe, responded calmly to Dr. Gachet's ministrations by stating that if the doctors saved him, he would only shoot himself again. He died on July 29, at 1:30 in the morning. Theo lamented that Vincent had finally achieved the peace that had always eluded him.

Van Gogh's friend Hirschig recalled the artist's intensity toward the end of his life: "I still see him sitting on the bench in front of the window of the little café, with his cut-off ear and bewildered eyes in which there was something insane and into which I dared not look."

In a note to Albert Aurier, Emile Bernard described Van Gogh's funeral:

On the walls of the room in which the body reposed, all his last canvasses were nailed, making a kind of halo around him and, because of the luster of genius that emanated from them, rendering this death even more painful for us artists. On the coffin, a simple white drapery and masses of flowers, the sunflowers that he so loved, yellow dahlias, yellow flowers everywhere. It was his favorite color, if you remember, symbol of the light that he dreamed of finding in hearts as in artworks. Also nearby, his easel, his folding stool, and his brushes had been placed on the floor in front of the casket. . . .

[Theo], who adored his brother, who had always supported him in his struggle for art and independence, did not stop sobbing painfully.

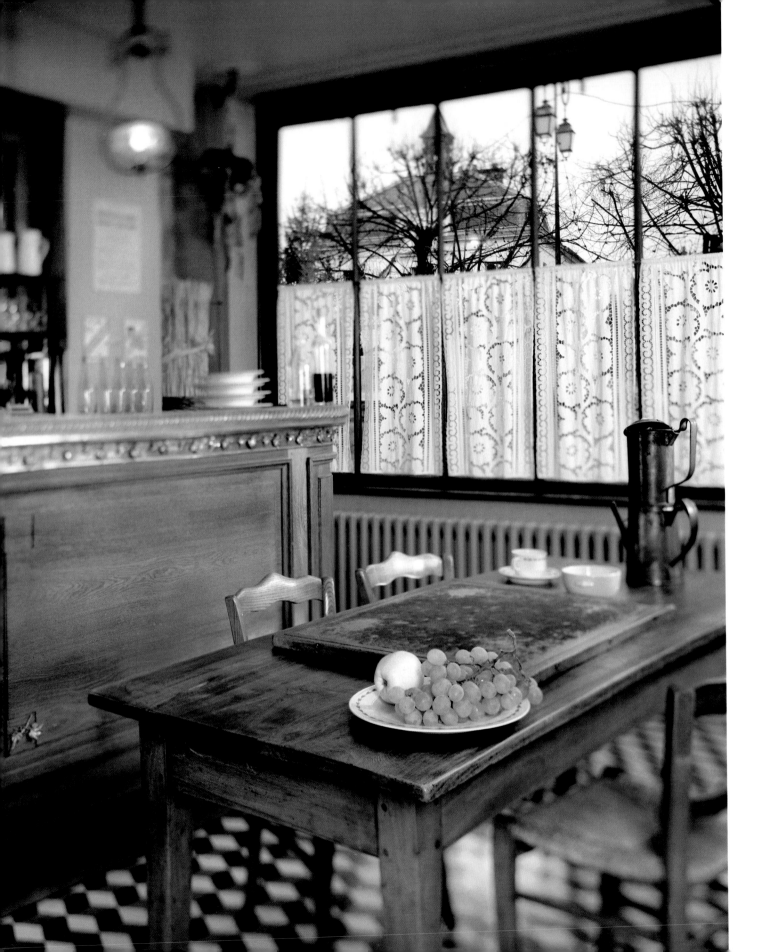

Outside, there was a fierce sun. We climbed the hill of Auvers talking about him, about the bold thrust he gave to art, the great projects that he was always planning, about the good that he did every one of us.

Dr. Gachet said at the gravesite: *Vincent was an honest man and a great artist. He had only two goals: humanity and art. It is the art that he cherished above all else that will ensure that he lives on.*

It is true, of course, that Vincent van Gogh lives on in his work, and his person is intimately connected to the greatness and success of his art. But the impetus behind his death remains a mystery. Anyone who wishes to examine that mystery must go further into his life, must look at the events and circumstances that brought him to this ending.

Having begun with an exploration of Van Gogh's last days, I wished now to delve deeper. And so I moved backward, in a sense, to the years that led him to the tragedy in Auvers.

FRANCE AND
NEW COLORS

Before his move to France in 1886, Van Gogh had lived for a little over a year in Antwerp, Belgium. There, he had begun to experiment with a new palette. Departing from the muted brown-and-gray scheme with which he had begun (and which he had used with such great success in his 1885 masterpiece *The Potato Eaters*), he started hesitantly exploring with complementary colors. Many of his artist peers were influenced by the color theories of the noted chemist Michel-Eugène Chevreul, director of the dye plant at the Gobelin tapestry works in Paris. Chevreul recognized that the appearance of a yarn was determined not only by the color with which it was dyed, but by the colors of the surrounding yarns; this concept, known as "simultaneous contrast," was to have an indelible impact on the world of art. Van Gogh, too, for a time kept a lacquered box of different colored threads; he would put one color next to another to test its luminosity.

While in Belgium, Van Gogh had been keenly aware that the central action of the art world was taking place in France. He considered himself a modern painter, a proponent of the vanguard—but with no original Impressionist paintings to study, and the core of the movement in Paris, he had been frustrated in his ambition to be part of the group.

In March 1886, he impulsively departed Belgium, leaving all of his belongings behind, and arrived unannounced on his brother Theo's doorstep in Paris. Vincent was very eager to participate in the city's artistic fervor, and quickly began to absorb new

Neil Folberg, *Dining Room, Auberge Ravoux*, Auvers-sur-Oise, 2002

ideas. It was during this period that he encountered, through Theo, some of his great artistic contemporaries, including Toulouse-Lautrec, Gauguin, Pissarro, and Georges Seurat. The paintings in the Impressionists' eighth and final exhibition, which opened in May of that year, convinced Van Gogh to relinquish the use of bitumen that gave the dark color to traditional paintings. A quick study, he soon started to alter his palette further, with the new and lighter colors.

This lighter, brighter tonal scheme would soon become enriched with brilliant pure primary colors. When Van Gogh moved to the South of France, in 1888, his sensibilities were galvanized by what he saw.

Van Gogh headed to Arles, toward the intense light and the Arlésienne women, who, according to his friend Toulouse-Lautrec, were beautiful and would be wonderful subjects to paint. He arrived at the Arles train station in February, to find its avenue of dappled plane trees covered in two feet of late snow, reflecting a bright blue sky.

Carrying his small suitcase, rolled-up canvases, and color box, he walked through the snow, from the train station past the place Lamartine with its Hôtel de la Gare and small public garden, past the bare plane trees, and through the opening in the medieval walls of the city. He settled himself in a small room at the Hôtel-Restaurant Carrel, at 30, rue Cavalerie.

Too tired that night to explore, he fell into a deep sleep. When morning came, he energetically walked out into the frost-bound countryside. The snow cover would last another month before magically transforming into masses of orchards in bloom—pear, almond, and cherry trees, all pink and white. He approached a prematurely blooming *amandier*, rising out of its blanket of snow, broke off a branch, and in his room placed it in a glass of water; this would be the subject of one of his most touching and beautiful canvases. The almond branch, with its delicate white flowers and stylized green leaves, cuts diagonally across the painting, with an orange horizontal line in the background, above which he signed "Vincent" in bright orange. As is the case with many of the Arles works, this painting's composition has a clear Asian lilt. The Impressionists had been deeply affected by the influence of Japanese art, from the time of its revolutionary appearance at the Paris Exposition Universelle of 1867. Van Gogh, too, was awed by the Japanese aesthetic, and suggested that the Impressionists were the "Japanese of France." Even before moving to France, he had fallen in love with Japanese woodcuts, tacking reproductions of them up on the wall of his studio in Antwerp. He later made

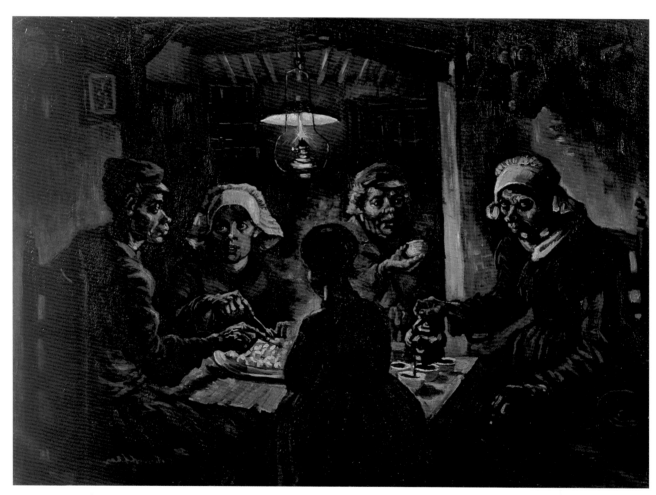

Vincent van Gogh, *The Potato Eaters*, 1885

direct copies—in thick oil paint—of works by Hiroshige and Keisei Eisen. The textures of those canvases and the vividness of the colors would transform the Japanese prints into new and exciting modernist expressions. In Provence that snowy winter, Van Gogh would declare more than once that he felt he was in Japan—his first letter to Theo from Arles enthusiastically reported: "The landscapes in the snow, with the summits white against a sky as luminous as the snow, were just like the winter landscapes that the Japanese have painted."

Van Gogh was eager to move further into a fresh aesthetic vision. He was determined to begin a new chapter of his artistic life by infusing his passion for the colors he had learned from the Impressionists with his love of the earth and the people who worked it—all bathed in the strong sunlight that was the South's special gift. Although his new direction developed in a particular way, the benchmarks of his style remained constant: his distinct brushwork, rapid painting, symbolism, and hidden images. As he wrote to Theo, he was loath "to express in figures and landscapes something sentimental or melancholy," but wanted to bring his focus to the human spirit, dark as it sometimes is, within nature. He elaborated in a letter to Theo:

> I see in the whole of nature, for instance in the trees, expression, and, so to speak, soul. A row of pollard willows sometimes has something of a procession of orphaned men about it. The young wheat can have something indescribably pure and tender, which rouses a similar feeling, as for instance the expression of a sleeping child. The trodden-down grass at the side of the road has something tired and dusty about it, like the people of the slums. When it snowed recently, I saw a small group of Savoy cabbages standing as if benumbed, and it reminded me of a group of women I had seen early in the morning standing in their thin skirts and old shawls by the water-and-fire cellars.

His "orphaned men" are telling: the motif of the solitary figure, the loner, walking on the road appears repeatedly throughout Van Gogh's work. He felt himself a stranger in his own family as well as in his country, an outsider. It was a feeling that haunted him throughout his life. (Interestingly, I've found in my work with young artists that even today they are often treated as outsiders by their peers; this seems to be a kind of typecasting—romantic but unfortunate—in the field of art.)

Neil Folberg, *L'Arlésienne*
(after Van Gogh), Paris, 2003

Van Gogh's paintings were made quickly and instinctively: the rapidity of the process enabled him to render his passions directly onto the canvas—perhaps this provides part of his work's immediacy, the directness of its impact upon the viewer. He painted the pink-and-white orchards in a frenzy, driven to capture as many of the "Japanese" landscapes as he could before the blossoms fell and disappeared. In his race against time that spring, he amassed fourteen paintings, which he shipped back to Theo in Paris. But his hopes that these beautiful scenes would instantly appeal to the buying public were misplaced; not one of the works sold.

It struck Van Gogh that the art collectors were not yet ready to respond to his new work—but he was undaunted, certain of the integrity of his project. He reassured himself that the public would one day come around, and he returned his attentions to producing paintings.

Van Gogh's expenses in the South were no less than they had been in Paris. He lived at the Carrel, eating the café's greasy fare and drinking its bad wine. ("Why can't they have soup, baked potatoes, rice and macaroni?" he complained.) After a fight with the proprietor over an additional charge for storing his canvases, Van Gogh changed his lodgings to the Hôtel de la Gare, on the place Lamartine, just a few blocks away outside the city ramparts. The move was a propitious one: his new landlords, Joseph and Marie Ginoux, became his friends and models.

In keeping with his drive for artistic innovation, Van Gogh wanted to revive and reinvent the tradition of portraiture. The Impressionists' style of capturing the fleeting moment generally precluded in-depth study of a person's experiences and the qualities of his soul. In contrast, Van Gogh desired to reveal the essence of a person as shown through the eyes, the gestures, the demeanor. He successfully captured Marie Ginoux as the quintessential Arlésienne—his representative of the women of Arles.

During his short career as an artist, Van Gogh would paint nearly four dozen portraits, none of which were properly acknowledged during his lifetime. He correctly

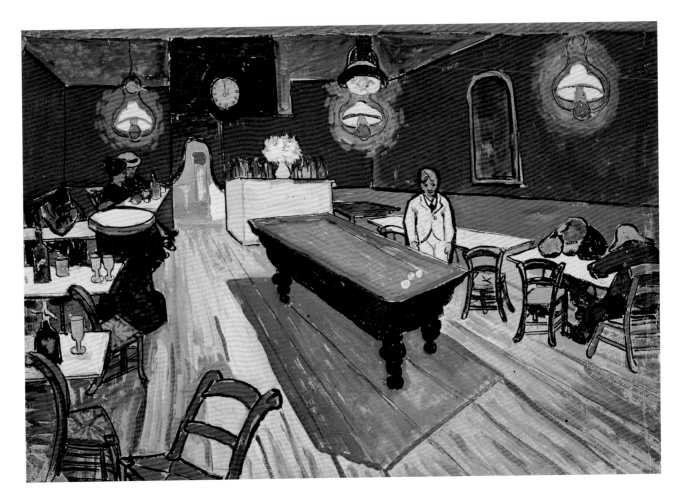

Vincent van Gogh, *The Night Café in Arles*, 1888

intuited that it would take a hundred years for these paintings to be understood and appreciated. (Recently, his portraits have commanded higher prices at sales and auctions than anyone could have imagined.) At that time in Arles, though, he could not even afford modeling fees, so it fell to his friends to sit the long hours until he turned his interpretative visions into masterly reality.

Van Gogh's love of nature often drew him to paint outside. After the fruit trees were denuded of their blossoms, he moved to painting the golden wheat fields under skies of saturated blue. Sunburned, mosquito-bitten, and afflicted by the unconquerable mistral, Van Gogh spent long hours in the fields. The cold, dry, whipping winds would sometimes last for days, even weeks, making everyone uneasy. Van Gogh tried to outwit the mistral, anchoring his easel's legs into the earth with pegs, but the wind's strength sometimes proved too much, at which point he wasted no time, but turned to drawing on sheets of paper tacked to boards.

Van Gogh did not complain about the heat or mosquitoes, because he lost himself in his art, at moments feeling an exaltation he had never before experienced. Immersed in his innovative experiments with exaggerated color and contrasts, for weeks on end he spoke to no one. Exhausted at the end of each day, his head filled with computations of color combinations to evoke the emotions he wanted the viewer to experience, he would trudge back to Le Venissat, the restaurant on the place Lamartine where he ate dinner every night, then make his way next door to the café at the Hôtel de la Gare to quiet his turbulent mind with drink before falling into bed.

As for the famously beautiful Arlésienne women, Van Gogh felt they had seen their day; other subjects interested him more. In Arles itself, he painted the seedy urban life around him. So-called night cafés (including the Café de la Gare) were open twenty-four hours. In the early hours of the morning, the homeless would put their heads down on the café tables to sleep. In Van Gogh's stunning painting *The Night Café in Arles*, 1888, the billiard table, the glowing gas lamps, the alcohol that muffled feelings are all depicted in disturbing blood-reds and garish greens; the colors and distorted imagery seem to speak metaphorically of man's passions, hopelessness, and depravity. Van Gogh gave this painting to his landlord and friend Joseph Ginoux in return for Ginoux's forgiveness of a debt.

In the hope of becoming more self-sufficient, and avoiding the ceaseless financial requirements of innkeepers, Van Gogh devised a plan to rent private lodgings, to be used both as a studio and a residence where he could sleep and cook his own simple

meals. He hoped to save Theo some of the hard-earned funds his brother was doling out to sustain him and his work. In May 1888, Van Gogh located a small house at 2, place Lamartine, very near the Hôtel de la Gare and the railway station. Painted a deep yellow on the outside, with green shutters, and a clean whitewash on the walls of its four tiny rooms, the house faced a small public park that Van Gogh would depict, sometimes according it almost mystical properties. His 1888 painting *The Yellow House* is so literal that it includes the mounds of earth on the place Lamartine where the gas mains were being installed. Use of the lavatory in the four-story hotel behind this house was included in the monthly rent of fifteen francs, but Van Gogh's finances did not allow for the acquisition of furniture immediately—so for some time after renting the house he would continue to sleep at the Hôtel de la Gare. Nonetheless, the artist was beside himself with happiness at finally acquiring his own home.

A STUDIO OF
THE SOUTH

Van Gogh had found a home, but he still desperately needed a community of peers.

The young artists with whom I work in America sometimes tell tales of being viewed as weirdos, or persecuted in their high schools for not being "jocks." Each year, the youngARTS program brings all of these young people together for a week in Miami, to share their ideas and talents. After their time of working together, I've noticed, they seem positively transformed. They have met a group of their own kind—some of them for the first time—and strengthened one another's resolve to become artists. During this "ARTS Week," they make friends with whom they will stay in touch, encouraging one another on the hard road that lies ahead. Although the young artists enjoy workshops and master classes that enrich them during this week (as well as cash awards and college scholarships), they all agree that the most important benefit is *being together*.

This crucial sense of artistic camaraderie was sorely lacking in the life of Van Gogh. He had long imagined a community of struggling artists cooperating to support one another. When he and Theo learned that Paul Gauguin was ill and in desperate financial straits in Brittany at Pont-Aven, an idea began to germinate in Van Gogh's head. Inviting an artist or two to live and work with him in the Yellow House might, he thought, benefit everyone: not only would it help his morale and aid the other artists, it would save Theo money, which he had been sending regularly to both Van Gogh and Gauguin to help sustain them.

Nearly all of Van Gogh's letters to Theo have a common theme: he describes his paintings, hoping to justify his brother's support. Van Gogh's failure to sell any of his paintings weighed heavily upon his conscience. Theo had written him: "I want to tell you something once and for all. I look upon it all as though the question of money and the sale of pictures and the whole financial side did not exist." And "You speak of money which you owe me, and which you want to give back to me. I won't hear of it. The condition I want you to arrive at is that you should never have any worries." Unfortunately, Van Gogh had taken to heart their parents' precept that unless a person supported himself, he was worthless. This notion was so deeply ingrained in him that Theo's absolution did little to alleviate Vincent's insistent desire to pay his brother back.

Once the idea of artistic communal living took hold of Van Gogh, specifically with regard to Gauguin, he began to envision an "Atelier du Sud"—a Studio of the South—in which a collective of artists could work. Theo would sell the artworks, dividing the proceeds among the associated members, and Van Gogh would finally be free of guilt.

When Theo and Vincent first proposed the idea to Gauguin, the response was not enthusiastic. In Pont-Aven, Gauguin was revered as the fulcrum of a large, established community of artists, which included Emile Bernard, Paul Sérusier, Charles Laval, and others. (Van Gogh had suggested more than once that he might join Gauguin in Pont-Aven, but when he learned that he would have to live in a large inn with numerous boisterous and argumentative artists, Van Gogh hesitated, knowing that he would need more privacy than was available.) Feared and admired, Gauguin ruled the Pont-Aven group with an iron fist. There were no artists in Arles to offer Gauguin comparable veneration—only Van Gogh, with his peculiar personality, so nervous and hypersensitive. Moreover, Gauguin was wary of the idea of living in close proximity to the brother of Theo van Gogh, the successful art dealer with the prestigious Galerie Boussod et Valadon, to which Gauguin looked for financial and career support. The backwater of Arles did not seem an auspicious location for Gauguin's grand ambitions.

But in the end, pressured by the suggestion that Theo would not be able to afford to support him in the North and Van Gogh in the South, Gauguin agreed to move south. It was five months, however, before he would make the trip: he arrived in Arles by train on October 23, 1888.

Although he was ready to submit to the lessons of Gauguin—the acknowledged master—Van Gogh was anxious to show him the strides he had been making in his

art. In expectation of Gauguin's arrival, Van Gogh began furiously creating paintings for the inside of the Yellow House with his most original ideas. Two paintings of sunflowers graced the walls of Gauguin's bedroom. In his various depictions of *The Garden of the Poets*, Van Gogh alluded to the great poets Petrarch and his young acolyte Boccaccio; Van Gogh envisioned a similar creative relationship with Gauguin, and believed that together they would profoundly affect the future of art.

In his 1888–89 painting *Bedroom at Arles*, Van Gogh attempted, through unprecedented color combinations, to achieve an atmosphere of "rest, or of sleep in general." In a letter to Gauguin, he explained that the painting was meant to give a feeling of complete serenity—but, as Van Gogh was an insomniac by then and couldn't judge for himself, he asked Gauguin to tell him how the four sets of complementary colors made him feel.

Van Gogh described the painting to Theo:

The walls are pale violet. The floor is of red tiles.
The wood of the bed and chairs is the yellow of fresh butter.
Sheets and pillows very light greenish-citron.
The coverlet scarlet. The window green.
The toilet table orange, the basin blue.
The doors lilac.

And that is all—there is nothing in this room with its closed shutters.
The broad lines of the furniture again must express inviolable rest.
Portraits on the walls, and a mirror and a towel and some clothes.
The frame—as there is no white in the picture—will be white.

From the moment Gauguin stepped into the Yellow House, Van Gogh's hopes of having a sympathetic friend with whom to share his dreams were crushed. Van Gogh's housekeeping and work habits disgusted Gauguin. Van Gogh's meals, lovingly prepared, were deemed inedible by Gauguin. Paint tubes were not capped, and were left oozing out of a color box that wouldn't close. On and on went the complaints—but as Gauguin examined Van Gogh's paintings, he had to admit that his Dutch friend had achieved something extraordinary. For the arrogant Gauguin, this was of course only cause for more aggravation.

Having been in the French merchant marine from age sixteen until he was twenty-one, Gauguin had learned to cook and to maintain a shipshape living space. He took over the preparation of meals, and Van Gogh did the shopping. The money that Theo sent was carefully divided into an exact budget and put into tin boxes. But although Gauguin brought apparent order to their living expenses, he also succumbed to occasional splurges—and their allowance would be suddenly lost.

The Yellow House was very small, and that winter it rained and rained. The two volatile artists were cooped up together for days, on top of each other, physically confined, but aesthetically poles apart.

Just a few days before Gauguin had left Brittany to come to Arles, he had walked with Paul Sérusier into the Bois d'Amour in Pont-Aven, and had insisted that the young artist paint the woods in greatly exaggerated colors. In the end, Sérusier had rendered a complete abstraction. The resulting painting, *The Talisman*, marked an enormous breakthrough in art: the beginning of the Symbolist movement, which would be led by Sérusier.

The triumph of having just participated in the discovery of this new way of seeing and painting had given Gauguin a sense of true invincibility; he came to Arles in a storm of enormous energy—energy that hit Van Gogh's fragile constitution like a bludgeon. Gauguin, convinced that the artist must paint less from reality and more from the imagination, told Van Gogh: "Don't copy nature too literally. Art is an abstraction; derive it from nature as you dream in nature's presence and think more about the act of creation than the outcome." Feeling that Gauguin's teachings were not valid for him, Van Gogh responded: "I devour nature ceaselessly. I exaggerate—sometimes I make changes in the subject, but I don't invent the whole picture. On the contrary, I find it already there." Van Gogh's resistance displeased Gauguin.

Normally when Gauguin worked, he took his time, studying his surroundings before he began painting. He had hoped to spend a restful month in Arles absorbing the atmosphere, but Van Gogh had him up and painting immediately. Often they worked beside each other on the same subject—painting the peasants at Alyscamps, for instance, in their *arlésien* finery—but Gauguin would paint the Provence locals in traditional Breton dress, rather than the Southern garb, a clear indication that he was missing life in Pont-Aven.

As tensions mounted between them, Van Gogh became more and more apprehensive. Seeing that his dream of a supportive and cooperative atelier was not to be

realized, and that friction was building with Gauguin, Van Gogh confided to his brother: "I can only think about his leaving." At night, Gauguin would wake with a start to discover a wide-eyed Vincent observing him, making certain that he was still there. Such moments were so unnerving that Gauguin—usually a combative character—became withdrawn and quiet. Van Gogh sulked or exploded at any perceived slight. According to Gauguin, when Van Gogh looked at Gauguin's portrait of him at the easel, painting sunflowers, Van Gogh said: "It is certainly me—but me gone mad."

Gauguin's departure was inevitable. Just a few days before he left, Van Gogh painted symbolic "portraits" of himself and Gauguin, as empty chairs. Van Gogh's is a simple wooden one with a woven straw seat, on which lie his pipe and pouch of tobacco; Gauguin's is a plush armchair with a green rush seat, looking like striped silk, on which rests a burning candle in a golden holder, with two books. The gaslight sconce on the wall radiates a glowing halo. Gauguin's chair is pictured at night, while Van Gogh's simple wooden chair is bathed in sunlight, as if to suggest that the two are as different as day and night. When the paintings were hung side by side, the chairs faced away from each other.

ABANDONMENT

Van Gogh's tremendous fear of abandonment—as symbolized by those empty chairs—stemmed from a powerful precedent in his life. Twelve years earlier, in 1876, he had written to Theo of a deep sense of loss at his father's departure: "After I had seen Pa off at the station, and had watched the train as long as it, or even only its smoke, was still in sight, and after I had returned to my room and Pa's chair was still drawn up to the table where the books and periodicals still lay from the day before, I felt as miserable as a child, even though I am well aware that we shall soon be seeing each other again."

Van Gogh had a complex relationship with his father, Theodorus van Gogh, a strict Protestant pastor in the town of Groot-Zundert in the Netherlands. A year to the day before Vincent was born, his mother, Anna Cornelia, had given birth to a child—whom she named Vincent—who died just hours after being born. That baby's tombstone was in the cemetery near the parish church where Van Gogh's father preached. As a young boy, Vincent often played in the cemetery—where he saw his own name and birth date (though with a different year) inscribed on the grave of his dead brother. The guilt of the survivor would trouble Vincent throughout his life.

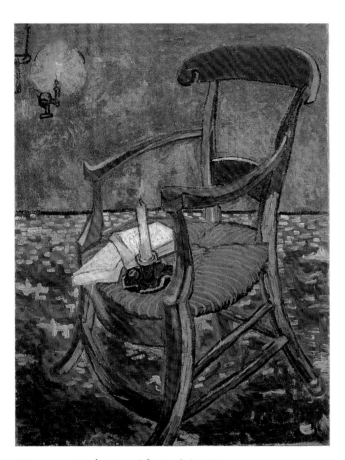 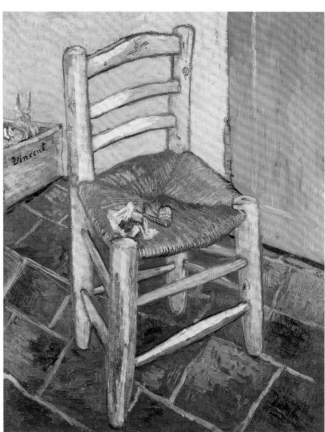

Vincent van Gogh, *Gauguin's Armchair*, 1888 Vincent van Gogh, *Van Gogh's Chair*, 1888

At the age of eleven, he was sent off to boarding school in Zevenbergen, twenty miles from home, and would later attend other boarding schools. He was an extremely lonely child, never able to fit in with the other students. "My youth," he once recalled, "was gloomy, and cold, and barren." A photograph of him at the age of thirteen reveals a sweet-faced young boy with light hair and the most sorrowful eyes imaginable.

Van Gogh held on to a distressing image of his parents departing, after leaving him on his own at school; it was a picture that would haunt him into adulthood. He later taught at a boarding school in London, and felt great empathy for the little boys pressing their noses against the school window, watching the back of their parents' carriages as they drove away. He well remembered that empty feeling that he'd had as a boy, and even sent Theo a sketch of the schoolboys looking longingly through the window.

Van Gogh's relationship with his pious father seems to have been fraught with difficulty and tension; he once wrote to Theo about how "hard" their father was. Theodorus died in 1885, without Van Gogh's having been reconciled with him—leaving an inconsolable yearning in the heart of the artist.

Van Gogh was furthermore clearly unable to have a happy, loving relationship with a woman. His own mother had given birth to him while she was still in mourning for his dead brother, and she had shown young Vincent little warmth or affection. As an adult, Van Gogh's first two great loves were unrequited—but his desperate longing drove him to relentlessly demand the return of his affections. In 1881, he became obsessed with his widowed cousin, Kee Vos-Stricker, who is said to have refused his persistent advances and proposal of marriage with a flat "Niet, nooit, nimmer!" (No, never, never!). Equally ill fated was his relationship in the following year with a prostitute named Clasina Maria Hoornik, known as "Sien." Both of these women were nurturing their own children (and Sien was pregnant with another baby) when Van Gogh became involved with them. Like an infant longing for sustenance, he seems to have been deeply attracted to this maternal quality. Their lack of response left him in despair, shame, and deep-rooted anger.

As the portraits of the empty chairs suggest, abandonment and terror of abandonment were at the core of Van Gogh's being.

In late December 1888, just two months after Gauguin's arrival, Van Gogh confronted him point-blank: "Are you staying or going?" Gauguin answered just as frankly: "Going." Van Gogh gave him a strip of newspaper with the headline: "The murderer fled!" Gauguin had, it seems, "murdered" Van Gogh's dream of the Atelier du Sud, which was to be such a hotbed of collaborative energies and support.

The next morning, Van Gogh was discovered bleeding and unconscious in his bed. His left earlobe was missing. According to the manager of a brothel that both Van Gogh and Gauguin frequented, Van Gogh had handed his earlobe to her the night before, saying: "Now you'll remember me."

Gauguin sent a telegram to Theo asking him to come immediately. Van Gogh was taken by the police to the Hôtel Dieu, the local hospital, where he regained consciousness and asked to see Gauguin, who did not come. Theo's subsequent arrival mortified Van Gogh; he later wrote a scathing letter to Gauguin, remonstrating him for informing his brother of his ordeal.

Van Gogh's letters to Theo had always painted a positive picture, suggesting that, against all odds (and all evidence to the contrary), the distressed painter had things under control. The truth of his deeply afflicted state was too awful to admit. Van Gogh counted on his younger brother looking up to him, and trusting in his powers as an artist who could lead the creative community to a better life. In a letter to his mother and Wil, Van Gogh exhibited clear denial of the state of his mental health, assuring them that although he had been indisposed for some time, all was quite well and he was back to painting.

Van Gogh and Gauguin continued to correspond, and, in fact, after Van Gogh's death, among his papers was an unfinished letter to Gauguin dated July 1890, again suggesting that he join Gauguin in Pont-Aven.

After two weeks in the Arles hospital under the care of Dr. Félix Rey, Van Gogh returned to the Yellow House, but his behavior remained erratic. The townspeople demanded of the authorities that he return to the hospital and not be allowed to stay at the Yellow House anymore. Realizing that he was steadily losing touch with reality, Van Gogh agreed to commit himself to the asylum at Saint-Paul-de-Mausole in Saint-Rémy-de-Provence, twenty miles from Arles.

Saint-Paul-de-Mausole was, as Van Gogh put it, a lunatic asylum. He was frightened by the aberrant behavior of his fellow inmates, but because he had suffered four major attacks in Arles—during which, as he wrote: "I had no idea what I said, what I wanted, or what I did, not to mention the three times before when I had fainting fits for inexplicable reasons, being quite unable to recall what I felt at the time"—he saw that he had to be confined. He hoped that, under the close supervision of Dr. Théophile Peyron, he would finally understand what had happened to him, and find a way to prevent it from recurring. Van Gogh was initially under the impression that his stay at Saint-Paul-de-Mausole would be for three months. In the end, he would spend more than a year at the asylum.

Dr. Peyron diagnosed the patient's malady as a form of epilepsy, as had Dr. Rey in Arles. At first, Peyron didn't seem to hold much hope for Van Gogh's recovery, but after several months of observing his lucid and productive patient, he was more encouraging.

Van Gogh's sparse room, with its sea-green curtains and metal bed frame, overlooked a wheat field enclosed by a stone wall. Because the asylum was not full, he was allowed to use an additional room as a studio. Once he began painting again, he found he was less disturbed by the presence of the other patients (in fact, he made a touching portrait of one of them). Mostly, Van Gogh immersed himself in landscapes; accompanied off the grounds by an orderly, he renewed his quest to define Provence through his paintings. According to Van Gogh, the asylum provided no distractions for its patients, and he knew that if he did not work—constantly and hard—his condition would deteriorate. He continued to suffer attacks, and would afterwards always urge his doctor to allow him to go back to his painting.

Van Gogh painted beautiful irises and sunflowers, like the ones that he had created to adorn Gauguin's bedroom in Arles. He made copies of the paintings of his bedroom at the Yellow House and a copy of *L'Arlésienne*; by adding gloves and books to the table at which Madame Ginoux sat, he gave her an air of gentility (countering Gauguin's harsh portrayal of her,

Neil Folberg,
Corridor at the Asylum of Saint-Paul-de-Mausole, Saint-Rémy-de-Provence, 2003

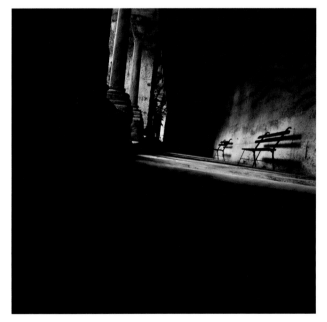

Vincent van Gogh, *A Corridor in the Asylum*, 1889

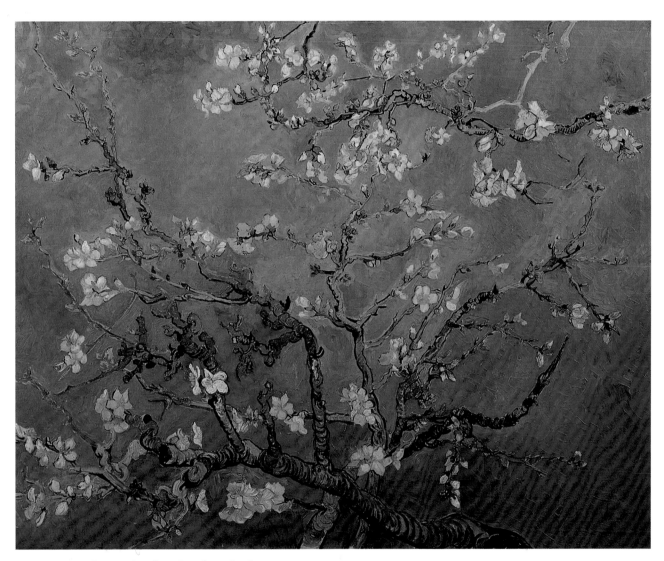

Vincent van Gogh, *Branches of an Almond Tree in Blossom*, 1890

looking like a madam in a brothel). Van Gogh made paintings of the entry to a nearby quarry, and of a ravine, as well as of the enclosed wheat fields with violet Alpilles hills in the distance. The mountains were a new motif for him; initially he had been partial to open, flat fields as far as the eye could see—like those in the Netherlands and near Arles—but now he perceived the small Alpilles surrounding Saint-Rémy-de-Provence as extraordinarily beautiful.

In February of 1890, Van Gogh learned of the birth of his nephew, Vincent. As a tribute to his new godchild, he began a painting of a blossoming almond tree, with exquisite white flowers supported by spring-green branches against a turquoise

Neil Folberg, *Courtyard at the Asylum of Saint-Paul-de-Mausole*, Saint-Rémy-de-Provence, 2003

background. But before he could finish the work, he suffered a terrible *crise*, and was confined to his room at the asylum, unable to continue working outdoors. When he regained his lucidity, at the end of April, the almond trees were no longer blooming—and so he completed this very hope-filled and beautiful present for his namesake in his studio, instead of working from life, which was his usual habit.

Van Gogh's paintings were changing, his lines were now more convoluted; instead of violently slapping on many thicknesses of paint as he had in Arles, his finish was smoother, with very little impasto. Theo understood that his brother was searching for a different style. After his most recent attack as he was painting the almond tree, Van Gogh was calmer, more at peace. He saw that he had a disease and wasn't as terrified as he had been when he suffered the first attack. He felt that he was not mad, because between attacks he was lucid, healthy, and prodigiously productive.

Walking in Van Gogh's footsteps—even to this quiet institution at Saint-Rémy, with such sad ghosts in its walls—was beginning to have a healing effect upon me. I found that I was fascinated by the story of this artist, and not only because his paintings are so profoundly moving in themselves. Ted had often told me that Van Gogh was his favorite painter, and so his work held special interest for me. But I was only now learning that the value of art is far more than simply aesthetic pleasure.

Immersing myself in the paintings and the nature that had sparked their creation gave me energy and left me craving more. I was beginning to see what power art could have to soothe and to revitalize. The work was tending to my wounds as it had tended to Van Gogh's more than a hundred years ago.

Indeed, this was a central impulse in Van Gogh's art; he identified deeply with the long-suffering simple man, but one of the purposes of his new style was to console himself. And he believed that to compensate for his lifelong struggle and suffering there would be an ultimate reward, either in this life or in the next. The immediacy and sensuality of his paintings reach out and engage us, but a close exploration of the meanings within the works results in deeper understanding of the painter himself—so driven and so deeply tormented. He wrote to his brother: "Gauguin, Bernard and I may . . . not conquer, but neither shall we be conquered; perhaps we exist neither for the one thing nor for the other, but to give consolation or to prepare the way for a painting that will give even greater consolation."

Van Gogh was not entirely unhappy staying at the asylum for an extended period of time. He appreciated the seclusion, removed from the drudgery of managing day-to-day living. As he wrote to his mother toward the end of 1889: "I shall always keep on feeling the shock [of the first attack]. . . . I intend to spend a great part of next year here, too, as it would be best for my work, even if it were not absolutely necessary for my health . . . as I have somewhat got my bearings here. . . . Change is always injurious to painting . . . the country here has not been painted yet . . . the other painters usually go somewhat farther on, to Nice or so." Vincent wished to give Theo a comprehensive take on Provence, a study that would be entirely unique.

Saint-Paul-de-Mausole had been built as a monastery in the eleventh and twelfth centuries, and was still run by nuns. Van Gogh, with his Protestant upbringing, had developed a distaste for ecclesiastic extravagance early on. He had served for a time in the 1870s as a lay preacher in the Borinage area of Belgium, but after being dismissed from his post (he was seen by church officials as disturbingly zealous) he lost all faith in organized religion. He once confided to Theo that, when he felt a religious compulsion, he would "go out at night to paint the stars."

Death may possibly not be the hardest thing in the life of a painter. I must declare that I know nothing about them, but when I look at the stars I always start dreaming, as readily as when the black points that indicate towns and villages on

a map always start me dreaming. Why, I wonder, should the shining points of the heavens be less accessible to us than the black dots on a map of France? Just as we take a train in order to travel to Tarascon or Rouen, we use death in order to reach a star. . . . To die peacefully of old age would be the equivalent of going on foot.

Van Gogh began yearning to paint nighttime skies in blues and halos of stars upon the death of a mentor, Anton Mauve, in 1888. Mauve, a respected Dutch painter, was married to Van Gogh's cousin, and had been his first art teacher. Memories of Mauve's kindness had always comforted Van Gogh; after Mauve died, Van Gogh sent his widowed cousin a beautiful painting of a pear tree he had made in Arles. Mauve's death inspired Van Gogh to look outward, toward the infinity of the sky, as a potential subject. While in Arles, he had painted the Rhône under a night sky filled with stars, as well as the glowing *Café-Terrace at Night (Place du Forum in Arles)*, and he had used the night sky with stars as the background also in his portrait of his friend Eugène Boch.

Now he was to explore brand new territory: a complete surrender to his own imagination. Van Gogh had always maintained that "if a painter paints as he sees, he always remains somebody." For him, *The Starry Night* that he painted at Saint-Rémy in June 1889—a powerful, ecstatic dreamscape—was both a leap and a great risk.

In December of that year, after a particularly violent epileptic attack, he wrote to Theo: "Don't worry too much. I fight calmly against my disease, and I think that I shall soon be able to take up my work again. And this will be another lesson to me to work straightforwardly and without too many hidden meanings, which disturb one's consciousness." The attacks came and subsided, but in April 1890, although he had recently had a two-month period of being detached from reality, Van Gogh felt just well enough to leave the asylum and move to Paris. He was desperate to escape Saint-Paul-de-Mausole and his fellow patients. "If a man responds to his environment with great sensitivity," he wrote, "a stay in an old monastic building is quite sufficient to explain these attacks."

He checked himself out of the asylum and headed north, toward Theo, Paris, Auvers, and the fulfillment of his destiny.

After my visit to Saint-Paul-de-Mausole, I walked in the grove of *oliviers* just out-side the confines of the asylum. In the distance are the Alpilles, these low, lilac-tinted mountains that Vincent captured so movingly on canvas. Just over the crest of

Vincent van Gogh, *Café-Terrace at Night (Place du Forum in Arles)*, 1888

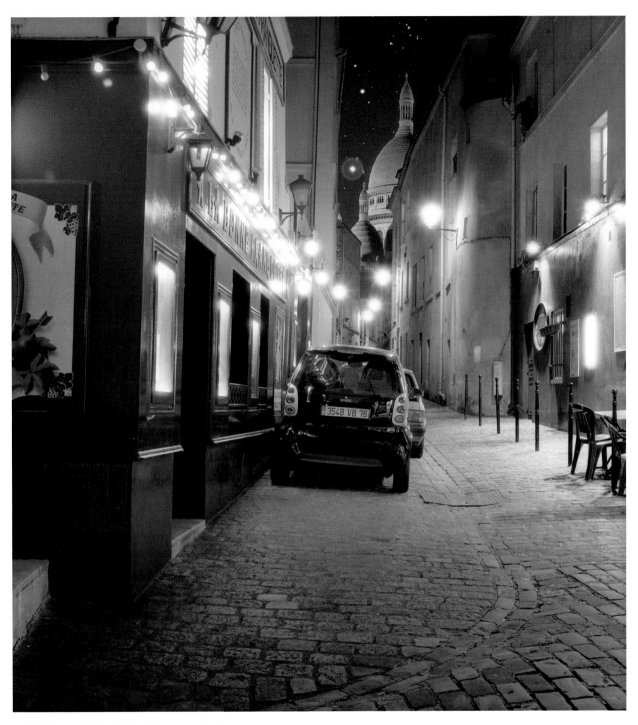

Neil Folberg, *Café at Night*, *Montmartre*, Paris, 2001

the ridge is Les Baux, one of the most beautiful villages I have ever visited, standing sentry over an expanse of fields and vineyards.

Confined to a small area around the asylum, Van Gogh never went over that ridge, yet his allotted space was more than enough for a man who painted the beauty of worn shoes and crafted a masterpiece from a few purple irises. His world was stiflingly small, but he did not need more than that. It is humbling to consider what Van Gogh accomplished under such constraints. And yet he believed that he had fallen short of what he wanted to do; his grand vision of achieving a *new art* had not, he felt, been attained. He had been one of many trailblazers in what was to be a long path.

BRINGING AN END TO SUFFERING: AN EXAMINATION

When I first began to trace Van Gogh's route in Auvers, I thought of the village as a lovely flower, gracefully opening its petals to me. But as my search continued, as I came to know both the village and the artist more intimately, I began to experience a sense of strange discomfort there. Having delved deeper into Van Gogh's creative impulses and processes in Arles and Saint-Rémy, I considered the tragic mental disturbances that contributed to his suicide. It was as if the flower's petals had retained their radiant beauty, while the roots threatened to suffocate me in their grasp.

Why did Van Gogh destroy himself? Art historians, psychiatrists, and writers are still searching for clues that might help us find the answer. My own understanding of Van Gogh's life is based largely upon reading his letters, and the recently published correspondence between Theo and his wife, Johanna.

Van Gogh had spent a year in the asylum at Saint-Rémy. When he checked himself out, on May 16, 1890, his doctor wrote in his file, summarily: "Cured." Diagnosed as having a form of epilepsy, Van Gogh was treated with hydrotherapy (known today to be useless for epileptics). Dr. Gachet also assured Van Gogh that he felt certain he was back to normal. These were the professionals of the day, and they plainly did not recognize what was happening to him or how to cure his illness. Only Van Gogh seemed to know that he was not "cured"; indeed, he lived in a state of constant fear, anticipating a recurrence of his attacks.

There are now many theories about the physical conditions that might have been the actual cause of Van Gogh's illness—ranging from lead poisoning to Ménière's disease, bipolar disorder, syphilis, and epilepsy. The general consensus, however, is that his

troubles were indeed physically based, and that he was not, as the popular myth has it, a "mad artist."

If epilepsy was in fact the affliction from which he suffered, his was a particularly insidious manifestation of the disease, which can take many forms. Van Gogh's fits were not characterized by seizures or frothing at the mouth; instead, he would be overcome by a terrible anxiety, a sensation of emptiness, and great fatigue. Suffering excruciating pains in his head, he would lose touch with reality, hear voices, hallucinate, and experience nightmares. The fits tended to occur every three or four months, by his own count. Van Gogh had an attack in April 1890. If his calculations were correct, he would be hit by another in July—and it was on July 27 that he shot himself. Dr. Gachet would testify that Van Gogh was completely lucid, and that this episode was not the result of an epileptic attack.

Certainly there were many possible factors leading to this tragic culmination. While under the care of Dr. Peyron in Saint-Rémy, Van Gogh had stopped drinking, but had made several trips to Arles to visit his friends Joseph and Marie Ginoux. It is very possible that Van Gogh drank a few glasses of the popular liqueur absinthe with his friends during these visits—once a very heavy drinker, he would likely have considered a couple of drinks inconsequential. It is now known that even a small amount of absinthe may bring on epileptic seizures (among other ill effects). After each visit to Arles, Van Gogh suffered an attack; sensing the oncoming siege, he would rush back to the asylum for safety. In his agony, he tried several times to commit suicide in the asylum: by eating paint, swallowing handfuls of dirt, and drinking kerosene.

In Auvers, anticipating that another attack would come during the summer, Van Gogh may have been without hope that his torturous fits would ever cease—and especially concerned that he could not endure another one in a small town lacking a safe asylum. Just before leaving Saint-Rémy, Van Gogh had been non compos mentis for more than two months, the longest stretch of acute illness since his affliction had emerged the year before.

It is now believed that Van Gogh was aware that he was also suffering from the effects of syphilis. In one of his letters, he surmised that he would have only about ten years in which to live and create; this might also explain why he painted so rapidly, attempting to produce as much work as he possibly could in his given time.

To complicate matters, Van Gogh's relationship with Theo had become increasingly fraught with worries. In 1886, the same year that Van Gogh arrived in Paris, his brother too displayed an early symptom of syphilis: temporary paralysis. Theo was Vincent's sole support, and was much beloved by him. Theo's debilitating disease certainly must have terrified Vincent.

On July 6, 1890, Van Gogh traveled from Auvers to Paris to visit Theo and his family. He witnessed significant tension between Theo and Johanna involving the economic stresses of family life: whether to move to a larger apartment on the ground floor of the same building, whether Theo should leave the Galerie Boussod et Valadon, where Theo felt he was not sufficiently appreciated, despite his success as a dealer. Theo was considering opening his own gallery. After hearing Theo and Jo's family arguments, Van Gogh rushed back to his refuge in Auvers, where he continued his frenzied pace of painting.

Theo had written to Vincent that, under the circumstances, he didn't think he could keep supporting Vincent as steadily as he had before. Van Gogh realized that now he had to share his brother's affection and financial support with Jo and their young child. It certainly must have crossed his mind that his brother might not continue to support him at all.

Van Gogh had been looking for a house in Auvers, so that Theo and his family could spend weekends with him. He had long dreamed of finally being able to have a home with his relatives; he painted decorative art during this period, so that he could put these paintings on the walls, as he had in the Yellow House in Arles. When Theo and his family refused his invitation to spend a month with him in Auvers (Jo had decided to go to the Netherlands instead, to introduce her parents to their new grandson), Van Gogh was shattered, and his loneliness and despair intensified.

Theo decided to stay on with Boussod et Valadon (although the firm did not raise his salary, as he had hoped they would). Unfortunately, he neglected to inform his brother of this, and so Van Gogh remained under the misapprehension that Theo was still in terrible monetary straits.

In addition to his illness, there were Van Gogh's pride, his perverse anger, and his constant sense of guilt at having to be dependent on his younger brother for sustenance. When he arrived in Auvers, because his nightmares had ceased, he had hoped that his health was improving. But the perceived severe financial burden on Theo overwhelmed Van Gogh to the point that he began to contemplate the awful notion that

a dead artist was worth more than a live one. He had seen the value of Jean-François Millet's paintings rise to dizzying heights after the painter's death—and felt that such inflation was a dreadful thing: "The high prices one hears of, that are paid for works of painters who are dead and who never received such payment in their lifetimes . . . is a disadvantage to living painters, not an advantage." It was, he said, "a moment when things are very strained between dealers in pictures by dead artists and those who deal in living artists."

Still, Van Gogh's death would enable Theo to become a dealer of a dead artist, with all the success that would entail. Furthermore, Theo would no longer have the burden of his financial upkeep. Now that Van Gogh felt his success was imminent, his debt to Theo could at last be paid in full.

Van Gogh believed that his own reward would be forthcoming as well. He agreed with Delacroix, who had written: "One must hope that the great men who were despised or persecuted in their own lifetimes will one day be granted the reward that was denied them on earth when they enter into a sphere where they enjoy a happiness of which we have no conception, part of which is the happiness of looking down to witness the fairness and justice with which Posterity remembers them."

Delacroix's words, which Van Gogh firmly believed, do convey comfort; today Vincent van Gogh and his art are remembered with the "fairness and justice" that are of course their due. Certainly the greatest comfort of all comes in viewing the paintings and visiting the places that inspired them.

For me, that comfort turned to wonderment as I watched my granddaughter fall in love with art—a love that began with our trip to Auvers when she was fifteen, and that grew substantially over the subsequent years. Her world had expanded and now would be filled with a glorious new dimension. As I picked my way through the colors and forms that had generously been bequeathed to me by Van Gogh and many others, I found that the raw hurt of losing my husband was abating. The power of such an experience was, it seemed to me, nothing short of miraculous.

A Gathering of Artists

Van Gogh did not have the benefits of a coterie of peers. The Studio of the South, his attempt to form an artist's cooperative, was short-lived: it existed for only two months. And the mutually supportive group of Impressionists who had congregated at Auvers-sur-Oise had dispersed long before his arrival. With the exception of Dr. Gachet, and occasional visits from Theo, Van Gogh remained alone at Auvers.

When he left the asylum at Saint-Rémy, Van Gogh had very much wanted to live at the home of the Impressionist patriarch Camille Pissarro in Eragny-sur-Epte in Normandy, and might have done so if Pissarro's wife had accepted Van Gogh into their home. Though he was a friend to Van Gogh, a kind mentor, and a solid advocate of so many artists of his time, Pissarro's denial to the young artist was a fateful turn in the end.

Following the footsteps of Van Gogh inevitably led me to the venerated Pissarro—and picking up the trail of Pissarro would in turn open the door for me to the wider world of the Impressionists.

As I became familiar with Pissarro's character and life, I could not help being reminded of Ted—who was a similarly gentle nurturer of everyone he knew: colleagues, artists, and family. Sarah was certainly touched by her grandfather's warmth and wisdom. Neil Folberg, too, was greatly moved by being in Ted's presence, although they knew each other for only a few years. All of Ted's children and grandchildren were mentored by him and influenced by his astonishing generosity—much as the Impressionists were by the man who was affectionately known as "Papa Pissarro."

The approach to Pissarro's last homestead in Eragny-sur-Epte is through miles of peaceful green landscape, flowing uninterrupted to the horizon beneath a broad sky and clouds. The village, an hour's drive northwest of Auvers, is not so different from the way it was a hundred years ago—nothing more than a few small houses, and fields that are still cultivated as they were in Pissarro's era. On the main road, not far from the large market town of Gisors, is the artist's house, tucked inconspicuously among a row of houses. It is now inhabited by a middle-aged woman named Mireille

Neil Folberg, *Moret-sur-Loing*,
2003

Sutter, who has recently been overjoyed by rumors that the French government is considering buying her home to turn it into a memorial for the artist. Interestingly, she has hung a seascape by Eugène Boudin—another important artistic mentor in the circle of the Impressionists—on her wall.

Pissarro's house has changed very little since the time his family lived in it. A leaded-glass window overlooks the back garden, where the artist's separate two-story studio is still in place. The wooden roof over the outer stairway to that creative refuge adds a civilized touch to this building, which was used originally as a barn. Inside the studio, enormous windows welcome a steady northern light; through them, one can still enjoy the serene, inspiring view of the adjacent apple orchards. (Indeed, the property was called "Apple Orchards" by the Pissarro family.) The house has the distinction of being slightly lopsided, which seems somehow in keeping with the Pissarros' lifestyle—artistic and friendly, but perennially hard-pressed financially.

Neil Folberg, *Atelier Pissarro, Eragny-sur-Epte,* 2002

Before the Pissarro family bought the house in Eragny, they had been evicted from various homes for lack of money (in Pontoise, Ennery, Osny); they had a terrible time making ends meet. Earlier, in the late 1860s, they had lived at Louveciennes, twenty miles from Paris. This had been a somewhat easier point in the Pissarros' lives, but they ultimately had to abandon this ivy-covered home, too—not for financial reasons, but to flee to England during the Franco-Prussian War. After they left Louveciennes, occupying Prussian troops turned the home into a slaughterhouse. Sheep were penned in the kitchen, and the soldiers used hundreds of Pissarro's oil paintings as aprons to protect their uniforms from the animals' blood while butchering, and wiped their boots on his canvases. When Pissarro returned home after the war, he was aghast to discover many of his paintings covered in mud. The better part of twenty years' work was ruined—but with astonishing resiliency, he immediately started to paint again, determined to build up an even better body of work.

Pissarro's friend Claude Monet also moved to England during the war. He had asked Pissarro if he, too, might store his canvases at Louveciennes for the duration of his absence. Pissarro placed Monet's paintings in a high alcove above his studio;

Camille Pissarro, *View Through a Window, Eragny*, 1888

ironically, those works went unnoticed by the Prussians—upon his return, Monet found them safely preserved.

Monet and Pissarro had been friends and artistic colleagues since 1859, when they met at the Académie Suisse in Paris. Monet, newly arrived from Brittany, and Pissarro, who had moved from St. Thomas in the West Indies, were both determined to become artists, but had no interest in doing so in the conventional manner. Early on, each demonstrated a stubborn individualism. Monet was nineteen when he first came to Paris, and was already making waves. It was the painter Eugène Boudin who recognized the young Monet's profound potential, and introduced him to plein-air work, leading him to stand on the rocky cliffs overlooking the bays of the English Channel and paint. Boudin was a model to Monet in more ways than one: artistically speaking, he taught Monet a love of the great heavens and outdoors, and Boudin's generosity as a friend would be reflected in his young protégé—who would in turn later provide much support for the struggling Pissarro.

In Paris, at Charles Gleyre's studio class in the academic Ecole des Beaux Arts, where Monet had enrolled at his father's insistence, the young artist was criticized for not aestheticizing his rendering of a live model: rather than striving for a depiction of physical "perfection," he had faithfully reproduced the model's feet as he had observed them—they were disproportionately large. In those days, such fidelity to reality was anathema to France's academic dictums. Artists were expected to adhere to strict rules of classical formality in order to qualify to show at the French government-controlled Salon—and it was crucial to be accepted at the Salon if an artist hoped to be represented by a private gallery. The Salon generally welcomed banal paintings illustrating myths and stories from history or religion. The depiction of unembellished reality was simply not permitted. For Monet and many of his cohorts, however, there was *only* reality. Boudin's influence, and Monet's own strong personality, excluded him from the mainstream of French academic painters.

Pissarro, ten years older than Monet, had left his home in St. Thomas, where he had been expected to work at his father's haberdashery and ship chandlery. From the West Indies, Pissarro had traveled to Venezuela, with the Danish artist Fritz Melbye, and spent two years in Caracas painting local scenes. When Pissarro first came to Paris in 1855, he was, like Monet, taken to task for what was perceived as crudeness in his rendering of a nude model. At a life-drawing class at François-Edouard Picot's atelier, Pissarro showed the model's pubic hair in his picture. When informed that no pubic

hair appears in Greek or Roman renderings, he replied: "The model is not a plaster cast. She is a living human being." He was told: "We are not drawing living humans," and was warned that he would never be accepted at the Salon. Pissarro's concise response: "I sketch what I see."

Unusual circumstances preceded Pissarro's birth in the West Indies in 1830. His father, Frédéric, had moved from France to St. Thomas at the age of twenty-three, to settle the estate of his recently deceased uncle. In time, Frédéric fell in love with his uncle's young widow, Rachel, and she became pregnant with Frédéric's child. The elders of the local synagogue refused to marry the couple, however, because Frédéric was considered Rachel's "nephew" (although they were not related by blood). The couple had three sons—Camille was the third—but it was not until after the fourth child was born that the elders relented and granted the religious blessing.

In the early 1850s, Pissarro's father sold his business interests in the Caribbean and moved the family to Passy, a hamlet on the outskirts of Paris filled with small homes and attached gardens. (Interestingly, Passy was the home also of Berthe Morisot's family, and so for a time, the two Impressionists unknowingly lived near one another—although while Morisot was still a child.) It was at their home here that Camille Pissarro likewise became embroiled in a forbidden love-match, with Julie Vellay, his mother's maid, a young Catholic woman from the Burgundian town of Grancey-sur-Ource. The artist secretly visited Julie's room in the evenings after her work was done, and they talked as he painted her. Pissarro knew that a discovery of their affair would mean Julie's immediate dismissal, and so their love was kept hidden for a year. But when Julie became pregnant, Pissarro finally had to confront his parents. They demanded that Julie leave the house, and the loyal Camille left with her—with his father's warning that if they married, Camille would cease to receive his monthly allowance and the rent for his studio. The young artist had not yet sold any paintings and could not support himself, let alone Julie and the coming baby. The couple moved into a ramshackle house on the southern slope of Montmartre. They would not marry until a decade later, in 1871, during their stay in London.

Pissarro had hoped that his mother, having experienced years of scorn herself, might have more compassion for his love. But she was not alone in condemning his relationship: Corot, Delacroix, Courbet, and all the other artists who cared about Pissarro had advised him never to get married—artists had one another, after all,

and there was no room for a wife and certainly not children. Pissarro was convinced, however, that Julie was the best thing in the world for him: she was intelligent, courageous, and hard working—and most importantly, her love gave him the confidence to risk becoming an artist.

Once he knew that his purpose in life was to be a painter, Pissarro never looked back; nor did he succumb to anyone else's idea of what an artist should be. It bolstered his confidence that the first painting he submitted to the Salon—his 1859 *Landscape at Montmorency*—was accepted, but his disdain for academic traditionalism continued to grow; Pissarro was in fact the only painter who eschewed the Salon to appear in all eight of the infamous Impressionist exhibitions in Paris. Years later, with his long white beard and gentle eyes, he was known as the unifying spirit of the movement. Although he and Julie lived in abject poverty for most of their lives, his commitment to the revolutionary new way of painting never flagged.

In Montmartre, Julie busied herself making their home more hospitable; she planted a garden in the small yard behind their house. Although she and Pissarro were saddened when their first baby was stillborn, they were confident there would be others—and indeed, the couple would give birth to eight children all told, five of whom lived to adulthood.

Neil Folberg, *Rural Road in Provence*, 2001

Pissarro longed to paint landscapes, and soon they managed to move into the countryside of La Varenne, just southeast of Paris, where Julie could raise rabbits and chickens. Pissarro never thought of this area as a permanent home, and within a few years he felt that he had exhausted its few interesting landscapes. Seeking new challenges, he explored the countryside, and when he entered L'Hermitage, a hilly, undeveloped area at the foot of the ancient town of Pontoise, he knew that he had found his own exclusive territory. Just as Van Gogh made Arles and Saint-Rémy his own, and as Cézanne appropriated Mont Sainte-Victoire in Aix-en-Provence, so, too, Pissarro had discovered in Pontoise the subject that he would come to define.

On New Year's Day, 1866, the expanded Pissarro family moved into a spacious but none-too-charming

home on the side of a hill, at 1, rue du Fond-de-l'Hermitage. Their three-year-old son Lucien and baby Minette settled in easily, but Julie, accustomed to the friendliness of her hometown of Grancey, did not fare well with the uncommunicative neighbors. Until they were legally married, she would not wear a wedding band, and the family did not go to church nor join in the community festivities. The peasant farmers had never seen anyone roaming the fields with a paintbrush instead of a hoe. Such strange intruders in their midst perplexed them, and so the local residents avoided the painter and his family. Julie took some solace in planting her vegetables and making their simple six-bedroom abode as comfortable as possible.

Meanwhile, everywhere that Pissarro cast his gaze appealed to him; he knew there would be no end of inspiration in these views. Heeding Corot's advice to focus his attention on landscapes, Pissarro left the house before dawn in the mornings and walked about in the countryside, waiting for the sun to appear so he could capture the light reflected on the trees, the small houses, the meadows, the sky. In Pontoise, he created some three hundred landscapes, most of them peaceful, harmonious, balanced depictions of nature, evoking a mystical connection with the earth: the fields of hay, the orchards in bloom, the red-tiled houses seen through leafless trees, and the small figures traversing the roads.

In his day, Pissarro was viewed as a firebrand, an outré revolutionary. Indeed, when he showed Corot his 1866 *The Banks of the Marne in Winter*, painted while living in La Varenne, and asked the older artist to sponsor him at the Salon of 1866, Corot took one look at it and was instantly repelled. Corot—painter of romantic landscapes of great charm and delicacy—admonished Pissarro that he had strayed too far from tradition, and opined that modern artists were spoiling God's beautiful creations. The winter scene that Pissarro had painted was cold, stark, and forbidding: precisely the way it was experienced by the peasants who had to walk through the frozen fields, and by Pissarro himself, who painted in the snow and blustering wind. Corot refused to be cited as Pissarro's master. The disciple had entered the world of *reality*, and had left his mentor behind in a land of beautiful conventions.

The painter and critic Odilon Redon wrote of Pissarro: "What a singular talent, which seems to brutalize nature! He treats it with a technique which in appearance is very rudimentary, but this denotes, above all, his sincerity. Monsieur Pissarro sees things simply: as a colorist, he makes sacrifices which allow him to express more vividly the general impression; and this impression is always strong because it is simple." And

the author Emile Zola remarked: "There is no other painter who is so conscientious, so exact. He is one of the naturalists who confronts nature head-on. And yet his canvases always have a character which is quite their own: a note of austerity and a truly heroic grandeur. They are quite unlike any others. . . . The originality here is deeply human. . . . Here you can listen to the deep voices of the soil and imagine the strength of the trees growing."

Such reviews heartened Pissarro; he felt he was at last being understood—but that did not provide bread and milk to feed his family. No one was *buying* his paintings. This was particularly distressing because recently his father had died, and Pissarro was shocked to learn that he had been disinherited. (Apparently, his father had felt that Camille's paintings would never bring in enough money, and that therefore giving him funds would only dissipate the inheritance.) Half the estate was left to Pissarro's mother, Rachel, and the other half to his brother, Alfred. When Camille asked Alfred for a share of the inheritance, his brother's only concession was to buy the gold frames that were required to exhibit at the Salon—and even that pittance was soon discontinued. Though humiliated, Pissarro realized that his father had died believing that he was doing him a service by disinheriting him, hoping to force Camille to take on another career so that he could support his family. In addition to denying Pissarro's worth as a painter, however, his father thus revealed how completely he had misunderstood his son's remarkable character, marked by honesty, loyalty, courage, and optimism. Although he had sustained parental insult, loss, and hurt, Pissarro was a benevolent husband, father, and father figure to many: a noble man in the truest sense.

Several years into my study of the Impressionists, I had the good fortune to meet Camille Pissarro's great-grandson, Joachim Pissarro—a respected curator of sculpture and painting at New York's Museum of Modern Art. I attended a symposium, connected with his 2005 exhibition *Cézanne and Pissarro*, at which he was leading a panel of scholars discussing the paintings of the two artists and their mutual influences. I immediately felt in Joachim Pissarro the echoes of his forebear's benevolence. The contemporary Pissarro has, of course, also inherited a passion for art and an understanding of its importance. It is inspiring to see that such positive attributes in a family can be transferred from generation to generation.

Camille Pissarro, *The Banks of the Marne in Winter*, 1866

The hilltop town of Pontoise particularly captivated Pissarro on market days. It had taken him a while to appreciate the upper part of the city aesthetically, having initially been attracted to the lower hamlet of L'Hermitage, with its unkempt natural beauty. Soon, however, he made it a habit to climb the steep road toward the Pontoise plateau, where he admired the impressive cathedral of Saint-Maclou, with its vividly carved animals crowning the stone entrance arches, especially the impertinent monkey grooming himself in public. The spires of the cathedral soar heavenward over the open market where Pissarro often set up his easel to paint the bustling scenes among the wooden stalls, filled with the fruits and vegetables grown in the nearby valley.

From higher up on the plateau, one can see across the river below the industrial town of Saint-Ouen-l'Aumône. In 1872, at Pissarro's encouragement, Paul Cézanne, along with his mistress Marie-Hortense Fiquet and their infant son, Paul, came to live in a small hotel in Saint-Ouen; it was the first of many times that Cézanne would transfer his family in order to be near Pissarro.

Cézanne was likely very happy to make the journey north from his home in Provence. His father, Louis-Auguste, a wealthy banker in Aix-en-Provence, had adamantly opposed his son's interest in painting, and was determined that he should study law. In 1860, Cézanne's mother and sister finally persuaded his father to let Paul go to Paris, where he first encountered Pissarro at the Académie Suisse. Very guarded and often irascible, Cézanne nonetheless befriended the older artist, confiding in him: "You are different from the others. You're not trying to manipulate me." Cézanne deeply resented the pressure his family exerted upon him to follow a route that was clearly not his own. "My dear friend," he wrote to Pissarro in 1866, "here I am with my family, with the most disgusting people in the world, those who compose my family stinking more than any. . . ."

Cézanne hid the existence of his mistress and child from his family, because he knew that his father would cut off his small allowance if he learned of them. The senior Cézanne felt that money should earn interest, and it infuriated him to see his son spending his allowance. "We die with genius," he admonished Paul, "but we eat with money." Having suffered similar parental indignities, Pissarro fully empathized with Cézanne's plight.

Although Emile Zola, a boyhood friend and schoolmate of Cézanne's in Aix, once described him as a man "whose soul is so affectionate, so gently poetic," Cézanne was notorious throughout his life for his explosive anger, irritability, and reclusiveness.

Pissarro's paternal nurturing seemed to elicit from Cézanne the sweeter virtues that Zola had noted in their youth. Cézanne's strong rapport with Pissarro led him to exchange the morbid subjects that initially intrigued him (e.g. *The Abduction* of 1867, or *The Strangled Woman* of 1872) for the sublime landscapes he discovered as he sat alongside Pissarro. He followed Pissarro's example also by lightening his palette, emulating his mentor's brushstrokes by copying Pissarro's *View of Louveciennes*.

In a curious parallel with Van Gogh (but seventeen years beforehand), Cézanne moved his small family to Auvers in 1872 in order to be near Dr. Gachet. Cézanne's adored son Paul was ill, and the family felt safer in close proximity to the good doctor. Despite this change of residence, Cézanne and Pissarro's close collaboration continued, and they often traveled between Pontoise and Auvers to paint in each other's company. Lucien, Pissarro's oldest son, recalled of this period: "Cézanne lived in Auvers, and he used to walk three kilometers to come and work with Father. They discussed theories endlessly; I remember some words that I overheard: 'The form is of no importance. It is the harmony.' One day, they bought palette knives to paint with. Several pictures remain of the work they did at this time. They are very similar in treatment, and the motifs are often the same."

I marveled at these works in the 2005 *Cézanne and Pissarro* show in New York. What I found especially fascinating was the juxtaposition of paintings made from identical vantage points by the two artists, with very similar color schemes and compositions . . . and yet it was always quite clear which painting was Cézanne's and which Pissarro's. By reducing the "variables" to a minimum, it seemed that the essence of each artist was highlighted.

I later learned that, in the course of his studies of these works, Joachim Pissarro had hoped to determine the dates of some of Cézanne's undated landscapes, by following Camille Pissarro's well-kept records of dates for the same scenes. The task proved impossible, however: the curator learned that Cézanne had often used Pissarro's paintings as study images—taking them into his atelier as references—and so there was no knowing which paintings were made by the two artists actually working side by side, and which were made separately. In the end, Joachim Pissarro had to give up on this particular quest.

Cézanne and Pissarro's relationship was both complex and fruitful. Today in Auvers, a reproduction of Cézanne's 1873 *House of the Hanged Man* stands in front of the actual house he painted during this period. In the work, one can see the first

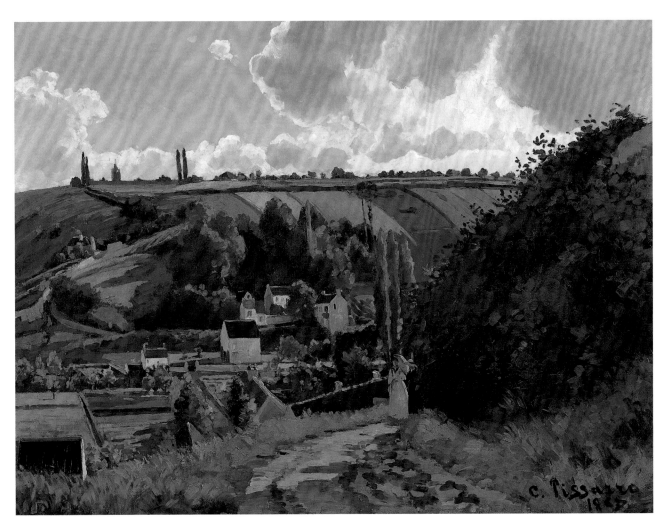

Camille Pissarro, *Jalais Hill, Pontoise*, 1867

Paul Cézanne, *Jalais Hill, Pontoise*, c. 1879–81

prophetic stirrings of the geometric breakthrough that the artist would later pursue so single-mindedly. Cézanne's ability to cull the influence of Pissarro, yet still to retain his own unique vision, testifies to the generosity of Pissarro. The genial teacher was not threatened by Cézanne's masterly creations; on the contrary, Pissarro reveled in his pupil's inspired achievements.

Van Gogh and Gauguin's fraught and often painful interactions during their period in Arles present a sad contrast. One can only surmise what might have resulted had Van Gogh's deep desire to work and live with Pissarro in Eragny been fulfilled. After all, Cézanne, with his uncontrollable temper, had been able to enjoy two harmonious years painting beside Pissarro. Perhaps under Pissarro's strong and soothing influence, Van Gogh would have come to a different end.

The Impressionists had provided one another with a level of psychic and emotional support that was sorely missing in the experience of Van Gogh. Much of their vital interaction transpired in an environment that the sensitive Dutch artist had difficulty abiding: Paris, with its tangled energy and buzz of urban life.

BOHÈMES AT THE CAFÉ GUERBOIS

Paris was a new city. Under the eye and direction of Baron Georges-Eugène Haussmann, the decrepit areas of Paris were razed and replaced with magnificent modern buildings and parks. Haussmann had diverted rivers to bring fresh drinking water into the city. The extraordinary structural changes—which had taken place following the instructions of Napoleon III—were attended by cultural developments that soon came to characterize the city: Paris now boasted cafés on broad sidewalks, where clients could sit for hours, chatting and watching passersby; restaurants glowing with newly invented gaslight; an exhilarating cabaret nightlife—all of which attracted the artists who would immortalize Paris, the shining hub of the late 1800s, in their work.

Pissarro, Monet, and Cézanne agreed that the old art was dead. No amount of government commissions could tempt them to compromise the integrity of their new vision. After a day of painting at the Académie Suisse, they needed to talk and drink and argue with the few other enlightened thinkers who had come to similar conclusions. The Café Guerbois, on the grande rue des Batignolles (now the avenue de Clichy), was the perfect setting for their heated discussions: it was nearby, welcoming, and inexpensive. A group of artists began to meet regularly at the café on Thursday

afternoons. The Guerbois's management cleverly seated them up front, just to the left of the entrance, to attract the bourgeoisie who—from a safe distance at the back of the café—found the boisterous congregation entertaining.

Edouard Manet held forth as the leader of this bohemian conclave, which came to be known as the "Batignolles," because Manet and many others lived or had studios in that neighborhood of Montmartre. Two years younger than Pissarro, Manet was elegant, handsome, and self-assured, with a blond beard that flared out squarely from his chin. He had spent six months at sea as a youngster, as his parents had attempted to dissuade him from becoming an artist, but the experience had only served to strengthen his determination. When he was seventeen, his parents finally allowed him to enter the atelier of Thomas Couture, where he acquired rudimentary painting skills. Although Manet quickly recognized that Couture was a proponent of the strict, classicizing art he was rejecting, Manet stayed for six years under Couture's tutelage, perfecting his technique. Even after leaving the studio, Manet would return to seek Couture's advice, hoping for approbation, which the conservative master could not provide.

Although Manet considered himself innovative, he never aspired to be a revolutionary; he sincerely believed he could persuade the jury of the Salon that fine painting depicting modern reality was worthwhile and deserving of honors. At the 1865 Salon, to his surprise, his *Olympia* caused a scandal; the model, Victorine Meurent, a well-known *grisette*, stared out from the paintings, naked and defiant, leaving no protective illusions to the men who had availed themselves of her favors. Critics advised pregnant women to stay away from the picture, and it was rehung out of reach at the exhibition to avoid possible vandalism. The stuffy bourgeoisie were outraged and humiliated when confronted with the model's audaciously direct look of contempt, and they in turn vehemently attacked Manet, the artist who had depicted her thus. Despite his dismay, Manet's resolve was only solidified by the challenge.

Manet had a number of worthy comrades in arms. Edgar Degas regularly attended the Guerbois gatherings, and he and Manet often met socially, in Passy at Berthe Morisot's family home, or at Manet's house in Montmartre. All three were from wealthy, influential families, but their passion to rip away the veil of hypocrisy and portray the world as they saw it overrode all class barriers. Proprieties of the day prevented Morisot from entering the cafés unattended, but she circumvented her exclusion by inviting artists to her home. Lively conversation coupled with good food

Edouard Manet, *Olympia*, 1863

and wine at the Morisots helped form deep bonds of friendship among many artists and writers of the time.

Morisot became particularly close friends with Pierre-Auguste Renoir, although they were from distinctly different backgrounds. The son of a tailor, born in Limoges but raised in the Paris slums near the Louvre, Renoir started his artistic career at thirteen, painting designs on porcelain. As soon as he had saved enough money, he joined the Atelier Gleyre, where he met and befriended both Monet and the young Frédéric Bazille.

Unfortunately, Bazille died only a few years later, in 1870, in the Franco-Prussian War. Although their friendship was thus relatively short-lived, it had a substantial effect on Renoir; Bazille offered him living space in his studio in Montmartre near the café, and eventually introduced him to the rest of the Guerbois group. Bazille also helped to support the impoverished Monet during the difficult years when Monet, his mistress Camille-Léonie Doncieux, and their baby, Jean, could scarcely manage in their dilapidated house in Saint-Michel in Bougival. The family often lacked wood in the fireplace, food, or light. Even Renoir—although destitute himself—would bring the Monets bread from his parents' table in nearby Voisin-Louveciennes. The sense of mutual support and responsibility among the Batignolles and their cohorts was extraordinary, so firm was their resolve in a common mission.

Having a circle of peers must surely have been encouraging—but life was far from comfortable for most of the Impressionists. The benevolent Pissarro managed to sustain the group as a paternal figure, even as his own adored family was often forced to live hand to mouth.

In the spring of 1869, Pissarro felt that he must move his family to Louveciennes from his beloved Pontoise. His children were suffering continuous colds and other illnesses in winter from the wet fogs off the rivulet Saint-Antoine across from their home at Fond-de-l'Hermitage, and Dr. Gachet had advised Pissarro to move away from the dampness. It was devastating for the artist to part from his chosen landscape, but for the sake of his cherished family he decided to leave Pontoise.

Monet found the house in Louveciennes for the Pissarros. It was a large, stone dwelling that had been built for the captain of the guards of Louis XIV. When Pissarro first saw it, he was certain that he could not afford it. Monet assured him that this beautiful house was available at the same rate as the one in Pontoise: it was too far

Neil Folberg, *Luncheon of the Boating Party* (after Renoir), Vétheuil, 2003

from Paris for a commute to work in the city, and too large for a weekend home, so the owners offered the house to Pissarro at an affordable rent. (The Pissarro family was often indebted to Monet. Later, when they purchased the house in Eragny, Julie asked him for a loan, which Monet willingly gave. Pissarro was long troubled by the transaction—it is said that even on his deathbed, he sent word to Monet asking for forgiveness. Monet immediately sent a letter of reassurance, but it arrived too late; Pissarro passed away before he could be comforted by his friend's response.)

While in Pontoise, Pissarro had generated what amounted to a kind of artists' colony, with Cézanne and later Gauguin living nearby, and others coming from Paris for a day of painting, as did Degas, Renoir, Monet, and Bazille. The artists living in the area of Louveciennes—among them Alfred Sisley—tended to gather around Pissarro as well. Pissarro had first met Sisley when they, Monet, and Renoir painted together for a few weeks in Fontainebleau. Sisley and Pissarro would often paint the same scenes—although Sisley's touch was light and lyrical, while Pissarro's landscapes were solid, spatial constructions. Monet walked up from Saint-Michel to Louveciennes to paint beside Pissarro as well, learning from him how to render shadows in colors that complemented the objects that cast them.

During 1869, an exceptionally productive year for all of them, Monet, Renoir, Sisley, and Pissarro drew closer together while in the area of Louveciennes. All were courageously experimenting with their developing theories. Working quickly, purposefully employing short strokes of complementary colors, Monet and Renoir created their lively masterpieces of clear light and luminosity, both titled *La Grenouillère*, named for the popular boating resort on the Seine; the paintings captured the beauty of sunshine reflecting on the surface of the water. Pissarro, on the other hand, while artistically rebellious enough to have his paintings refused by the Salon, did not initially render the incandescence of light as successfully as Monet and Renoir. It was not until Pissarro worked with Seurat—adopting the tenets of Pointillism (which Pissarro later rejected)—that his Paris boulevards would achieve

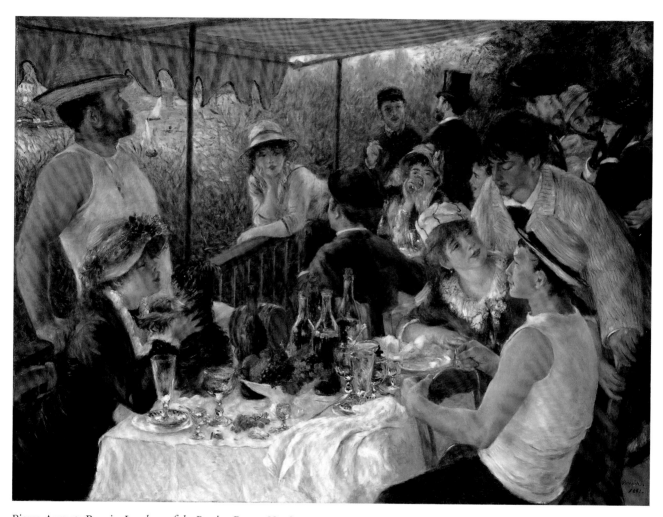

Pierre-Auguste Renoir, *Luncheon of the Boating Party*, 1880–81

a dissolution of form via ravishing light. Those works would finally win him well-deserved recognition and financial security.

The artists were not the only ones to escape the city for more bucolic settings. Liberated by the newly invented steam-train from their daily drudgery as laundresses, seamstresses, and clerks, working-class Parisians thronged to a day of leisure at La Grenouillère, with its famed floating restaurant. There they swam, ate and drank, danced, and strolled along the embankment. Casual restaurants with dance floors, called *guinguettes*, sprouted up along the banks of the Seine and other scenic rivers to welcome revelers. (Much later, further downstream at Chatou, Renoir painted his 1880–81 *Luncheon of the Boating Party* at the *guinguette* Fournaise—which still today hosts visitors hoping to revive the spirit of joyful relaxation so wonderfully depicted in the painting.)

In 1870, Monet continued waterside painting during his honeymoon with his new wife, Camille-Léonie, on the beaches of Trouville. In the same year, when the family moved to London to escape the Franco-Prussian War, Monet was astounded by an exhibition he saw of the works of J.M.W. Turner and John Constable—he found the light that seemed to emanate from their paintings dazzling. He would assimilate this sense of luminosity and, back in France, incorporate it into his own work.

In London, both Monet and Pissarro met the art dealer Paul Durand-Ruel. The paintings by these two artists were Durand-Ruel's first encounter with Impressionism; he was enthralled, and purchased several works. These sales enabled Pissarro finally to marry his companion, Julie, in a small ceremony attended by French compatriots. (Pissarro's mother and brother Alfred, also temporarily living in London, declined his invitation to the wedding: they still would not accept Julie as a family member.)

When they returned to France, Monet and Pissarro brought their friends Renoir and Degas to Durand-Ruel's gallery in Paris. The gallerist looked at their paintings and bought them immediately. He marveled that Monet and Pissarro, both financially hard-pressed, would bring such fine artists to him—surely they knew that if the dealer purchased these works he would have less money left to give them for their own paintings. He complimented the group: "Your unselfish support of each other forms a strong brotherhood, and you won't fall into the sea."

Pissarro moved back to Pontoise. The climate in Louveciennes had not improved his children's health, and he could see no reason not to return to his preferred landscape. Now wearing a thick gold wedding ring, Julie felt more socially accepted

in the town. Still, despite the new connection with Durand-Ruel, Pissarro's paintings were not selling well.

Around this time, Gauguin was working as a stockbroker during the week, and traveled to Pontoise on Sundays to paint with Pissarro. In 1879, Gauguin, his wife, Mette, and their three children spent a month in Pontoise staying at the Pissarros' home. There would be many times over the years that Gauguin would visit Pissarro, referring to him with unbounded affection and respect as "God the Father" (an appellation Cézanne, too, used for Pissarro). It is almost ironic that Gauguin had the opportunity to be bolstered by the nurturing Pissarro, strengthening his artistic identity—and that Gauguin's very strength would put Van Gogh at such a disadvantage in Arles some years later.

Pissarro occasionally left his quiet haven and took the hour-long train ride to Paris, to try to find a buyer for his work. After the war, the Impressionists had moved their meetings from the Café Guerbois to the Café de la Nouvelle Athènes on Place Pigalle, near the studio and home of Degas—and it was here that Pissarro would join them and take part in their highly volatile artistic conversations.

The artists found some solace in sharing their aggravation at not being accepted by the Salon. Outside of their own small group, there were so very few people who understood and appreciated what they were fighting and starving for: an art that would capture the fleeting moment, not only what they saw, but what *mattered* to them—spontaneous, alive, honest, and full of vibrant color. The pace of their world was changing rapidly with the advent of industrialization: instead of slowly passing views from horse-drawn carriages, they experienced landscapes that whizzed by, assailing their senses—and they in response painted quickly, crystallizing an instant in time, an impression.

Although the painters shared their newest work with one another, each had a different way of portraying the new vision. Consequently, showings would often incite theoretical arguments. There were those, such as Degas and Manet, who still believed in painting in the studio, with its steady blue northern light; others, like Monet, painted only in the open air, fascinated with capturing the changing effects of the sun. Cézanne, on the other hand, sought to portray basic structure: How much *solidity* underlies the surface of things? How deep is the earth? How does it affect the surface? Pissarro had no interest in copying the masters at the Louvre, while Degas maintained that "an artist must copy these paintings over and over before he can paint even a radish from nature."

They debated Chevreul's color theories, painting shadows with complementary colors (rather than the traditional black or brown), recognizing that an individual

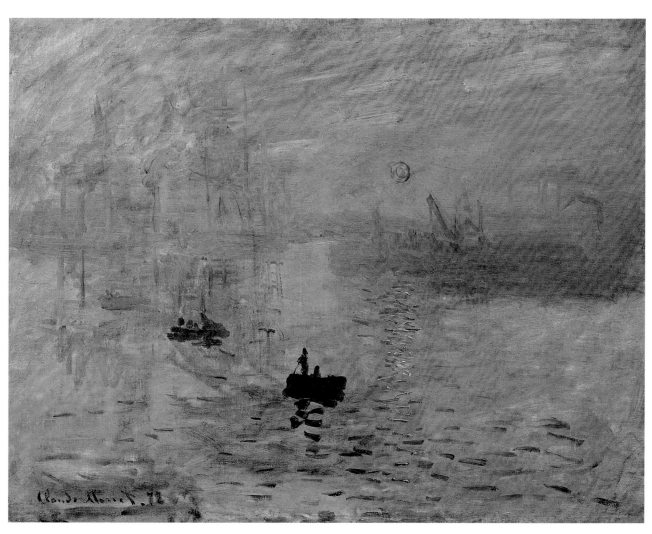

Claude Monet, *Impression, Sunrise*, 1872

color is not absolute in its effect, but is contingent upon the colors around it; these became basic Impressionistic tenets. They discussed optics and the power of the brain to influence vision. The public was accustomed to approaching an academic painting to look at its details; such viewers had not yet realized that they needed to stand back from the Impressionist paintings to familiarize the eye, to give it enough space to comprehend and "complete" the painting.

Their various theories made for lively debates, but there was one unifying certainty: all were determined to break the stranglehold of the Salon by refusing to paint trite subjects in order to be accepted. They would paint what they saw around them. While they might take academic paintings as references—as Manet did when he used Titian's *Venus of Urbino* as a basis for his *Olympia*—they would create their art in the current vernacular. From this spirited artistic ferment, they forged a coherent and identifiable movement.

REVOLUTION
IN PARIS:
THE IMPRESSIONIST
EXHIBITIONS

When Monet arrived in Paris from Le Havre in 1859, he was confident in his own prodigious talent, certain that he was going to be a resounding success. His flamboyance, originality, and insatiable drive attracted Renoir, Bazille, Pissarro, Sisley, and even Manet to follow him on painting forays to Brittany, Fontainebleau, or the banks of the Seine. A powerful artist with a powerful personality, Monet would eventually become the leader of the Batignolles group.

Fourteen years later, in 1873, now frustrated and financially destitute, Monet invited members of the Batignolles to his home in Argenteuil on the Seine, a fifteen-minute train ride from Paris. He was forced to acknowledge that there was no hope of gaining acceptance to the Salon, for himself or his cohorts. Unwilling to compromise, with his indomitable spirit, Monet proposed to the gathering of painters that they reconsider the earlier suggestion of Bazille (by now deceased) of mounting an independent exhibition. Their sole dealer, Durand-Ruel, who had been buying their paintings since 1871, was in financial trouble himself and could no longer support them. Monet felt they must take matters into their own hands. Pissarro enthusiastically obtained from a baker in Pontoise a blank form designed to be filled in as a union contract, and the six "officials" signed the charter of the Société Anonyme Coopérative d'Artistes-Peintres-Sculpteurs-Graveurs. The six painters—Pissarro, Degas, Sisley, Monet, Renoir, and Morisot—cast themselves simply as a "société anonyme coopérative" (cooperative corporation) because each believed in

creative independence, and while they supported one another, they did not want to be associated with any school of art that might restrict them.

They were not to remain "anonymous" for long, as the first exhibition held in 1874—at the photographer Félix Nadar's studio on the boulevard des Capucines—created a sensational scandal. These "Impressionists" (as they were derogatively labeled, after the title of Monet's 1872 *Impression, Sunrise*) audaciously displayed what appeared to be sketches, unfinished works, not polished paintings. The brazen brushstrokes revealed no attempt at harmonious blending in the acceptable manner. The exhibition was met with blanket ridicule and condemnation from the Parisian public and critics.

The paintings sold by the thirty participants in the exhibition did not cover the costs of creating the work or mounting the show. Pissarro, who had finally begun to achieve some acceptance, was once again penniless. His friend the critic Théodore Duret had warned Pissarro that by participating in this exhibition he would ruin his reputation.

For just such reasons, Manet refused to exhibit with them—and he tried to convince Berthe Morisot not to show as well, but she stubbornly ignored his entreaties. It was one thing, he felt, to be refused by the Salon; you could always submit work again the next year—but an independent exhibition signified an outright revolt. Manet was sure that the Salon would ban any artists who defied their regulations. He was determined to follow the established procedures, hoping eventually to win government medals and commissions.

The group dissolved their *société*, but Pissarro's reaction to the fiasco testified to his irrepressible optimism: "We must keep showing until they become familiar with our art so that they will finally accept us." In the meantime, far from being accepted, the group had become infamous. The Paris press reacted en masse, mostly deriding the exhibition, although a few critics, while acknowledging that this group of artists had broken every academic rule, conceded that the Impressionists showed considerable talent.

Manet, who had been hitherto acknowledged as one of the leaders of the avant-garde, understood from the media's strong reactions—albeit mostly negative—that he had been bypassed by the other artists in the group. He knew that he had to learn how to paint in this new, "Impressionistic" way in order to keep abreast of what he recognized was the emergent new art.

Manet's family country home in Gennevilliers was just across the Seine from Monet's home in Argenteuil. In the summer of 1874, Manet spent stimulating hours

with Monet and Renoir, assimilating new techniques with brushstrokes and palette in the garden surrounding Monet's home, and along the river. In order better to see the reflections and colors of water, Monet (following the lead of Daubigny) painted in Argenteuil from a studio boat that he and Gustave Caillebotte had constructed together. Manet immortalized Monet and his wife, Camille, in the bright sunlight and reflected ripples of the Seine. Painting in the open air, adopting short, energetic brushstrokes to create the feeling of motion, and using a new, lighter palette were all innovations for Manet, and while he preserved his autonomy from any group or school, during this period he admired and experimented with the theories of the Impressionists.

In 1875, Monet, Renoir, and Sisley, desperate for funds, auctioned off work at the Hôtel Drouot. Morisot joined in the auction—out of sheer loyalty, as she was not in financial straits. Pissarro could not afford to participate, but he watched as the crowd attacked his colleagues so belligerently that the police finally came to break up the ruckus.

Pissarro vowed then and there that he would organize the second exhibition of the "Indépendants," as the Batignolles group called themselves (only later would they adopt the term "Impressionists," the label with which they had been lambasted at their first independent exhibition). To that end, Pissarro visited the wealthy Gustave Caillebotte, a painter with sympathetic sensibilities, at Caillebotte's home in Petit-Gennevilliers. It was agreed that the second exhibition would take place at Durand-Ruel's gallery on the rue le Peletier in April of 1876, with Caillebotte helping to bankroll the presentation.

The attendance at this show was greater than that at the Nadar exhibition, and the crowds seemed somewhat less scornful of the groundbreaking works, so infused with light and exuberant color. But the international press remained mostly derogatory, and the exhibition was a financial failure. Each of the artists earned a mere three francs in profit—still, at least this time they had not incurred debt.

In spite of their lack of monetary success, the Indépendants were making some progress. When the official Salon exhibition opened some weeks later, in the spring of 1876 at its usual venue at the Palais de l'Industrie on the Champs Elysées, the critic Jules-Antoine Castagnary noted that the show at Durand-Ruel had made an important mark: "The younger artists have flung themselves into frank simplicity to a man, and

without suspecting it, the crowd acknowledges that the innovators have the right on their side. . . . People who have been to Durand-Ruel's, who have seen the landscapes, so true and so pulsating with life, which Messieurs Monet, Pissarro and Sisley have produced, entertain no doubts as to that."

Caillebotte was determined to see to it that the Indépendants would exhibit every year from then on. Fearing an early death—his brother René had died at twenty-five, in 1874—Caillebotte wrote his will in 1876, when he was only twenty-eight; in it, he bequeathed funds "to cover the 1878 exhibition of the painters known as the Impressionists or intransigents." He also donated his collection of sixty-seven Impressionist paintings and pastels to the nation of France on the condition that within twenty years they would be hung in the Palais de Luxembourg, which exhibited only living artists. He further stipulated that the paintings be transferred to the Louvre upon their creators' deaths.

Caillebotte had the rare foresight and patience to provide the public with the opportunity, if not to understand, at least to accept this innovative art. When Caillebotte died in 1894 at the age of forty-five, Renoir, his executor, insisted that the French government live up to its obligation to hang the paintings, but—with sad lack of vision—the state exercised its option to hang only thirty-eight of the paintings; the twenty-nine they rejected reverted to Caillebotte's surviving brother. The Musée d'Orsay now houses the Impressionist works that were destined for the Louvre. Thanks to Caillebotte, Renoir's 1876 *Ball at the Moulin de la Galette*—with its sunlight filtering through leaves, mottling the dancers at La Butte Montmartre—hangs here today, among thirty-seven other Impressionist masterpieces.

Caillebotte succeeded in bringing together the fractious Impressionists for a third exhibition in 1877. Locating an apartment on the rue le Peletier, he and Degas paid the rent and there they hung the most refined and progressive paintings of the 1870s. Monet showed his series of eight paintings of the Gare Saint-Lazare, with its peaked glass roof over a train that billows blue smoke as it enters the station; also presented were Renoir's *Ball at the Moulin de la Galette* and Sisley's *Flood at Port-Marly*. Thousands of people came to the galleries to snigger and poke fun, but the pure vitriol seemed to have dissipated. The public no longer saw the Impressionists as subversive or dangerous— but neither did they buy the work. Hoping to save the artists from trundling all their paintings back home after the exhibition, Durand-Ruel again arranged an auction at

and attending a leading boys' school. But his mother's death, when he was only thirteen, left Edgar alienated and emotionally stunted—no amount of advantages could fill the cold void left by her absence.

Throughout his life, Degas was touched by that primal loss. He never married, and his relationships with women were always complex. Degas's remarkably frank paintings of women seem to be an attempt to repair his wound. In many works, he discarded the idealized image of women and allowed them to become flesh, blood, and feelings—capturing them with their masks off: laundresses yawning, exhausted ballet dancers awkwardly sinking onto a bench, café habituées dazed with absinthe and alienation, prostitutes in brothels, bawdy and unselfconscious. Critics of the day interpreted Degas's depiction of the unadorned feminine as an indication of his revulsion for women; women had hitherto been treated on canvas as pretty objects designed to please a man's eye. But Degas's ability and willingness to show women as they are, flawed and human, seems a gesture more of compassion than of misogyny.

Neil Folberg, *Dancers Adjusting Their Skirts*, Paris, 2002

In reverting his name from "de Gas" to "Degas," the son rebelled against his family's privileged class; he further distanced himself from his father when he declared his intentions of becoming an artist. Degas learned to paint traditionally by copying historical paintings in the Louvre, beginning at a young age. Only when he was introduced to Japanese prints did he finally break loose from the academic copyist mold. Under the influence of Manet—who had shown that there was a world of artistic subjects beyond the classical traditions—Degas felt free to paint what truly interested him: opera singers, ballet dancers in their moments offstage, laundresses, cabaret singers, racehorses at the track. In nearly all of his works, he remained behind the scenes, to catch the true nature of performers. His inquisitive intelligence prompted him to embrace the relatively new medium of photography, and to apply its potentials in making his paintings. He was intensely interested in physical movement, both human and equine, and studied the work of Eadweard

Edgar Degas, *Four Studies of a Dancer*, 1878–79

Edgar Degas, *Blue Dancers*, c. 1890

Muybridge—in particular his *Clinton with Rider*, a series of photographs of a horse and rider in motion.

Degas justified his unrelentingly harsh attitude toward people: "If I did not treat people as I do," he said, "I would never have a minute to myself for work." Work became an even greater priority in 1878 when, after his father's death, Degas found himself in need of vast sums to pay off family debts. Although his eyesight was deteriorating, he greatly increased his production—in 1870, while volunteering with the French National Guard, he had contracted an eye illness; his vision would become progressively worse until in old age he was almost blind. He later revealed that it was partly due to his failing eyesight that he depicted the beautiful abstract ballerinas in such vibrant pastel colors.

Degas found Pissarro to be a good partner in the organization of the Impressionist shows; both wanted the exhibitions to go forward, but for different reasons. The two artists' characters complemented each other: Pissarro was accessible and warm, while Degas was closed and caustic—but they worked well together in persuading other artists to join them in exhibiting independently. Degas had been influenced by a meeting with Jean-Auguste-Dominique Ingres, who famously advised him to "draw lines, young man, many lines." That mandate contrasted sharply with Pissarro's notion of modeling by color. They shared, however, a desire to take old traditions and revitalize them, and had a common sense of values.

Neil Folberg, *Jockey and Trainer*, Chantilly, 2004

Degas felt that he and Pissarro were the best draftsmen in the group, and he invited Pissarro to work at the engraving press in his untidy studio on the third floor of a building he rented near the place Pigalle. The American painter Mary Cassatt, who had first seen Degas's art at the second of the Impressionists' exhibitions and had become his disciple, often worked in his studio. She and Degas urged Pissarro to join them in founding *Le jour et la nuit*, a journal in which original engravings would be published every month—as Degas put it, turning "the Impressionists into black and white." Although the publication did not succeed, it stimulated

Edgar Degas, *Race Horses in front of the Stands,* 1866–68

Pissarro's appetite for printmaking, and when he finally had his own studio in Eragny, he installed an engraving press.

In 1883, in the face of Degas's inflexibility, and knowing that Monet was destitute, Durand-Ruel offered Monet a solo show at his gallery. It was a flop; almost no one attended the exhibition, let alone bought the works.

Monet had by this time become desperate, a sharp contrast to his position only a few years earlier, in 1876, when he had moved to Mongeron, the estate of his wealthy benefactors Eugène and Alice Hoschedé, to paint decorative wall panels for their home. There, in his own studio, Monet had painted the turkeys running free on the massive lawn, the forests and streams on the Hoschedé property, and the private train that brought the couple's guests directly from Paris to their home.

Hoschedé was the owner of Gagnes-Petit, a Paris department store, and spent much of his time in the city conducting business, leaving Alice and their five children at home. Meanwhile, recovering from a bungled abortion, Monet's wife, Camille, stayed in their tiny apartment in Paris with their son, Jean. In December, Alice Hoschedé became pregnant; the son she bore, Jean-Pierre Hoschedé, would always hold that Claude Monet was his father. Camille also became pregnant again—very much against doctor's orders. Meanwhile, Eugène Hoschedé's business went bankrupt, and now both families were impoverished.

Alice Hoschedé, Monet, the pregnant Camille, and seven children moved to Vétheuil, into a small two-story home on the main road along the Seine, while Eugène Hoschedé remained in Paris. Alice took care of everyone. After Camille gave birth to another son, Michel, in 1878, she never recovered her strength. In September of the following year she passed away and was buried in Vétheuil; her simple gravestone rests in the small cemetery beside the church captured by Monet in somber mist-filled paintings. At her funeral, Manet eulogized: "Camille's beauty will live forever in Monet's paintings." Indeed, over the course of their years together, Monet had painted her many times, including on her deathbed—blue, gray, and yellow brushstrokes rendering her lifeless face strangely exquisite.

That winter, a grief-stricken Monet painted the Seine filled with ice floes, while Alice tried to feed eight children on little money. In 1883, Monet moved this very large family to Giverny, where he had rented a run-down house in a barren area bordering a swamp. When asked by Manet why he chose this godforsaken location, Monet replied that it was the only residence he could afford that could accommodate his family of ten.

Salvation came from an unexpected source. Durand-Ruel, low on cash but holding a large inventory of Impressionist paintings, had the inspired idea of trying to sell them in New York. In 1886, when the news came that the three hundred paintings Durand-Ruel showed at the American Art Association near Madison Square were an instant success, and that twenty-seven of them were bought immediately, Monet breathed a sigh of relief. A new and enthusiastic market was keenly interested in his paintings; he was going to survive.

None of the catalogs of the eight exhibitions that took place in Paris used the term "Impressionist," but in New York, the catalog proclaimed "Works in Oil and Pastel by the Impressionists of Paris," and the American crowds excitedly responded to the vision of these daring artists. The Impressionists were coming into their own.

THE HILL OF
MONTMARTRE

Paris is a walking city. Indeed, it may be the best city in the world for pedestrians, because it is quite flat, except for one soaring hill at its north end: Montmartre. At the time of the Impressionists—prior to the construction of the Eiffel Tower—that hill dominated the cityscape. Even today, when I visit and trudge up and down its steep cobblestone streets, I feel that Montmartre is magically separate from the rest of Paris.

In the formative years of the Impressionist movement, most of the artists lived and worked within Montmartre's rural confines. It is easy to envision them here. In 1886, newly arrived from the Netherlands, Vincent van Gogh stood atop the hillock known as La Butte, painting the rooftops of Paris. Nearby, on the rue Lepic, he and Theo shared a third-floor apartment for two years before Van Gogh moved to Arles. (That house on Lepic still stands; on a recent visit I was almost saddened to find it newly repainted, after years of charming dilapidation.) Of course, at the time that Van Gogh was painting the city, there was no glowing Sacré-Coeur behind him; instead, a battery of workmen clambered over wooden scaffolding erecting the church's walls of travertine stone, mined from quarries outside of Paris. Chalky white dust settled upon the crest of the ridge and swirled over the cavernous hole dug in the earth, from which would soon emerge the magnificent many-domed basilica.

Montmartre is shaped like a three-tiered wedding cake: the bottom layer descends into the city proper; it is extensive and relatively flat, filled by the boulevard Montmartre, the Opéra Garnier, the Gare Saint-Lazare, and Haussmann's European quarter, where Manet lived for most of his life. The middle tier of Montmartre is smaller, with a more pronounced incline to its narrow streets, and includes the area of Batignolles, the Café

Claude Monet, *Camille on Her Deathbed*, 1879

Neil Folberg, *Drowned* (after Monet's portrait of his wife Camille on her deathbed), 2006

Guerbois just off the place de Clichy, and the Nouvelle Athènes quarter, pierced by the rue Pigalle leading into the place Pigalle. Here, the Café de la Nouvelle Athènes once hosted the Impressionists' weekly meetings, presided over by Degas, who lived nearby. The confection of Montmartre is crowned by the small and steep summit called La Butte. This is where the famous windmills once dominated the terrain, interspersed with kitchen gardens, vineyards, roses, and on its western face, an "outlaw" territory called the Maquis, dotted with wooden shacks and wild shrubs offering convenient hideouts from the law. Today, La Butte is of course topped by Sacré-Coeur, a radiant ornament of Paris.

At 12, rue Cortot on La Butte, one of Renoir's ateliers has now been converted to the Musée Montmartre—an ivy-covered building set back from the street and shaded by trees. On my first visit there, I could not help being struck by Adolphe Willette's extraordinary 1885 mural (transferred here from its original location at the nearby cabaret Le Chat Noir). It depicts a farandole of mad abandon: pierrots, masked cocottes, a carriage pulled by stampeding horses careening through a black sky, a glowing skull, a dark hooded funeral. To me, Willette's work embodies many of the existential questions and obsessions of fin-de-siècle Paris. Certainly it gives a flavor of the tumultuous era.

RENOIR AND DEGAS: OPPOSING APPROACHES TO A COMMON GOAL

In the mid-1870s, while still a bachelor, Renoir kept a house and studio at the bottom of the hill of Montmartre, on the rue Saint-Georges. He was fortunate to have a fine selection of models, and partly for this reason, his studio was a popular meeting place for friends. In order to paint his *Ball at the Moulin de la Galette* on site at an open-air dance hall, Renoir rented an additional studio on the rue Cortot, closer to the *guinguette*. Using his friends as models for the crowd of clerks, shop-girls, and artists enjoying lively music as the sunlight filtered through the trees dappling their Sunday best, Renoir painted this large and intricate canvas during the weekdays, when the dance hall was closed to the public. Every night, friends helped him tote the enormous canvas from the dance hall to his nearby studio for finishing touches.

While working on the large painting, Renoir frequented a restaurant on the rue des Saules (today known as the Restaurant La Maison Rose). On its garden swing, he posed a young lady wearing a long white dress trimmed with royal blue bows, as her small daughter and male admirers gaze up at her. Many claim that *The Swing* was painted in the garden behind Renoir's rue Cortot studio, but in a memoir by his son, Jean Renoir (the celebrated filmmaker), it is placed at La Maison Rose, and Jean mourns the loss of the garden with its innocent swing to a glassed-in terrace.

It was across the street from his lower studio, at the *crémerie* on the rue Saint-Georges, that Renoir met Aline Charigot, a young seamstress, who was lunching with her mother. Aline was nineteen: more than twenty years his junior. Renoir was attracted to anyone who used her hands, and was especially partial to seamstresses—he came from a working-class family, and both his mother and grandmother had been seamstresses. Although poor, Renoir was grateful that he had not been born into a bourgeois or intellectual family; he had no trust in intellectuals, but had great respect for artisans.

Jean Renoir wrote that his father's main complaint about "progress" was that it had substituted individual creativity with assembly-line production. An object was interesting to Renoir only if it was the authentic expression of the workman who created it. When a workman became part of a team, with each member specializing in only one aspect of production, the resulting object became, in Renoir's eyes, "anonymous." "It isn't natural," he declared. "A child can't have several fathers. Can't you just see a kid with ears inherited from one father, feet from another, his mind coming from an intellectual and his muscles from a wrestler? Even if each part were perfect, he would not be a man but a corporation; you might say, a monster." There was, he believed, a deep joy in the struggle with *total conception*, confronting all of its problems, and then solving them; the loss of that experience was for Renoir the crux of the malaise in the modern industrial world.

Renoir was passionate about painting women; voluptuousness and sensuous skin tones particularly attracted him. He was not interested in his model's mind, only in her physical allure and the sensations they stimulated in him. "I loved women even before I learned to walk," he claimed. Aline modeled for Renoir in her free time, most famously as the peach-cheeked, robust young woman fondling a small dog in his 1880–81 *Luncheon of the Boating Party*.

In the late 1880s, he and Aline lived with their firstborn son, Pierre, just below Montmartre's La Butte, on the rue Houdon. Dr. Gachet paid the family a visit, and was startled to find the four-year-old Pierre looking pale and sickly. The doctor attributed the boy's pallor to the city air, and invited Aline to bring the child to Auvers, where Pierre had often enjoyed himself. At the time, Renoir was with Cézanne in Aix, painting Mont Sainte-Victoire. Aline declined the invitation: "If Renoir knew his son was near the Oise, and he wasn't there to keep an eye on him, he wouldn't sleep a wink," she explained to Gachet.

But upon Renoir's return from Provence, the family did move farther up the hill, to the crest of La Butte, to the Château des Brouillards, just a few blocks from the rue Houdon, but a much healthier environment. Here, surrounded with roses and lilacs from the garden and trees bearing plums, apricots, cherries, and pears, Pierre thrived. The building had been a dairy, and Renoir's children enjoyed fresh milk from the local cows. Jean Renoir recalls of that dwelling: "Once you entered the wrought-iron gate you found yourself in a lane too narrow for a carriage to pass. To the left were some outbuildings . . . all that remained of an eighteenth-century mansion."

Neil Folberg, *River Fog on the Seine*, Vétheuil, 2001

Montmartre was truly a town in itself, providing both haven and inspiration for artists. Young laundresses carried woven baskets of clothes while singing folk tunes as they climbed La Butte to the rue de Tourlaque, where they hung the laundry out to dry. Renoir's 1887 *Bathers* features a recognizable Montmartre girl, Suzanne Valadon (who also modeled for Degas and Toulouse-Lautrec). A former acrobat, Valadon turned to modeling after a fall, and became a fine painter in her own right. Mother of the artist Maurice Utrillo, she and her son both had studios on the rue Cortot. Van Gogh's paintings help us to visualize the small gardens and windmills of La Butte, while Renoir brings to life workers, students, and artists, at work and at play.

Degas, on the other hand, portrayed the dissolute nightlife of Montmartre: the empty eyes and drunken stupor of his 1876 *Absinthe Drinker* at the Café de la Nouvelle Athènes capture the despair of the working class. And ripping away any romantic

illusions through the most candid rendering, his explicit brothel scenes leave little to the imagination. In a discussion with the dealer Ambroise Vollard, Renoir compared Degas with Toulouse-Lautrec: "Lautrec just painted a prostitute, while Degas painted all prostitutes rolled into one. Lautrec's prostitutes are vicious . . . Degas' never. . . . When others paint a bawdy house, the result is usually pornographic . . . always sad to the point of despair. Degas is the only painter who can combine a certain joyousness and the rhythm of an Egyptian bas-relief in a subject of that kind. That chaste, half-religious side, which makes his work so great, is at its best when he paints those poor girls."

Neil Folberg, *Young Girl*, Paris, 2002

The lofty Degas remained aloof from his subjects. But Renoir enjoyed the company of people; he didn't believe an artist should merely observe. Degas had always been a loner and became increasingly so as he grew older. In old age, when almost blind, Degas rued his isolation; he praised companionship and marriage, yet felt he could never have been successful at love. Unkempt and despondent, Degas spent his last years roaming the streets of Montmartre, tapping his blindman's cane, alone and bereft. He had been forced to leave his home of twenty-five years at 37, rue Victor-Masse, which was torn down so that a modern building could take its place. Degas was financially solvent at the time, and could have bought the property to save his home, but his depression and loneliness were so pervasive that he was frozen into inaction. Every day he would stand behind the wooden fence surrounding the construction site, staring sightless through the cracks at his loss. At his new apartment, his collection of works by Ingres, Delacroix, and his peers, as well as his own paintings, were left carelessly stacked against the walls. After his move, he never painted again.

Degas died in his solitary room in 1917, just a few blocks from where he was born, on the rue Saint-Georges. When Renoir learned the news, he remarked sadly: "Any conceivable death is better than living the way he was."

By contrast, Renoir's gregariousness often lured him out of his beloved Paris. Although he kept a home and studio in Montmartre until his death in 1919, he frequently

joined his friend Cézanne to paint in the Midi. Berthe Morisot and her husband, Eugène Manet (Edouard's brother), kept a spare bed ready at their summer home in Mézy, so that whenever Renoir dropped in to paint with Morisot, he would know he was welcome.

Degas and Renoir embodied two opposing poles of temperament among the Impressionists: the one moody and reclusive, the other overflowing with love and eager for the joys of friendship. Interestingly, these two very different characters shared the artistic mission of setting in motion a new way of seeing and rendering.

Ultimately, the knot of Montmartre artists would loosen and the individuals would go their separate ways. But the creative ferment of that time together—sharing and debating ideas, sometimes disdaining, sometimes envying one another's work—was crucial to the development of the Impressionist movement, in all its varied manifestations.

A VISION OF SPACE: CÉZANNE'S FAMOUS MOUNTAIN

Possibly the most extreme personality among the Impressionists was that of Paul Cézanne—mean, obsessive, and distinctly antisocial. Cézanne was also, arguably, the Impressionist who pushed this revolutionary new way of seeing furthest into the realm of the untried. The Impressionist who was least interested in the life of Montmartre was drawn instead to a different mountain, which eventually came to be closely associated with his name and his work. In Cézanne's later years, Mont Sainte-Victoire, an asymmetrical gray wall of rock, seemed to anchor the painter to Aix-en-Provence. This was an artist whose credo was that art is a harmony parallel to nature; his departure from Paris and return to his hometown in the South—though Aix was slow-moving and conservative—proved to be a distinct blessing. With very little to distract him, he was able to pursue his painting experiments with an obstinate single-mindedness.

In Montmartre, Cézanne's rebellious nature and provincial manners had formed a very destructive combination for him socially. Only occasionally did he appear at the Café Guerbois or the Nouvelle Athènes—and when he did, he was sure to be wearing his paint-stained clothes and laced-up boots, garb more appropriate for the forests and trails of Provence than for the chichi world of Paris nightlife. Aggressively perverse, he ate with his knife, passed wind in company, and generally seemed endlessly compelled to shock his friends with his coarse behavior.

Cézanne's old friend Emile Zola saw through this brusque façade, recognizing the artist's timid, gentle soul. Zola invited the painter to stay with him for weeks at a time at his opulent home in Médan, to socialize with Zola's friends. Over the course

of thirty years, the childhood companions had written warm letters to each other and cherished the enthusiasms of youth, their dreams of celebrity and success. But in 1886, when Cézanne read Zola's book *L'Oeuvre*, and realized that the protagonist—a failed artist who commits suicide—was based on himself, his intense pride was shattered. It was a harsh betrayal of a man who was by nature already vulnerable. Cézanne never spoke or wrote to Zola again. Years later, Zola admitted that he believed Cézanne to be one of the greatest painters who had ever lived, but the author never tried to repair the damage he had done through his novel. When Zola was asked why he had not written any academic books on the art of painting, he replied frankly that art was not his field and that he felt out of his ken. That feeling, however, had not restrained him from wounding his friend, a brilliant artist who already was a fragile recluse.

In 1894, Monet wrote to a friend about Cézanne: "How unfortunate that this man should not have had more support in his existence. He is a true artist who has much too much self-doubt. He needs to be bolstered." Monet made an effort to help Cézanne by inviting a few friends, including Renoir and Sisley, to Monet's home in Giverny. He welcomed Cézanne, saying: "At last we are here all together and are happy to seize this occasion to tell you how fond we are of you and how much we admire your art." Dismayed, Cézanne stared at Monet and replied: "You, too, are making fun of me!" He turned on his heel and departed. Giving Cézanne genuine support was not easy—but eventually Monet's kindness struck its chord. When he was once again safely isolated in Aix, Cézanne wrote to Monet: "May I tell you how grateful I was for the moral support I found in you and which served as a stimulus for my painting."

Rainer Maria Rilke, who wrote his *Letters on Cézanne* after the painter's death in 1906, credited Cézanne as his most formative influence. For forty years, Cézanne had explored the innermost elements of his art, which make for such astonishing freshness and purity in his paintings. Rilke realized that without such utter perseverance, the artist will remain at the periphery of art, and can attain only accidental success at best. Cézanne portrayed Mont Sainte-Victoire thirty times in oil and forty-five times in watercolor. Standing in front of one of these paintings, Rilke experienced a visual epiphany: "For a long time nothing, and then suddenly one has the right eyes." The poet had regarded countless paintings in search of narrative or lyrical meaning— with "immature eyes," as he put it—but here, he understood, was a work of art, to be accepted and judged as such. With poetic precision, Rilke defined Cézanne's lifelong achievements as results of "an infinitely responsive conscience . . . which so

incorruptibly reduced a reality to its color content that that reality resumed a new existence in a beyond of color, without any previous memories."

While he was in Aix, Cézanne lived at his family's country home, Jas de Bouffan, a grand manor with a farmhouse and fields, including a pond and an allée of chestnut trees. Decorated by the fledgling artist himself, the house's salon featured a portrait of Cézanne's banker father, Louis-Auguste, with whom he had a steadily contentious relationship. In spite of familial strife, however, Cézanne was content to be back in the countryside around Aix. With his conviction that art can develop only from contact with nature, he was enamored with painting *en plein air*. This might be attributed in part to Pissarro's influence in Pontoise; there, the two artists had painted outdoors, and Cézanne had enjoyed the most successful of his few friendships.

In Provence, the extraordinary blue Gulf of Marseilles in front of L'Estaque was a favorite motif, as was the Château Noir and the Gardanne with its cubistic houses. He painted his own Jas de Bouffan many times, in rich greens and browns, with very prominent chestnut trees. Regarding Mont Sainte-Victoire from the Bellevue villa (owned by his brother-in-law, Maxime Conil), Cézanne painted the entire expanse of the valley with a viaduct running through it, modeling with color. "Look at Sainte-Victoire there," Cézanne enjoined a friend. "How it soars, how imperiously it thirsts for the sun! And how melancholy it is in the evening when all its weight sinks back. . . . Those blocks were made of fire and there's still fire in them. During the day shadows seem to creep back with a shiver, as if afraid of them." His obsession with the mountain would grip Cézanne's attention for the rest of his life. This relationship most impressed Rilke, who wrote: "Not since Moses has anyone seen a mountain so greatly."

Over the course of the years that Cézanne was in Paris, he rented studios in various parts of the city, using them as a base for his painting forays to the outskirts of the city. In 1869, he and Marie-Hortense Fiquet began their relationship, which three years later produced a son, Paul. This was all kept from Cézanne's family for many years. His father ultimately learned of the affair and the child, and was initially livid, although he would relent shortly before his death. In 1886, the artist's sister Marie, a devout Catholic, persuaded Cézanne to marry Marie-Hortense. Although he was at this point no longer in love with Hortense (he contemptuously referred to her as "the Ball"), he married her to legitimize his adored Paul, by then

fourteen years old. Cézanne's father and mother even signed the registry at the wedding—and just six months later, Cézanne's paternal nemesis passed away.

Although Cézanne was now estranged from Hortense, they continued to live at Jas de Bouffan. Ten years later, Cézanne's mother died, and his brother-in-law Conil, an inveterate gambler, sold the family home to pay his debts. When Jas de Bouffan passed into other hands, so did Cézanne's portrait of his father, painted when Cézanne was a novice. Perhaps unhappy memories persuaded Cézanne to allow his home to be sold out from under him.

Totally immersed in his painting in the later part of his life, Cézanne was becoming more withdrawn, avoiding even his few devoted friends—it is said that when any of them met him by chance, he waved them off, and they would obediently cross the street rather than cause him unease. A mystique developed around him; he was talked about in awed and reverent tones by the young artists. Because Cézanne's paintings were not exhibited, in order to see his work, Van Gogh, Pissarro, and other artists would visit the benevolent dealer Julien "Père" Tanguy, on the rue Clauzel in Montmartre. Tanguy had a collection of Cézanne's paintings that he had accepted in exchange for paints and canvases—this was common practice for Tanguy (drawing much criticism from his wife). When asked to display the paintings, Tanguy would bring out one canvas at a time, fully aware that these were rare treasures.

Neil Folberg, *Pont des Trois Sautets, on the Arc River*, Aix-en-Provence, 2002

As he grew older and became ill with diabetes, Cézanne turned to religion. A practicing Catholic, he attended vespers and mass at the Saint-Sauveur cathedral in Aix. As Rilke noted, in painting the beauty of nature, Cézanne discovered religion in the landscape.

Cézanne's work was becoming increasingly appreciated. In addition to Tanguy's aid, he had support from the art dealer Ambroise Vollard, who in 1895 arranged Cézanne's first major solo exhibition, with some 150 works. The rapt attention the paintings drew, especially from the young painters, caused Durand-Ruel to buy a large quantity of the artist's work—Cézanne was the only Impressionist he had neglected until then. In 1889, Vollard purchased all the canvases in Cézanne's studio. Still, the painter's commercial success was limited, and

Paul Cézanne, *The Bridge of Maincy, near Melun*, 1879–80

Paul Cézanne, *Mont Sainte-Victoire, above the Tholonet Road*, 1896–98

Cézanne came to appreciate the foresight and generosity of his father, who had left him a substantial income.

In 1901, Cézanne bought a piece of land halfway up the hill of Les Lauves, a long, hot trek up from the apartment he had acquired in Aix to replace Jas de Bouffan. A year later, the simple atelier he had designed was built. He used the space only for painting, and walked back to town each night to sleep. The second floor of the building contained his studio, a large room with wooden floors and a northern exposure. Tall, slim trees from a neighbor's plot shielded the window, but from the opposite side of the room, he was able to see Saint-Sauveur's tall steeples surrounded by the rooftops of the village.

While he was supervising the construction of his atelier, Cézanne climbed the hill to its very crest, where he discovered a new view of Mont Sainte-Victoire. While the mountain was more remote than when viewed from Bellevue and Château Noir, from here its shape appeared triangular, rising majestically into the heavens from a wide base of fields and small farmhouses. Cézanne was to paint his mountain from this spot many times, creating some of his most iconic and monumental works.

Today in Cézanne's atelier one can still see some of the simple objects that appear in his paintings: the metal coffee pot, the plaster cast of a *putto* attributed to Pierre Puget. In the corner is the tall stepladder and extension easel he used for his masterwork *The Large Bathers*, 1899–1906. On the wall next to the north window there is a floor-to-ceiling slot that permitted the enormous canvas to be removed from the studio. Cézanne once confided to a rare visitor to his atelier that the provincial Southern town had forbidden him from employing a nude female model to pose for the *Bathers*. Instead, he explained, "an old invalid poses for all these women"—a tribute indeed to his remarkable artistic imagination.

Cézanne became the most deliberate of painters—taking so long to finish a still life that he could not use real apples, peaches, or flowers, but painted from artificial ones. This slower, studied pace reflected a fundamental change from his earlier technique, which was quick and assertive. As he grew older, his focus intensified and his pace slowed accordingly.

Still hanging on a hook in his Aix studio is the matted suede jacket with large round buttons that Cézanne was wearing when he was caught in a violent thunderstorm while painting on the road near his atelier one day in late autumn. A few weeks earlier, he had written to Emile Bernard: "I have sworn to die painting rather than to waste away vilely

in the manner that threatens old men who allow themselves to be dominated by passions that coarsen their senses." On October 23, 1906, eight days after the storm, his wish was granted. Cézanne's wife and beloved son did not arrive in time from Paris to be with him before he died. Sadly, they remained estranged even in death; Cézanne was buried in his family's tomb in Aix, and the Conil family was to fill up the rest of the space. Hortense and Cézanne's son Paul are interred far away in Paris.

Cézanne had physically removed himself from the Impressionists in order to advance beyond them: he had no choice but to suffer loneliness. His unique vision forced him outside the group, leaving him alone both in the closed space of his studio and outside in the face of the mountain. The climb up Mont Sainte-Victoire was a solitary pursuit, yet what he brought back from that journey is visionary and universal.

In 2006, for the centennial of Cézanne's death, Aix-en-Provence finally honored its native son in grand style. When I learned that the city's Musée Granet was presenting a retrospective of his paintings of Provence (co-hosted by the National Gallery in Washington, D.C.), I knew I had to come to France to feel the excitement of seeing these paintings on Cézanne's own turf. The air in Aix was positively electric with pride, which was felt in room after room of the exhibition—featuring masterful depictions of Mont Sainte-Victoire, as well as several of the Bathers and his seminal 1890–92 painting *The Card Players*.

Neil Folberg, *Renoir's Garden*, Cagnes-sur-Mer, 2003

The pride was particularly poignant, I think, because it had been so long in coming. I recalled hearing of one Henri Pontier, a curator who was a contemporary of Cézanne's, who vowed that the painter's canvases would never hang on the walls of the Granet. Pontier refused to exhibit Cézanne's work no fewer than three times: first in 1906 (just before the painter's death) and again in 1907 and 1911. As I meandered happily through the show, I could not help wondering how red Pontier's face would be if he knew of these joyous centennial events!

On my many previous visits to Aix, I had often pressed my face in frustration against the closed metal gate of Jas de Bouffan—Cézanne's family home, which

was privately owned and closed to the public. But now, one hundred years after his death, I found the gates open. The town of Aix has taken possession of the property, and not only is the public allowed entry, there are also plans to turn Jas de Bouffan into an educational center. (Also now open to the public is the quarry of Bibemus—where Cézanne painted the golden rocks in proto-Cubist style.)

I walked into Jas de Bouffan, past a row of plane trees—realizing only now that these were *not* the famed chestnut trees of Cézanne's paintings, as I'd thought from my distanced position at the closed gate on previous visits. Only when I reached the back of the stately mansion did I finally discover the allée of horse chestnuts (along with the ornamental pool and sweet farmhouse) that are so familiar from Cézanne's paintings.

It has taken many years for Aix to recognize and celebrate the genius of Cézanne. But the town's slow-and-steady pace is precisely one of the factors that made the painter love the place so much. He was happy and fruitful in his last years here, within easy reach of his magnificent mountain.

RENOIR IN THE
SOUTH: AN ANCIENT
OLIVE GROVE

Renoir's concern for Cézanne first brought him to the South of France, where for a time he painted beside Cézanne in Aix. Although his rather anemic, purple-hued painting of Mont Sainte-Victoire is not a greatly successful piece, Renoir did well artistically in the areas closer to Nice.

When he arrived at the town of Cagnes-sur-Mer, Renoir knew that he had found his true home. The mountains seen at a distance comforted him; they were not so close as to be intrusive. Taxes were practically nonexistent, and the locals could manage a good life with very little—the kitchen gardens, chickens, and rabbits reminded Renoir of the simple, happy life of Julie and Camille Pissarro in Pontoise. The orange blossoms from the groves that terraced the hills were sold to the *parfumeries* in nearby Grasse. Mounted on donkeys, the farmers visited one another, their simple ways harmonizing with the natural rhythms of the land.

Over the course of several years, Renoir and his family lodged in Cagnes in various rented houses. His son Jean Renoir remembers one of them: a post office in the old part of town, divided into three sections: the first was the post office proper, the second, an apartment for the proprietor, Ferdinand Isnard, and the third, overlooking a large grove of orange trees, was inhabited by the Renoir family. Isnard, a retired chef who had served with the legendary Escoffier at the Savoy in London, was fond of Renoir, and to please "le patron," he prepared traditional Cagnoise dishes he had learned from his parents.

Paul Cézanne, *Apples and Oranges*, c. 1899

Jean Renoir recalls that during warm weather, Baptistin, the general houseman, would take his father in a horse-drawn carriage trimmed with white fringe to paint in the countryside. Renoir, enchanted by the olive trees and the little farmhouse at Les Collettes, would ask Baptistin to urge the horse up the hill on the other side of the Cagnes River so that Renoir could paint the farm. Having observed Renoir's attachment to the property, the farmer knew exactly whom to approach for help when the trees on the land were threatened with extinction—those olive trees were to be razed to make way for commercial hothouses. Renoir purchased the nine-acre farm to protect them, to preserve the beauty of nature, and in the end, his protective gesture was richly rewarded. The artist's final home and atelier were at Les Collettes.

Climbing the hill to Les Collettes, one comes upon those massive olive trees, twisted and marked from centuries of rain, winds, and sun. Majestic in their aura, the convoluted sculptures seem to be cast in petrified stone, crowned by delicate, silvery leaves, their fruit reappearing young and fresh each season. Renoir worked among these splendid trees in his outdoor studio—poetic justice since he himself had saved them. Renoir, gnarled in his old age like the olive tree itself, remained fruitful and created great beauty. In the warmth of the healing sun of the South, this noble figure developed through the force of his person and the joy of his creations.

Although his glass-walled studio has vanished, the views that Renoir painted remain. Across the valley, the steep hillside of Haute-de-Cagnes rises up in the distance, the fourteenth-century Château Grimaldi clinging to its summit. Renoir cherished his ancient farmhouse, and made many paintings of it. Given to preservation, Renoir

Neil Folberg, *Still Life with Apples and Onions, Atelier Cézanne,* Aix-en-Provence, 2002

was satisfied to leave his new property the way he found it. He did not want to live in the farmhouse and was content to keep renting a home in Cagnes; he also owned a comfortable home in Burgundy, and maintained his home and studio in Paris as well.

In his later years, Renoir was afflicted with rheumatoid arthritis—complicated by a broken arm from a bicycling accident in 1897—but he persevered, painting some of his freest and most sensuous works. In the most trying circumstances of illness and aging, he remained true to his artistic vision and professional vocation. To keep his fingers flexible, he juggled three leather balls, but had to

Neil Folberg, *Forest*, Provence, 2002

Paul Cézanne, *Chestnut Trees at Jas de Bouffan*, c. 1885–86

Pierre-Auguste Renoir, *The Farm at Les Collettes, Cagnes,* 1908–14

give this up as his disease progressed; he substituted a wooden stick, which he would toss in the air, making it turn round and round, catching it first with one hand and then the other. He became emaciated, and his skin was so sensitive that every day one of his family members wrapped strips of linen around his palms so that the wood of the brush handle would not chafe his flesh. Then, at his request, they forced his paintbrush into his misshapen, paralyzed hand.

Fortunately, Renoir's arms were straight and strong, his eyes remained sharp, and no amount of pain deterred him from attacking the canvases with as much passion and vigor as ever. Finally, his deformed legs would not allow him to walk, and Aline—usually so stoic—wept when she traveled to Nice with Jean to order Renoir's wheelchair. Rather than let the wheelchair confine him, two people carried the painter in a sedan chair, his neck and shoulders wrapped in a plaid wool blanket against any draft, and brought him to his outdoor studio among the ancient olive trees.

When Sarah and I first visited Renoir's atelier, at the beginning of our fateful trip together, we both halted when we came upon that wheelchair. For me, it evoked memories of my husband's illness—he had been confined to a wheelchair for some time. But as with Renoir, that confinement did not seem at all to limit Ted's interest in and involvement with the world; each day, he was maneuvered into his office and spent productive and creative hours furthering his various projects. As I stood in Renoir's studio, I considered the remarkable fact that mere physical limitations can mean so little.

But illness did prevent Renoir from traveling comfortably, and so Aline persuaded her husband to build a large house at Les Collettes, in which his many friends could gather around him in the mild winter climate of the Midi. He was greatly pleased with the building's balconies that allowed him to see the sweep of the Mediterranean and the fishermen of Cros-sur-Cagnes bringing in their daily catch of sardines (which Renoir swore were the best in the world). Aline had intended for the house's outer walls to be covered with wisteria vines, but the plant did not thrive—and still today the building is rather stark, its yellow stone sharply contrasting with the deep azure sky of the Midi. The building's interior, however, glows with landscapes that Renoir painted in his later years.

Today, there is a sense in this house that Renoir and Aline and their three boys have just left and will be back any moment. The rooms are filled with family photographs, fresh flower arrangements, and ceramics by Renoir's youngest son, Claude. In the kitchen is the large cast-iron range where Aline's Saturday pot-au-feu was prepared. The furnishings are simple throughout, and dominating the living room is the original

of one of Renoir's *Bathers*. In the atelier, the artist's wheelchair rests innocuously. The room still holds easels covered with unfinished paintings and a reproduction of one of his interpretations of Gabrielle, Renoir's favorite model.

Jean Renoir relates that his father was so concerned about his three sons that when he and Aline attended theater performances in Montmartre, at intermission they used to jump into a carriage and drive home to check that the children were sleeping and well. Perhaps his tender protectiveness derived from being an older father—he had his first child at forty-five, and his third son when he was nearly sixty. Curiously, well into his forties, Renoir was still adamantly against being tied down by marriage, but he soon became a devoted husband and father. When he and Aline began raising children, Renoir came to feel that they were his greatest creations.

The portraits of aristocrats and well-to-do families that Renoir had painted before his marriage had begun to bring him some celebrity toward his later years. He socialized with the upper classes in their great mansions and was concerned about making a good impression—coming from a working-class background himself, Renoir could not have been fully at ease in these new circles. He began to disassociate himself from the radical Impressionist group, and was worried that having a seamstress for a wife might not be good for his image. Eventually, however, Aline's sweet nature, lack of pretension, and marvelous meals endeared her to his friends, creating a congenial atmosphere and allaying Renoir's concerns.

Renoir's friend Berthe Morisot was one who was at first appalled when Renoir brought Aline to her home at Mézy. Aline was no longer the curvaceous model of Renoir's *Luncheon of the Boating Party*; childbearing and a healthy appetite for Burgundian sausages and beans had caught up with her. But even Morisot—who revered stylish beauty and had an abhorrence of fat people—could not resist Aline's homespun charms. Emotionally somewhat reserved, Renoir tended not to show affection to his wife in public, but his son Jean writes that his parents had a very loving relationship.

Renoir preferred the wildness of the farm to the formality of the house where he lived with his family at Les Collettes. It was initially Aline who planned the formal garden of the villa. Renoir did not include the house or the garden in any of his paintings, but he did use the flowers, particularly the roses, as subjects for his work. Eventually won over by Aline's enthusiasm, however, Renoir drafted plans to transform the garden into a Florentine *giardino*, with his sculpture of *Venus Victrix* as its focal point. Aline saw to it that the paths through the property were wide enough to allow for

his wheelchair. Behind the farmhouse, she installed a kitchen garden, with a large area devoted to growing artichokes. As Renoir enjoyed the aroma of carnations, hothouses were installed for them—but the venerable olive trees were never disturbed. An old vineyard spilled over the hill toward Haute-de-Cagnes, providing grapes for wine, and the blossoms from the orange orchard perfumed the air in the springtime. Jean Renoir said that even blindfolded he would recognize the scent of Les Collettes. When his two younger sons climbed the trees, stripping them of their sweet fruit, Renoir replaced them with sour orange trees, so that the children would not be tempted to disturb the pristine state of his garden.

Situated on a slope between the Gulf of Nice and the mountains, with its breathtaking views of rooftops, palm trees, crescent-shaped beaches, Antibes and its jetty of gray rocks, Les Collettes provides a powerful aesthetic experience. The painter's success derived largely from his understanding of the simplicity and harmony within nature, so evident in this location. In stark contrast to his friend Cézanne, Renoir's deep familial and personal relationships fill Les Collettes with warmth. Even his wheelchair seems infused with the energy that emanated from his being. Although Cézanne had pursued his artistic vision under difficult circumstances, Renoir persevered under far more formidable physical handicaps, while maintaining and developing warm and loving relationships with both friends and family. In Les Collettes, he proves to be a trustworthy and tender guide to a happy way of life.

MONET AND
GIVERNY: EARTHLY
PARADISE

By allowing his garden to retain a sense of wildness, Renoir hoped to invoke the organic peace and tranquility of nature. His friend Monet chose a very different approach with his garden at Giverny: he designed his flower plantings with great care, to correspond to the colors he wanted to use in his paintings. Monet himself cultivated and collected a great many flowers, transforming a desolate and neglected site into a blossoming paradise. Renoir discovered beauty in nature and sought to preserve it; in contrast, Monet vigorously manipulated nature to create beauty.

During the summer when I was traveling with my granddaughter, we stopped at Giverny. As Sarah bent over an enormous yellow rose to breathe in its fragrance, the expression of euphoria that appeared on her face seemed to close the generation gap. On a later visit to Monet's gardens, I brought my friend the conductor Michael Tilson Thomas. In a moment of astonished recognition, Michael stared at a hill covered with orange

Neil Folberg, *Monet's Home*, Giverny, 2001

poppies near Monet's home. "They are really *here*," he said of the flowers. "They painted what they saw."

In Giverny, what Monet saw and what we see today are the flowers and trees that he planted. The fields of poppies that Monet painted at Argenteuil are now blanketed over by industrial buildings, but in Giverny they still grow in inspiring profusion.

The genius of Giverny is apparent the minute you enter the gates. The estate is maintained today by six full-time gardeners, just as Monet crafted it more than a century ago. Each season's replanting of the flowerbeds, in front of the pink house with the green shutters, produces the very color combinations that were meticulously designed, over a period of years, by Monet.

In 1883, when Monet moved to Giverny with Alice Hoschedé, along with her six children and his two, the artist was destitute. He had rented the Maison du Pressoir, a sturdy but rundown house with gray shutters and an apple-cider press in the earthen cellar, because the property was large enough to contain his family, and just barely affordable. To create a basic flower garden, he immediately planted seeds, as he had in all the houses he had rented previously. As he became increasingly affluent over the course of the following four decades, he slowly turned Giverny into one of the most beautiful residences in all of France. At first, Monet did all the gardening himself, but as his paintings began to sell, he was able to hire a team of gardeners to turn his flower beds into a palette of colors; eventually, he also created the extraordinary water garden, the jewel of Giverny.

During the course of his development as an artist, Monet traveled extensively. Spending many months away from home each year, he left Alice with very little money to take care of eight children and run the household. Although she had no doubt of Monet's love for her, their correspondence sometimes reveals her unhappiness; especially difficult for her was living in a village of several hundred inhabitants who looked at their unusual domestic arrangements with suspicion. Alice was never able to reconcile herself to Monet's spending so much time away from her, but their attachment

Claude Monet, *The Artist's Garden at Giverny*, 1900

was such that she remained at Giverny, impatiently awaiting his return from his painting expeditions.

Monet's art required him to work out-of-doors; when the weather was bad, he was unable to paint. After a long siege of inclement weather, he sometimes came empty-handed to dealer Durand-Ruel—which was financially disastrous for the painter, given his need to feed an extended family. His letters to Alice reflect his constant preoccupation with the weather and the changes in light. "The locals would be glad of some rain; it hasn't rained at all since September," he wrote her from Italy in 1884. "Let's hope that their prayers won't be answered until I leave."

Monet indeed painted what he saw, and with unstinting integrity. In the coastal village of Bordighera, Italy, his sensitivity to the dazzling light and colors is clear in a letter to Alice describing his artistic struggle:

> I haven't managed to capture the color of this landscape; there are moments when I'm appalled at the colors I'm having to use, I'm afraid what I'm doing is just dreadful and yet I really am understating it; the light is simply terrifying. I have already spent six sessions on some studies, it's all so new to me that I can't quite bring them off; however the joy of it here is that each day I can return to the same effect, so it's possible to track down and do battle with an effect. That's why I'm working so feverishly and I always look forward to the morrow to see if I can't do better next time.

Monet's search for landscapes took him many times to the Channel coast, to childhood haunts where he and Boudin had first set up their easels. At the Musée d'Orsay, I had been intrigued by Monet's depictions of *The Rock Needle and Porte d'Aval, Etretat*: an extraordinary rock jutting out of the sea beside a massive cliff with an arch in it. I followed Monet's trail to the village of Etretat, where my hotel window provided a high vantage point, overlooking the pointed rock and the "drinking elephant" (as the author Guy de Maupassant described the extraordinary cliff of Porte d'Aval). I was fortunate to experience that view on my first morning in Etretat through a beautiful fog—precisely the sort of atmosphere Monet would have sought. He once complained in a letter to Alice, when he was painting Charing Cross Bridge in London, that "although by nine o'clock I'd already done some work on four paintings, I was convinced that I was going to have a very bad day. As always

on Sunday, there wasn't a wisp of fog, it was appallingly clear in fact. . . . Meanwhile, kitchen fires began to be lit. Thanks to the smoke a mist descended, followed by clouds. . . ."

As the mist slowly lifted that morning in Etretat, the street lamps separating the village from the beach were haloed in a golden mist. I threw on a windbreaker and, breathing in the smell of wet sand and brine, I hurried down the path through the dark grass covering the steep hill to the seaside below. As the sun warmed its edges, the rock arch at the end of the beach became clearer. Wooden fishing boats were pulled up on the pebbles, the fishermen readying their nets for a day on the sea. The vision that inspired Monet was still here, unchanged by the years.

Over the following days, with Etretat as my base, I scouted the Normandy coastline—from the town of Fécamp, where the sea creeps into a natural harbor, forming a splendid refuge for sailing ships (the village is also known for its Bénédictine liqueur), to Sainte-Adresse, where Monet painted his father seated on a terrace with flags flying in the wind and ships out at sea. The artist's beloved aunt, Madame Lecadre, lived in Sainte-Adresse; it was she who paid several thousand francs to buy Monet out of the army after he contracted typhoid while serving in Algiers. (At the Musée Marmottan Monet in Paris, a painting by Charles Lhuiller depicts a dashing Monet in his uniform of red pantaloons, knee-high boots, and navy-blue tunic, a kepi on his head. Apparently, he made a better model than a soldier.)

In the industrial town of Le Havre, I had some difficulty determining where Monet painted his *Impression, Sunrise*—until I realized that the smokestacks surrounding me on the quay were actually in the painting, but obscured by a bluish-mauve fog. As I traversed the old streets of the city, I imagined Boudin helping his young protégé Monet look closely at nature, thus stimulating Monet's lifelong commitment to painting *en plein air*. I was enchanted by Boudin's images of sunrises at the Musée Malraux in Le Havre, and they helped me to understand his influence on the young Monet. His importance to the Impressionists in general was even clearer to me after a visit to the Musée Eugène Boudin in Honfleur, the village where Boudin was born, just west of Le Havre; with his careful balance of tightly composed vistas and wildly loose brushstrokes, Boudin was clearly a vital precursor of the movement.

I next visited the wide beaches of Trouville and Deauville. On his honeymoon in Trouville with his first wife, Camille, Monet painted her sitting on a chair on the beach under a parasol. I recalled seeing his 1870 *Beach at Trouville* at London's National

Gallery, noticing that grains of sand, churned up by the wind from Trouville's beach, were embedded in the paint on the canvas.

The Norman coastline was at the heart of Monet's oeuvre: the savage storms, the star-speckled nights, the indentations of shingle beaches cutting into forty miles of chalky cliffs rising up from the sea. Maupassant, who accompanied Monet on a painting expedition, described the dimensions of the artist's fortitude in challenging the elements while painting his 1885–86 *Etretat in the Rain*: "With both hands, [Monet] took hold of a shower that had fallen on the sea and flung it down upon the canvas. And it was indeed the rain that he had thus painted, nothing but rain veiling the waves, the rocks and the sky, which were barely visible under the deluge. . . ." Elsewhere, Maupassant outlines Monet's approach to depicting light over the course of several paintings of a single scene: "[Monet] walked along, followed by the children who carried his paintings, five or six canvases showing the same subject at different times of day and with different effects. He took them up or abandoned them as the changing sky dictated. And the painter stood before the motif, waiting, examining the sun and the shadows, in a few brushstrokes capturing a ray of sun or a passing cloud, which, scorning the fake or conventional, he rapidly set down on canvas."

The writer Octave Mirabeau's description of Monet's serial paintings summarizes their accomplishment beautifully: "A single motif . . . is sufficient for him to express the many and disparate emotions through which the drama of the earth passes between dawn and dusk."

In 1890, when Monet's financial burdens had begun to be alleviated, he returned to Giverny to purchase the home he had been renting for seven years. In 1893 he bought a piece of land on the other side of the roadway, where he would construct his water garden. He expanded the pond dramatically in 1901 when he obtained permission to divert the Ru, a branch of the Epte. In a unique way, Monet managed to construct his own universe in which to experiment with light, color, and atmosphere. He was obsessed with the reflections of the lilies he himself had planted, in the pond of his own creation. As part of the Zen-like composition, tall stands of bamboo create the feeling of an Asian forest as you pass over the wooden Japanese bridge, laden with purple and white wisteria. Weeping willows droop over the mirroring surface of the water. Monet would spend many hours at a time studying the reflections of the sky and clouds on the surface of the ponds; he welcomed shadows and variations of weather, light, and seasons. He often focused on the grasses growing beneath the surface of the water,

Claude Monet, *Saint-Lazare Station*, 1877

Claude Monet, *Water Lilies*, 1916–22

Neil Folberg, *Marine Landscape*, Normandy, 2002

trying to capture their movements as they waved to and fro. Monet built a tunnel under the roadway connecting the water garden with his home and flower gardens.

The lively colors blooming in front of Monet's home extend into its interior as well: the walls are painted in mauves and shades of blue, the dining room in sparkling bright yellow; the kitchen is lined with tiles of blue and white, bright copper pots and pans are stacked along the shelves, and throughout, Japanese prints fill the walls.

Monet's "studio boat"—similar to the one he and Caillebotte had built in Argenteuil—was moored where the Epte meets the Seine, a short walk from Monet's home. He constructed a boathouse on the Ile aux Orties, which held several small rowboats. In the nearby fields, Monet painted his famous haystacks and poplar trees, rotating the unfinished paintings as the light changed. Pursuing this technique under difficult conditions far from home, Monet depicted the Rouen cathedral in various shades of light and color. Although these works are recognized today as masterpieces, Monet's unrelenting quest for perfection in his artistic investigations left him doubtful about their success. These works brought him great acclaim, and yet he wrote to Durand-Ruel in May of 1912: "Now, more than ever, I realize just how illusory my undeserved success has been . . . I know that if they are exhibited they'll be a great success, but I couldn't be more indifferent to it since I know they are bad, I'm certain of it."

The death of Alice's husband, Ernest Hoschedé, in 1891, finally allowed Monet to marry Alice, in the small church on the hill of Giverny. Monet's life was becoming more orderly and he could dedicate his energies fully to painting for many years to come. He died in 1926 at the age of eighty-six.

Edouard Manet, *Berthe Morisot Reclining*, 1873

Berthe Morisot

Eager to experience Monet's paintings of water lilies, I visited the Musée d'Orsay, where I studied his 1899 *Water-Lily Pond, Green Harmony*, with its many delicate shades, and the Japanese bridge suspended over grassy waves of reflections. At Paris's Orangerie, in the Jardin des Tuileries, a twenty-two-panel work surrounds the viewer, rendering the physical sensation of being situated in the very midst of the water gardens; but somehow even in the Orsay's smaller depiction, Giverny seems to encompass the viewer.

While moving through the extraordinary collection at the Orsay, I was unexpectedly halted by Edouard Manet's 1868 masterpiece *The Balcony*. In the painting, Berthe Morisot's dark eyes are lit with a smoldering flame; she averts her gaze with something like defiance, or perhaps repressed desire. Nearby, in Manet's 1872 *Portrait of Berthe Morisot with a Bouquet of Violets*, her face is framed by a tall black hat, her enormous brown eyes searching those of the man who is depicting her—revealing her deepest feelings, trusting both him and her yearning for him. Although I did not yet know the story of their relationship, the charged connection between this artist and his beautiful subject was palpable.

Still on the search for water lilies, I next visited the Musée Marmottan Monet. Downstairs, I entered an oval room replete with majestic paintings of Monet's water-garden, illustrating differing effects of light and atmosphere. Sitting on the bench in the center of the room, I immersed myself in the deep azure pool threaded by dark, feathery willows; floating, waxy-white lilies; turquoise and purple lily pads with orange smudges—a fantastic cacophony of colors.

The museum's upstairs galleries contain Monet's private collection, which had originally hung in his bedroom on the second floor of his home in Giverny. In Renoir's painting of Camille, Monet's beautiful first wife, she radiates with a blush of young happiness. Monet's own infamous *Impression, Sunrise*, once owned by Ernest Hoschedé, is back where it belongs in this Monet collection.

As I turned the corner, I was met again by Morisot's disconcertingly seductive gaze, in Manet's 1873 *Berthe Morisot Reclining*. She looks enigmatically and candidly out at us, her vulnerable eyes belying her slightly ironic smile.

A roomful of Morisot's own carefree paintings dispels the proud darkness of that sensual, magnetic woman. Infused with light and gentle color, Morisot's paintings fairly glow with joy. First is the shipyard in Fécamp, a study of the rustic canvas sling used to suspend a hull; beside it, a small cargo ship is being mounted by ladders; it is a shipyard textured with soft edges.

As I made my way around the periphery of the room, past Morisot's paintings, with their short, lively brushstrokes in delicate hues, I suddenly found myself confronted by a bold and uncompromising expression that one could not forget even if one wished to. Berthe Morisot's 1885 self-portrait, made when she was in her mid-forties, is completely unlike the depictions of her by Manet—so much so that I might not have recognized this as the same woman. Clear-eyed and calm, her graying hair parted in the middle and pulled back in a black ribbon, she gazes unapologetically at the viewer with a force of personality that is nearly overwhelming. Around her neck, a blue scarf is tucked into her jacket. She holds a palette and brush in her hand, demonstrating clearly that she is a painter.

In the presence of Morisot's striking self-portrait, the surprise I felt gave way to pride—even relief—to discover that this sensuous, talented woman possessed such dignity and such a strong and unbounded character. Paradoxically, she seemed to me to be both the most vulnerable and the most powerful of the Impressionists. Who was this intriguing creature? How could I not be drawn to travel in pursuit of her art and of her person?

THE DISCREET OUTSIDER

On a sunny morning in Paris, I strolled up and down the rue Franklin in Passy, near the Trocadéro, searching for Berthe Morisot's hidden home and studio. In Anne Higonnet's wonderful 1990 biography of Morisot, I had seen a photograph of the white mansion, and my curiosity was piqued—but I could not locate the building.

Frustrated, I returned to my hotel. I was to leave Paris the next day, and had very little time to solve this mystery—so I went directly to the source. I telephoned Higonnet at New York's Barnard College, where she is a professor of art history, and she kindly informed me she had found the Morisot home by passing through the gate of a Jesuit school on the rue Franklin; the white house was in the back, overlooking

Berthe Morisot, *Self-Portrait*, 1885

Edouard Manet, *The Balcony*, 1868

Neil Folberg, *The Balcony* (after Manet), Paris, 2002

the Seine. So early the next morning, I returned to Passy and knocked on the door of a very modern Jesuit school. I asked if I might come through to see the Morisot home, but the guard curtly refused; he assured me the house did not exist. After some discussion, it eventually became clear that the former buildings had been razed in order to build this new structure. I felt some satisfaction at having found my answer—but when I called Higonnet to tell her the news, she was devastated. She had been hoping that one day, when the value of Morisot's work finally became apparent to the French government, her Paris home would be turned into a museum.

Morisot was one of the central figures of the Impressionist movement; sadly, it would seem that among many in her homeland she has yet to be acknowledged as such. She grew up in a well-to-do home; her father was a high-ranking government official, her family was cultured and affluent. While Berthe and one of her sisters, Edma, both serious painters, managed to circumvent many of the strictures that were so rigorously in place for nineteenth-century women, Morisot's work continues even now to meet with obstacles to its acceptance.

From the very beginning, the Morisot sisters painted with professional dedication: their master was Camille Corot, who encouraged them both to paint outdoors when they spent the summer at the Ville d'Avray near Corot's home. In 1858, when Berthe was seventeen, she and Edma registered to study and paint at the Louvre. It was there, two years later, that their friend Henri Fantin-Latour first introduced Berthe to the celebrated Edouard Manet. The encounter occurred under the watchful eye of Berthe's mother, but this did not stop Manet from being charmed by the young and beautiful painter, or from noting her talent. Their artistic relationship would soon flower, and their mutual influence was to be profound.

Early on, Edma and Berthe had made a pact that they would devote themselves completely to their art, forsaking any other life. But in 1869, having lost all hope of a career, Edma gave in to society's expectations and got married, to a naval officer named Adolphe Pontillon. Berthe was bereft, feeling that she could not paint without

her soul mate, whom she considered to be the finer artist. Berthe had relied on Edma's eye to assure her of the quality of her own paintings; now she found herself alone and confused.

At twenty-eight, Berthe was approaching the age when her chances of marriage would diminish. For a woman of her class, there were scant acceptable professions, and that of an artist was downright scandalous. She suffered her mother's constant harping on the necessity of marriage: for Berthe to end up an "old maid" would constitute a complete failure, according to Madame Morisot—not only for Berthe but for herself. Furthermore, Berthe's mother had no great love for her paintings, and could not imagine that anyone might want to purchase them. Her mother's merciless badgering and lack of support ate away at Berthe's self-esteem, and she found herself unable to work for months.

Profoundly despondent, Berthe knew she had to get away from home for a change of scene. Spending two of the summer months in Edma's house at Lorient in Brittany helped to revive her. Berthe began to paint again. Her depiction of Edma on the quay of Lorient was much admired by Manet, and Berthe presented it to him upon her return to Paris.

Back in the city, Morisot began to spend time in Manet's studio, not as his student but as a friend, artistic colleague, and sometime model. During those visits, including the many hours that Morisot posed for Manet, her mother is said to have accompanied her as chaperone—staying occupied by embroidering or reading, but never leaving the two alone. Still, the deep attraction Manet and Morisot felt for each other is obvious in his portraits of her. Manet was a married man (his Dutch wife, Suzanne, also modeled for him), and the hopelessness of Manet and Morisot's love can be read in her eyes in his paintings of her. Manet's own fascination and emotional involvement make these portraits—he made eleven altogether—among the most moving works of all his oeuvre.

As it was unacceptable for Morisot, as a single woman, to enter the Guerbois or the Nouvelle Athènes cafés, she was excluded from most of the Impressionists' artistic discussions. Her only natural contact with male artists came while painting in the Louvre, when all were preoccupied with their work. Morisot was frustrated by this imposed isolation, and she convinced her mother to invite a number of the artists to the regular Tuesday salon evenings at the Morisot home. There, animated conversations took place among Degas, Renoir, Manet, Monet, and one of Morisot's closest friends,

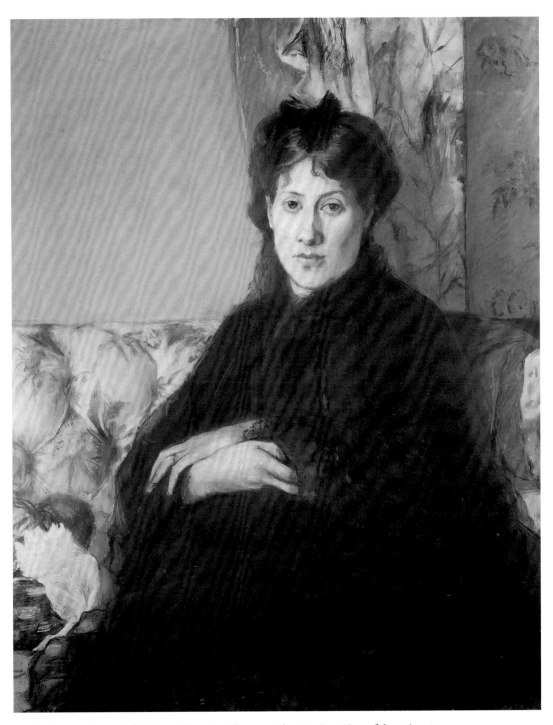

Berthe Morisot, *Portrait of Madame Edma Pontillon, née Edma Morisot, Sister of the Artist,* 1871

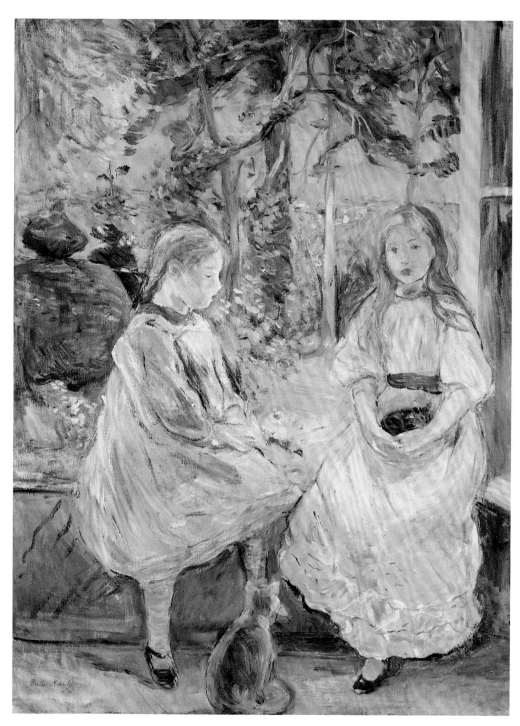

Berthe Morisot, *Young Girls at the Window*, 1892

the poet Stéphane Mallarmé. These evenings allowed her to participate both in the group and in the vital artistic discourse of the day.

As a respectable upper-class woman, however, Morisot encountered additional professional obstacles. She was not, for example, permitted to paint from live models, neither at the Académie Suisse nor in Gleyre's atelier. Even in her private lessons with Corot and other teachers, it was deemed improper for her to draw live nudes. Ironically, this proved to be something of an advantage to Morisot: many of her male counterparts in the Impressionist group had had to *unlearn* academic lessons of classical modeling in order to alter their approach to painting. Without such strict classical training, Morisot was free to allow her instincts to flourish in her work.

Neil Folberg, *Anna and Lou, Great-Great-Great-Grand-daughters of Berthe Morisot*, Château du Mesnil, 2002

Although she was not as desperate for money as her male cohorts, Morisot wished to command good prices for her paintings—like many artists, she looked for verification of her abilities in the market for her work. Her touching painting of Edma admiring her baby daughter, *The Cradle*, 1873, now in the Musée d'Orsay, marked Morisot's first triumph in the art world. When Degas proclaimed that the nascent group of avant-garde artists wanted both Berthe and Edma to join them in the historic inaugural Impressionist exhibition in 1874, it was a sincere tribute to their art. Although Edma hesitated and finally refused, Berthe enthusiastically accepted the invitation. Manet, who wanted no part of the rebellious independent exhibition himself, vociferously opposed her participation, but—showing full confidence in her own vision—Morisot diverged from her mentor's path. Although she continued to work with Manet and loyally championed his art, from this point on she developed deep and collaborative working relationships with Degas, Monet, and Renoir.

Morisot's spirit of independence had led her to join the Impressionist group, and her work continued to develop along an individual path. She was an outsider among outsiders: as a woman, of course, and with her genteel family background, she stood out even among the Impressionists, but most importantly, her artistic vision was hers alone. Extraordinarily, she managed to retain both her role as a discreet and elegant

woman and the integrity of her art. Focusing on the themes of family life, she painted in private gardens or inside homes, transforming such simple scenes as the nurturing love between children and their mothers, the chore of hanging laundry, or the task of shelling peas, into delicate and moving visual poetry.

Surprisingly, rather than marginalizing her as a "radical," Morisot's independence seemed to make her more attractive as a candidate for marriage. In 1872, while he was painting her portrait with the bouquet of violets, Manet suggested to Morisot that she marry his younger brother, Eugène. During the summer of 1874, the Manet and Morisot families vacationed together at Fécamp, and in December of that year, Morisot and Eugène were wed.

It was an auspicious union for the young artist, allowing her to retain the liberty to pursue her creative passion—and assuring regular contact with her brother-in-law. It was not, however, a marriage of deep love on Morisot's part. The couple approached their improbable union gingerly, fully aware of their respective sensitivities and non-traditional needs. Eugène, who was an amateur painter, respected Berthe's talents, and he took pride and pleasure in enabling her to progress. He was sensitive to the particular exigencies of a painter and was in full sympathy with her obsession to create. It was he who spoke to dealers, had her paintings framed, and supervised their display at the Impressionists' exhibitions. His liberal politics dovetailed with Berthe's. Her grace and elegance bewitched Eugène; his letters to her are filled with profound love and the desire to make her happy.

And Berthe, in turn, was supportive of her husband. She felt that the Manet family had underestimated Eugène, and she resented their insensitivity toward him. Edouard had always been the center of attention, with his outrageous talent, wit, and dandyism. Shunted to the side, Eugène had grown up quiet and self-effacing. Now married to the stately and loyal Berthe Morisot, Eugène took his place beside her in a world of revolutionary writers and artists that filled their homes with a vibrant and innovative spirit.

In 1878, at the age of thirty-seven, Morisot finally enjoyed the immense fulfillment that she had long craved: their daughter, Julie, was born. The new mother exclaimed with amazement that her baby had "Manet fingers." Morisot's paintings of Julie reflect the love and joy that this beautiful child brought her.

Through all the stages of Julie's life, Morisot continued to paint her lovely daughter. A particularly touching image is *Eugène Manet and his Daughter in the Garden*

of Bougival, 1883, in which Eugène and Julie, a doll-like toddler, enjoy each other's company in the garden of the rented residence where the family lived while their home in Paris was under construction. For two years, they moved about like gypsies until the five-story building on the rue de Villejust (now rue Paul Valéry), near the Arc de Triomphe, was complete. Their new home included a large salon-studio with a high ceiling for Morisot. Following the Manet family tradition, they entertained on Thursday evenings.

When Edouard Manet died in 1883, both Berthe and her husband felt a deep loss: Eugène had lost a brother and Berthe had lost a very close friend. Writing to Edma, she mourned "the friendship now of such long standing that bound me to Edouard, an entire past of youth and work collapsing . . . you'll understand how shattered I feel . . . I'll never forget the old days of friendship and intimacy with him, while I posed for him and while his ever-delightful wit kept me alert for those long hours."

Later that year, Berthe and Eugène moved into the house on the rue de Villejust. The family occupied the ground-floor apartment and rented the floors above. Morisot used the salon as her painting studio, and hosted their close circle of friends in the same room. At night she would whisk away her painting equipment, hiding everything in a closet—insisting on maintaining the strict decorum of the nineteenth-century bourgeoisie. While she had some moderate success in selling her paintings, Morisot did not aggressively push herself forward; it seems she was well aware that as long as her behavior did not raise any eyebrows, she was free to paint as she wished.

Over the course of a decade, Morisot had had a strong professional rapport with her circle of artists; in 1884, she wrote to Edma that those ties were strengthening: "I'm beginning to become friends with my Impressionist colleagues." Like Degas, Morisot was so very protective of her time to paint that her sisters, Edma and Yves, felt that a wall had been erected between them, separating them from her. All the sisters missed the warm, shared experiences of their youth, but Edma and Yves blamed Berthe for the estrangement, claiming that she was cold and heartless. Berthe felt she was accused unjustly; she was simply an artist striving to realize her creative visions, and such visions would brook no compromise. Further adding to the tension with her sisters, Morisot's connection with the Manet family made her wealthier than they were. That wealth enabled her to fill her home with paintings by Manet, Renoir, Degas, and Monet. Maintaining her usual low profile, Morisot relegated her own work to the hallways and storage rooms of her home.

In 1886, Eugène and Berthe subsidized the eighth and final Impressionist exhibition, after which Morisot showed with private dealers, and in various prestigious international expositions. In the same year, Eugène—who had long been in frail health—developed an illness from which he would never recover. Morisot wrote to a friend: "My husband is coughing badly, almost never leaves his room; just picture to yourself a sick man, sitting on all the furniture, greatly to be pitied and no less high-strung."

She continued to invite friends to the house, both to distract Eugène from his discomfort and to help herself overcome her sense of isolation. The surly Degas was withdrawing from social life; still, he felt quite at home at 40, rue de Villejust and was always comfortable to meet there with Renoir and Mallarmé. (Morisot's daughter Julie recalled, however, that Degas was also prone to unexpected fits of rage in the company of the family. He was not at all fond of children, and had a tendency to pinch them cruelly without warning.) Monet visited less frequently, as he lived so far away in Giverny, but his feelings for Morisot were always very congenial. Renoir often visited the Morisot-Manet family at their summer residences, and when he painted with Morisot in Mézy, he was influenced by her colors.

It was Mallarmé who discovered the Château du Mesnil in the village of Juziers, near Meulan, which would become the Morisot-Manet home. In October 1891, after years of deliberation, Berthe and the failing Eugène purchased this seventeenth-century manor house, with a towering *pigeonnier* in the driveway and a stand of chestnut trees to the side of the façade. In Morisot's words, Eugène was "crazy about it"; sadly, he did not enjoy Mesnil for long: only a few months after the purchase, in April 1892, Eugène Manet died.

Morisot was disconsolate after her husband's death. In her journal, she wrote: "I want to go down into the depths of pain because it seems to me it must be possible to rise from there; but now for three nights I've wept; mercy . . . mercy. I say 'I want to die' but it's not true at all; *I want to become younger. . . .* What I would like would be to recapture the moments when I had strength and vigor, a line of conduct, a rule, a faith; but that's beyond my powers." Her diary etched her remorse: "I have sinned, have suffered, I have atoned for it." Perhaps she felt guilty for never loving Eugène as passionately as he loved her. Yet mixed with the regret was profound gratitude for Eugène's kindness and understanding.

Only work could restore Morisot's equilibrium: she painted every day. To protect Julie's inheritance as well as to allow herself to pursue her own artistic endeavors, the

Pierre-Auguste Renoir, *Berthe Morisot and Her Daughter*, 1894

Berthe Morisot, *Before the Mirror*, 1893

Neil Folberg, *Before the Mirror* (after Morisot), Château du Mesnil, 2003

ever-resourceful Morisot rented out the Château du Mesnil and cleared out all the furniture from the rue de Villejust house to rent it as well. She and Julie moved to 10, rue Weber near the Bois de Boulogne, where the Thursday night salons continued as usual.

In 1894, the death of Gustave Caillebotte and the subsequent refusal of the French State to hang the bequest of his collection of Impressionist paintings in the Palais du Luxembourg once again stirred up the fundamental controversy about the artists. Meanwhile, the collector Théodore Duret proposed to Morisot's friend Mallarmé that, as her paintings had *not* been included in the Caillebotte bequest, Morisot's *Woman at a Ball*, c. 1879—an exquisite rendering of a young woman dressed in a white satin ball gown—be purchased for the State. The State accepted the proposal, and hung the Morisot painting at the Luxembourg. The Caillebotte bequest paintings, showcasing the other Impressionists, were not hung there until a year later. It is of interest to note that the unassuming Berthe Morisot was thus the first Impressionist to conquer the Palais du Luxembourg.

During her life, Morisot contended dexterously with social conventions. She married, she gave birth to a child, her demeanor and social graces were faultless—and yet she painted such radically new pictures. Finally, France had accepted her work in its most prestigious museum. In triumph as in trial, Morisot continued to paint constantly, furthering her personal Impressionist vision. In this, she was no different from Monet at the end of his life, from Van Gogh in his final tragic moments, from the irascible Cézanne facing Mont Sainte-Victoire, from the aged Pissarro on the boulevards of Paris, or from the crippled Renoir, who on his deathbed marveled that he had learned something new that very day. The artists had in common a purposefulness of focus that never allowed their visions to cease growing.

Furthermore, Morisot managed to live both her professional life and her family life to the fullest; she nurtured her adoring friends and proved unfailingly loyal to her Impressionist colleagues, right up until her death at the young age of fifty-four.

Her daughter, Julie, developed very close friendships with Monet's children and stepchildren, and with Degas, the Renoirs, and the Mallarmés. Indeed, after Morisot's death, Degas avuncularly arranged Julie's marriage to Ernest Rouart, the son of his close friend Henri Rouart.

In a sense, Berthe Morisot's most complete creation—a truly remarkable achievement—was the integration of her art with the rest of her life. I had first encountered her through her art; now I felt myself drawn, like a moth to a flame, to her elusive domestic realm. Little did I know that stepping into her world would take me out of the nineteenth century and bring me again into the twenty-first. Meeting Morisot "in person" meant entering the world of her modern-day descendants, and discovering how the present was connected to the past.

A FAMILY IDYLL

As my car sped northwest out of Paris toward Meulan, the location of Berthe Morisot and Eugène Manet's home, I was fearful that I would be disappointed again. What if—like the white mansion on the rue Franklin in Passy—the Château du Mesnil no longer existed? I had looked at the images in the book *Une famille dans l'impressionisme* (A family in Impressionism), written by Morisot's great-nephew Jean-Marie Rouart. There, Morisot's paintings and the photographs of Mesnil depict a rather grand but very inviting manor house; the photographs showing Morisot's family gathered together in front of the mansion made it seem even more livable and homey. To me, the Château du Mesnil seemed to symbolize Morisot's uncannily balanced professional and personal life.

As I drove through the suburban neighborhood of Meulan, my hopes began to fall. All the houses I passed were modern and utilitarian—without any character or spirit. Surely the Château du Mesnil could not be located in such an unimaginative environment. Just as I had begun to despair, I turned a corner and came upon an old brick wall that loomed up out of a field of poppies, and there on the left was a stately metal gate, which was open.

The Château du Mesnil was immediately recognizable, by the old square tower—the *pigeonnier*—to the right of the driveway, and by the noble stand of chestnut trees that rose straight ahead of me. As I got out of the car, I noticed a toy in the house's entryway: a small, yellow-and-red plastic truck that a child could ride. Its presence pleased me; it seemed to testify that the Château du Mesnil was still throbbing with family life.

From a farmhouse across the road, however, a woman came running, admonishing me for driving up to the house uninvited. This was, after all, private property—not

Monet's Giverny, or Cézanne's or Renoir's ateliers, all of which are open to the public. The Château du Mesnil is a private residence, and I was trespassing. The caretaker told me in great agitation that the property was owned by the Rouart family, and that I would need their permission to enter. I was amazed to discover that the Château du Mesnil had not left the hands of the Morisot/Manet/Rouart clan. I had found my way to the essential link to Morisot's home life. Never have I been so pleased to be evicted; I knew I would soon return to the place, and to the story of Berthe Morisot's family.

Back in Paris, I called Anne Higonnet directly, to ask whether she was acquainted with any of the Rouarts. She told me that all of her contacts had died; however, she did know of Yves Rouart—although she had never met him personally. After some effort (and with guidance from Anne), I made contact. Yves Rouart was delighted with my enthusiasm for the story of his great-grandmother, Berthe Morisot. He agreed to meet me at the Château du Mesnil.

Several months later, I made an appointment with Monsieur Rouart and returned to the château. A dark-haired, energetic man in his early sixties opened the front door and looked surprised to see a stranger. Although I had arrived at the time we had agreed upon a week earlier, it seemed that I had caught Yves Rouart and his family in the middle of Sunday lunch. (I would ordinarily have called to confirm on the morning of the appointment, but to be honest, I must have been afraid that he would change his mind, so I just appeared at his door.) Surrounded by his seven children and two small granddaughters, Monsieur Rouart, dressed in a faded T-shirt and jeans, apologized for having to neglect me while he returned to his family gathering. He showed me into the salon and asked me to wait there a short while.

I was quite relieved to be left alone to get my bearings. From the kitchen came the sounds of animated discussion in the voices of numerous youngsters. They were blithely living their daily lives, while I felt rather awkward—a stranger who had invited herself in. In tracking down historical personages, I'd always been able to interpret them as I wished—and was therefore quite comfortable with them, even the ill-mannered Cézanne and the tortured Van Gogh. Here was a *living* family, with their own preoccupations and concerns. Soon enough, however, I managed to relax a bit, reminding myself hopefully that my affection for Morisot and my curiosity about her would erase the gap of foreignness.

I looked around me in the grand living room, with its high ceiling edged by white plaster moldings. The walls were covered with paintings by artists I did not recognize.

Berthe Morisot, *The Cherry Pickers*, 1891

Neil Folberg, *The Cherry Tree in Berthe Morisot's Yard*, Château du Mesnil, 2003

I had hoped to see Morisot's portrait welcoming me, but there were no Morisots, nor Manets, nor Renoirs. It struck me, however, that these unrecognized paintings, which constituted the personal collection of the Rouart family, might serve even better than the iconic works to help me understand the history and tastes of this celebrated Impressionist clan.

When the family luncheon ended, many of the young people ambled outside to relax on the thick green carpet of grass shaded by old trees. Yves Rouart entered the salon and immediately recognized my interest in the surroundings; he gently guided me through each painting. Almost all of them had been painted by one member or another of the Morisot/ Manet/Rouart family.

High above the entranceway to the salon is a copy of a Rubens, painted by Yves's grandmother, Julie Manet. The walls of the study off the salon are filled with frescoes by Julie's husband, Ernest Rouart. In the latter's scenes, a white peacock, tail unfurled in full glory, struts under blue skies. Although he was no Edouard Manet, Ernest Rouart—who was, incidentally, Degas's only pupil—had unmistakable talent, but living among geniuses has its drawbacks, inevitable comparison being one of them. A portrait by Julie in the living room, of a woman wearing a skimmer hat, was obviously touched up by her mother: it is saturated with Morisot's signature blue, and has far more confidence and robustness than Julie's other works. I was reminded of Morisot's double portrait of her sister Edma and their mother, which Manet touched up. After much deliberation, Berthe submitted that painting to the Salon—and it was accepted—but she never felt that the full credit for the work was rightfully hers.

Things were going well with Yves. This very informal person, whom I hadn't met before and whose lunch I had interrupted, was now casually but very intentionally telling me stories of the family about which I had so long been curious. He seemed aware of the intensity of my curiosity, and deliberately included many interesting details. From the ground floor, we proceeded upstairs, where a corridor punctuated with airy windows runs the length of the manor: it is a perfect, light-filled picture

Neil Folberg, *Young Women,*
Château du Mesnil, 2003

gallery. The rooms off the opposite side of the corridor are also filled with pictures. In one of these bedrooms, Julie's turquoise-shaded depiction of Venice, with a gondola full of Rouarts, serves as a happy travel memento. An oil portrait of a young woman by Ernest Rouart rests on the wooden easel that was a gift from Edouard Manet to Berthe. The rooms seemed energized with the lives that had passed through them.

Propped up against a cabinet in one of the bedrooms is a portrait by Henri Rouart, the patriarch of the family, of his wife, Hélène Jacob-Desmalter. I learned through Yves that Henri Rouart was a remarkably gifted man: an industrialist with several important patents, a successful businessman, a noted art collector, and an artist—a student of Corot's—whose work was included in the 1874 Impressionist show at Nadar's studio. In his Paris home near the Gare Saint-Lazare, Henri Rouart filled the walls with works by Delacroix, Courbet, Corot, Degas, Manet, Renoir, Monet, and many other prescient choices. His critical eye was so exceptional that Degas took Henri Rouart's advice when gathering his own collection. At his death, Rouart's prestigious artworks were sold to avoid squabbling among the family; those family members who could afford to do so bought back the paintings they had grown up with.

Yves's cousin Jean-Marie Rouart (whose book on the family had led me to the Château du Mesnil) recalls the powerful emotions he experienced with some of the paintings in Morisot's home on the rue de Villejust. Manet's *Berthe Morisot with a Bouquet of Violets* particularly agitated Jean-Marie as a pubescent young man. (His confession is quite understandable: Manet's portraits of Morisot are certainly provocative in their way, even to those of us who are far from puberty.)

It was an extraordinary experience to find myself in these halls and rooms, confronted with the hallowed echoes of this place. I had spent such a long time with Berthe Morisot—through her work, and discovering her life—that there was something unreal about being in this house, with the flesh and blood of her relatives.

As Yves and I turned to retrace our steps down the long corridor to the wooden stairway, a young woman appeared from one of the rooms and came toward us. My heart gave a leap. She had exactly Morisot's dark hair and piercing eyes; it was as if Manet's

portrait of her with the bouquet of violets had come to life. Yves noted my astonishment, and seemed to realize what was going through my mind. It must have happened often: this was his daughter, Lucie Rouart, the image of her great-great-grandmother, Berthe Morisot. The resemblance is truly uncanny, but perhaps even more stunning is Lucie's presence, which echoes that of her ancestor precisely: confident and yet vulnerable, resolute and profoundly graceful.

Yves introduced us, and Lucie put me at ease at once by telling me about herself. She is a fashion designer, and during the course of our chat, she invited me to her atelier in Paris. I immediately accepted, happy for the opportunity to get to know her better.

A week later, I knocked at the door of Lucie's showroom-studio in Paris, near the Faubourg Saint-Honoré—a distinctly twenty-first-century space. Light flooded the corner storefront, which was stocked with young, stylish attire. In a back room lined with windows, Lucie's desk was covered with intriguing snippets of fabric and tissue designs. Thumbtacked to her punchboard for inspiration was a magazine tear sheet showing Henri Matisse's *Dancers*. (The new generations have, naturally, moved forward.) This was Lucie's creative hideaway.

We talked about life in Paris: Lucie told me that she was living with her boyfriend nearby, and she recommended a Chinese restaurant near the Palais Royale, which I assured her I would try. Down to earth and open, this charming young woman was very comfortable with her illustrious family, and happy to pursue her own identity. My tendency to see her as Berthe Morisot did not disturb her. Lucie enjoyed talking of how close the family is and how much love is shared by everyone. Surely the Château du Mesnil has much to do with this harmony: it is a refuge where they can all gather in comfort. How wise Morisot was to acquire this haven for her family!

NEW FRIENDS

Having enjoyed Yves Rouart's hospitable tour of the Château du Mesnil so thoroughly, I felt comfortable asking him for another favor. I longed to visit the house that Morisot and Eugène Manet had built in 1883 on the narrow rue de Villejust (now rue Paul Valéry). Yves was hesitant at first: his ninety-four-year-old mother, Victoria Rapin Rouart, was still living in that family home, and it was not easy to intrude on her. In the end, though, he agreed to accompany me to the Paris home.

It was night when Yves opened the door into the tall building just south of the Arc de Triomphe. A jovial caretaker met us at the base of the house's inner stairway. In the ground-floor apartment, we entered the high-ceilinged white salon-atelier

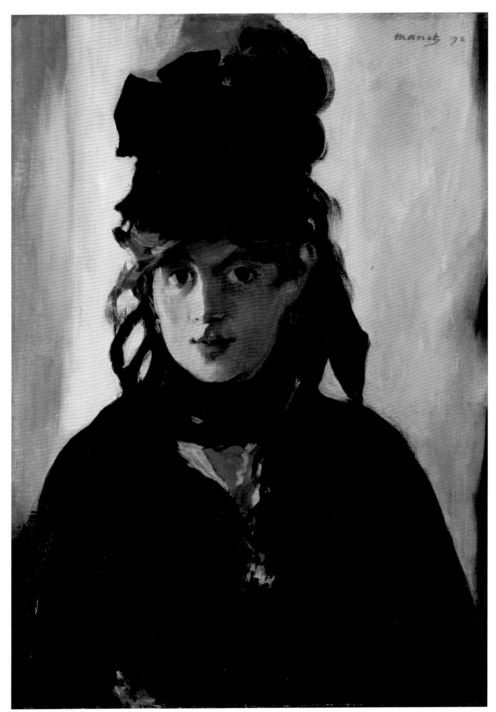

Edouard Manet, *Portrait of Berthe Morisot with a Bouquet of Violets*, 1872

Neil Folberg, *Lucie Rouart*
(after a portrait of Berthe
Morisot by Manet), Château
du Mesnil, 2003

where Berthe and Eugène had entertained Degas,
Mallarmé, Pissarro, Renoir, Manet, Monet, and other
figures of the vanguard. This was the very room where
the Impressionists gathered to exchange their burning
notions while enjoying superb meals, presided over by
Morisot (who had a penchant for exotic recipes). This
salon was much smaller than the one at the Château
du Mesnil; it seemed to me that it could barely have
contained all their explosive ideas. The room was now
extremely quiet, as if the storm had passed through and
spent itself.

I was grateful that Madame Rapin Rouart was asleep
upstairs and so would not be disturbed by our intrusion.
Still, I left a box of *marrons glacés* as a token of my appre-
ciation; I hoped the glazed chestnuts would please her
as much as they do me. Recognizing Ernest Rouart's
paintings on the walls, I felt as if I had now acquired a
degree of intimacy with the family.

Yves led me outside and down a stone path through
the small garden to an imposing three-story brick building with large floor-to-ceiling
windows that had served as Ernest Rouart's atelier (now a residential and commercial
rental space).

The rue de Villejust has been renamed rue Paul Valéry, after one of France's
most important poets—although Valéry only boarded for a time in this house (he
was married to Berthe's niece—a match that was made through Degas's auspices). I
find it perplexing that the street was not renamed for Morisot, one of the founders of
Impressionism, who, after all, *built* this house with her husband.

Some days later, at Yves's suggestion, I entered the Passy cemetery, not far from
the rue Paul Valéry, to visit Morisot's grave. Pausing just inside the entrance, I paid my
respects to Julie Manet and her husband, Ernest Rouart, who are also buried there, their
gray tombs effectively softened by a planter of large white chrysanthemums.

I wandered the winding paths until I spotted the dark bronze bust of Edouard Manet
atop a marble pillar. Berthe Morisot lies directly beneath it—literally buried at Manet's
feet. Unadorned, a horizontal expanse of dark cement proclaims the names "Berthe

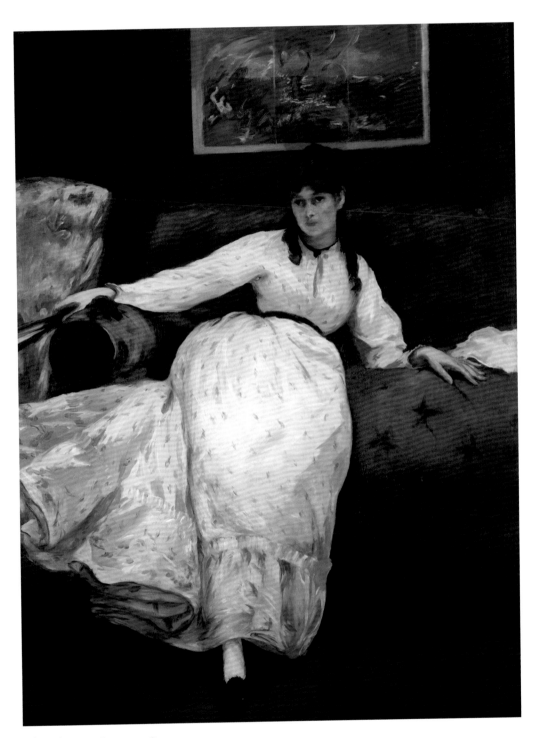

Edouard Manet, *Repose*, c. 1870–71

Morisot" and "Eugène Manet." There is no mention whatsoever of Morisot's seminal role in the Impressionist movement, no indication of her importance as an artist.

At the Château du Mesnil, I had noticed an imposing plaster bust of Morisot. It struck me that that rendering might have served her more justly as a funerary image, cast in bronze atop a marble column at least as tall as Manet's in the Passy cemetery. Indeed, after Morisot's death, there was a proposal to place that particular rendering upon her grave, but—perhaps because it all too honestly reveals Berthe's strong personality—her daughter prevented its public display. Even after Morisot's death, Julie was, it seems, perpetuating her mother's ruse, making sure not to taint Morisot's "proper" image.

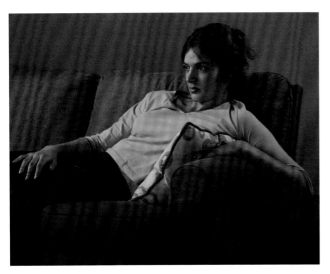

Neil Folberg, *Repose* (after portraits of Berthe Morisot by Manet), 2002

It was difficult for me to understand why there should still be any need for subterfuge. In France, however, some things change very slowly. The artist and critic Arnaud d'Hauterives, in his introduction to the book *Berthe Morisot, or Reasoned Audacity*, recalls reading a text on Morisot written by her grandson Denis Rouart. D'Hauterives confesses: "In its time, this book surprised me because it was devoted to a woman painter, and I believed that painting was only a man's affair." This rather unforgivable admission was made at the late date of 2002—and by a man who holds the lofty title "Sécretaire perpétual de l'Académie des Beaux Arts" (Secretary of the Academy of Fine Arts, in perpetuity). I began to understand the hidebound mentality that Morisot was forced to circumvent in order to realize her visions.

Encouragingly, though, also in 2002, France finally decided to present a retrospective of Morisot's work. More than a century earlier, her colleagues Degas, Monet, and Renoir had freely acknowledged her contribution in an exhibition of no fewer than four hundred paintings at Durand-Ruel's gallery, on the occasion of the first anniversary of her death. In the 2002 retrospective in Lille, the French government presented 125 of her paintings and watercolors, chosen from the eight hundred or so that had comprised her life's work. Walking from room to room of that exhibition, I pursued the emblematic Morisot blue, while breathing in the rich fragrance of her delicate but vibrant touch. Comprising works gathered from all parts of the world, many privately owned, the show permitted me to discover paintings I may never see

again. Other spectators were equally appreciative; the positive coverage in a French newspaper thrilled Anne Higonnet and convinced both of us that Morisot's star would at last ascend above the French cultural horizon.

Some time later, as I continued my investigation into Morisot's life and family, Yves Rouart invited me to meet him at Paris's Musée de la Vie Romantique, to see the exhibition *Au coeur de l'impressionisme: La Famille Rouart* (At the heart of Impressionism: The Rouart family). The small museum, located on a narrow street in Montmartre, was crowded and bustling. With quiet pride, Yves steered me through the show. There were works by Corot, Renoir, Manet, Degas, Delacroix, and many others—paintings that had once been a part of the vast collection of Henri Rouart. At least seven Morisots were there, including the beautiful 1883 *Eugène Manet and his Daughter in the Garden of Bougival*.

I recognized some of the pictures that had been hanging at the Château du Mesnil, and there were many more modern paintings that were new to me. A number of these were painted by Yves's uncle Augustin Rouart (Jean-Marie's father), in the Nabi style. Augustin Rouart had been somewhat eccentric in that, although he devoted his life to painting, he never once exhibited his work. In addition, he was quick to spend any money that came his way, and consequently Jean-Marie grew up poor in the midst of the wealthy Morisot/Manet/Rouart clan.

Yves suggested that I could gain a more intimate look at this complicated family history by reading Jean-Marie's book *Une jeunesse à l'ombre de la lumière* (Youth in the shadow of light), and offered to introduce me to the author. As I was already familiar with Jean-Marie's *Une famille dans l'impressionisme*, I was eager to have a look at the volume and meet him. *Jeunesse* did not exist in English yet, so I immediately set out to have it translated. I received the English version a few days before Yves, Jean-Marie, and I were to meet for lunch. As soon as I opened it, I was enthralled; I could not put it down until I had finished.

Jean-Marie is a member of the Académie Française, and so I had somehow expected his book to be very intellectual, or impenetrably academic. I was pleased and surprised to find it passionate and romantic instead. Through his writing, Jean-Marie opened the doors of Villejust and Mesnil, just as his cousin Yves had done, and revealed a world that I had not at all anticipated. What I had found so stimulating—the venerable family, so

overflowing with creative talents—Jean-Marie often found suffocating. He took refuge from the family's blinding "*lumière*" in writing.

Of the Château du Mesnil, Jean-Marie relates that the Rouarts used it for weekend gatherings:

> Saturdays and Sundays this world of painters and gay revelers, along with their permissive relatives, went off to the Château du Mesnil. . . . It was a splendid castle, with outbuildings covered with woodbine.
>
> In the distance, I could see the tall towers and concrete structures of the Poliet and Chausson factory. It was the threatening presence of modern times. I thought that house, which had been one of the high places of Impressionism, which still had a certain refined and old-fashioned charm, was like Venice before Mestre, a sort of vestige of an exceptional time destined to disappear.

Although Jean-Marie might have found the grandeur of his family's history something of a burden, he did not turn his back *entirely* on art. I learned through his book that when he and Yves were young, they used the family's artistic treasures to lure girls out to Ernest Rouart's studio, where they would dance irreverently to the beat of Ray Charles records!

After reading his memoir, I was very much looking forward to meeting Jean-Marie Rouart. At our lunch with Yves, I found Jean-Marie to be gentler, more congenial, than I had expected him to be. He resembles Yves, but his eyes have the particular sparkle of someone who has come to terms with his shadows and pokes fun at them. When I handed Jean-Marie the English version of his book, he seemed astonished, as if I had given him a treasure. My enthusiasm for his story made our first meeting celebratory.

I was intrigued by his affiliation with the Académie Française—the venerated guardians of the integrity of French traditions and language. Its forty elected members are known as nothing less than *immortels* (immortals), and serve the Académie for life. To me, it seems the perfect symbol of French deference to time-honored customs. I asked Jean-Marie if they wear robes at their ceremonies. His reaction was one of delight: he said that yes, it is one of the last vestiges of tradition. He informed me that the Académie was to have a ceremony in just a few weeks' time, and asked if I would be interested in attending. Of course, I said I would.

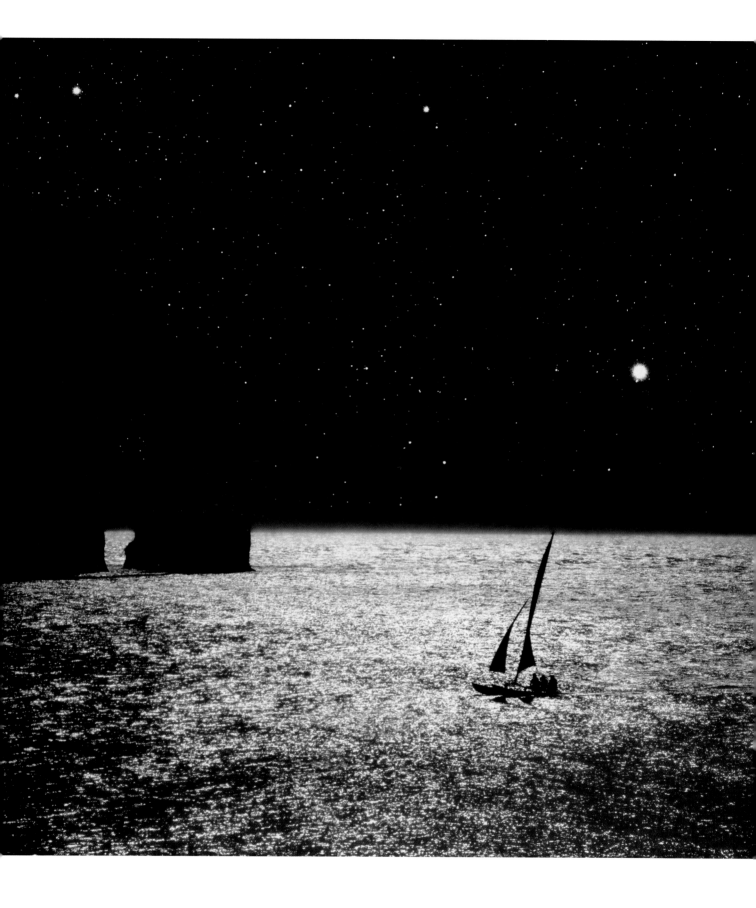

Journey's End

DOUBLY BLESSED

Yves Rouart shepherded me into the domed white edifice of the Académie Française on the Left Bank and sat next to me. The building houses the Académie des Lettres as well as the Académie des Beaux-Arts: it was here that the fate of the Impressionists was decided. The governing body for the Salon, which had held the artists in its vise-like grip for so many years, had been located in this very building. And here I was, with Berthe Morisot's proud descendants. I felt as if we were treading triumphantly on ground that had seen its share of ancient battles.

After the ceremony, which was filled with pomp and gold filigree, Yves translated the keynote speech for me. The gist was this: in order to preserve the purity of the French language, the members of the Académie—and everyone else in France—should communicate only in French, in all affairs, including all economic and business transactions. The Académie's longtime role as guardian of *la langue française* is well known, but I was nonetheless surprised that anyone could still make such an argument, which seems to me somewhat arcane in this day and age. I found it almost amusing that now, nearly one hundred fifty years after the Impressionists refused to abide by the Salon's stodgy rules, the Académie still holds on to such outmoded mandates.

Change, it seems, does not always come easily.

Later that evening, craving the comfort of a home base, I retreated to a corner in the garden courtyard of my hotel, the Four Seasons/George V. There, sipping a *kir royale*, I mulled over the puzzle of recent experiences, and found my mind wandering. The hotel's fantastic flower arrangements seemed a contemporary answer to Monet's palette. And the thought of Monet drew my mind to what was irking me.

The issue of French traditionalism is complex. I am all for moving forward—but am also aware that a certain intractability, though sometimes frustrating, also protects much that I treasure in France. I know that during my ritual visits to the Auberge Ravoux in Auvers-sur-Oise, I will find the white lace curtains in place, and the menu will offer *œufs en meurette*, just as they were offered to Van Gogh. I rest assured that Monet's water-lily ponds are—and always will be—safely ensconced at Paris's Orangerie, and that I will

Neil Folberg, *Etretat and Arcturus*, Normandy, 2003

be able to visit Morisot's self-portrait at the Musée Marmottan Monet whenever I wish. The essential culture of France is still an irresistible magnet, filling Haussmann's streets with a thriving international throng . . . a throng that includes me.

Still, I hope that Pissarro's last home and atelier in Eragny, undisturbed for more than a hundred years, will eventually become a special place of honor for the artist, as the Auberge Ravoux now is for Van Gogh. In addition to his artistic genius, it was Pissarro's generosity that assured that the Impressionists would survive. When he came to Durand-Ruel with Monet, asking the dealer to accept the work of Degas and Renoir, Durand-Ruel was astonished at their magnanimous spirit, which he rightly predicted would bring the Impressionists eventual success.

But even Durand-Ruel had no idea how powerful the group's support was for one another. Renoir admitted that he would have given up if he hadn't been encouraged by Monet's indomitable spirit; painting with Monet not only spurred him on, but also influenced his art. In turn, Renoir's friendship with the prickly Cézanne bolstered Cézanne at a time when virtually no one yet understood his genius. Pissarro, painting alongside Cézanne, Monet, Renoir, Van Gogh, and Gauguin, too, encouraged them all to forge ahead in the new style. And of course the works of Manet and Morisot developed side by side with many mutual influences as well. Visionary that he was, though, Durand-Ruel could not have foreseen how popular these artists would eventually become. Reproductions of Van Gogh's sunflowers and Monet's water lilies have multiplied to global profusion, as the prices for the originals have reached astronomical heights (and incidentally: rarely have the transactions been negotiated in French!). I suppose for these artists, there has been some vindication after all.

In the courtyard of the George V, I pulled my wrap closer against the damp night air, unwilling to leave this garden. My thoughts turned to Morisot's growing success, and I felt grateful that her descendants Yves and Jean-Marie had enabled me to know more about who she really was. Just as Degas had extended his hand in professional friendship and support to Morisot, so, too, had Yves and Jean-Marie befriended me.

I derive the greatest satisfaction watching France's burgeoning reverence for Morisot. Her brilliant contemporaries recognized her talent early, sponsoring the retrospective of her work just a year after her death. It is at last becoming clear to even the most conservative that Morisot was one of the shining lights of her time—as well as one of the most courageous, achieving her professional success without sacrificing her personal values or family.

My journey in pursuit of these great artists has educated me and enriched me culturally, but I am certainly not an academic, nor am I a critic. Their creations have made me an art lover—an *amateur*, in the French sense of the word—impassioned and enchanted. At heart, though, I am simply a curious traveler. What moves me most are the touching relationships of the human beings who created these paintings through helping one another.

As I sat in the Paris night with my thoughts, I did not feel alone.

These beneficent creators have permitted me to bestow a gift of my own. Our trip through France had a very surprising effect on my granddaughter Sarah. Standing on the same ground as Cézanne when he painted Mont Sainte-Victoire, leaning over to smell a yellow rose in Monet's garden, walking in Van Gogh's footsteps at the Saint-Rémy asylum, and then entering the room where he died in Auvers stimulated Sarah's sensibilities toward art. As I write, only a few years after that visit, she has decided to devote herself to supporting the work of emerging young artists. I am certain that our trip was one of the chief turning points for Sarah.

As for myself, there are a number of beautiful personal and familial ironies. My serendipitous first visit to Auvers-sur-Oise launched my journey with the Impressionists. I began this journey while mourning my husband's death: my world was gray; I felt sapped of energy and joy. As the Impressionists' compelling story unfolded, I was moved by their plight and by their ability to triumph through mutual support—always magnanimous, and often noble.

I now realize why this special aspect of their story moved me so deeply. In my own work with NFAA's youngARTS program, I have observed sadly that, at their schools, budding artists are often looked at as oddballs, or even become outcasts. The Impressionists had the same experience. I am filled with empathy for both groups, and understand the vital importance of their friendships and encouragement of one another.

On that Paris evening, as my journey was drawing to a close, I considered those young American artists, and yearned to go back to the United States to renew my work with them—to assure them of their rightful place in the world, to help them understand that they have a community of like-minded peers.

For twenty-six years now, the youngARTS program has gone into high schools throughout the United States to locate gifted young dancers, visual artists, writers, musicians, actors, filmmakers, and photographers. The artists are encouraged with financial support, but also—and I think just as importantly—by being brought together

each January, for what we call "ARTS Week" in Miami. Their time together is crucial: it shows these young people that they are not alone and that they are by no means odd! On the contrary, they are outstandingly talented—so talented, in fact, that each June, twenty of them are named Presidential Scholars. They travel to Washington, D.C., where they are awarded gold medallions by the President of the United States—and as they receive them, they stand proudly alongside the young mathematicians, scientists, and representatives of other disciplines. It is a true confirmation of both the importance and the absolute legitimacy of art in America.

I thought again of Van Gogh and the Impressionists: of the obstacles they faced, and the years it took for the value of their achievements to be acknowledged. I thought of my husband, Ted, and the love and integrity he brought to all his endeavors—not least the founding of this wonderful program to help young artists circumvent some of the difficulties they might otherwise face.

I felt a new energy welling in me: with my granddaughter's help, I would work to let the world know about these gifted young people.

And today, Sarah and I have a mission. The youngARTS program is stronger than ever, but we want to make it much more visible, to get the word out everywhere, so that when a youngster wins the youngARTS Award, he or she will be instantly recognized as a shining star. We want this award to be a kind of Heisman Trophy for young artists, to help them on the path to success.

I have Van Gogh and the Impressionists to thank for bringing me here.

Normally, for me, travel has many sweet pleasures and lasting rewards—one of the principal joys being that my responsibilities lie elsewhere. Sometimes, with good fortune, the discoveries of the journey can be treasured in one's daily life of home, family, cares, and concerns. This time, the journey turned my gray world into glorious colors.

As I left the chill of the evening garden for the warmth of my room at the George V, I contemplated packing for my return home, where, with renewed vigor, I would embrace the challenges that await me.

France had been so generous: Van Gogh, Pissarro, Monet, Renoir, Cézanne, Degas, Manet, and Morisot were there to accompany me now. The Impressionists had entered my life to provide the most fundamental definition of beauty, and such impressions can last a lifetime. As a traveler, I was doubly blessed.

A Gathering of Artists

PHOTOGRAPHS

CAMILLE PISSARRO

159　*Camille Pissarro*

163 *Camille Pissarro*

PAUL CÉZANNE

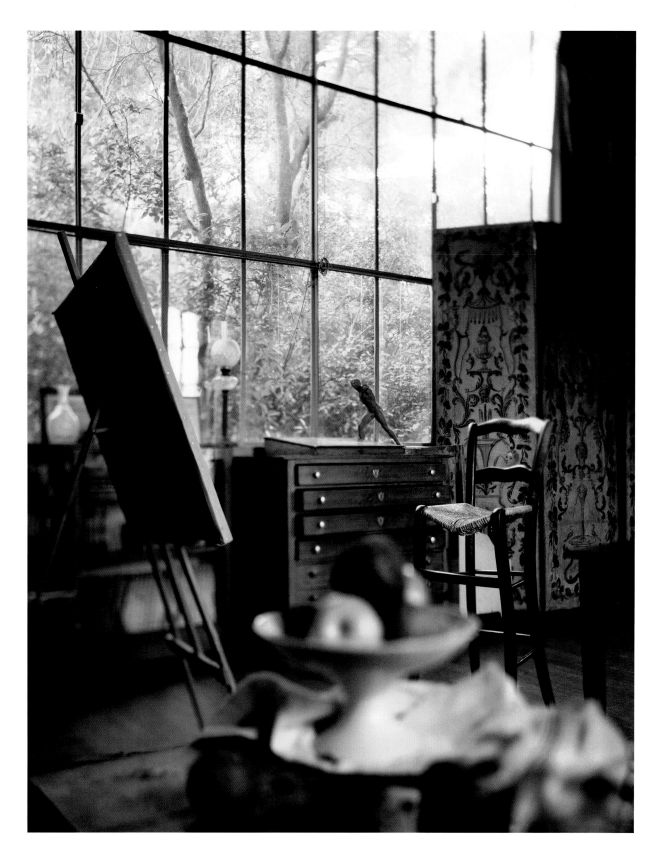

171 *Paul Cézanne*

173 *Paul Cézanne*

175 *Paul Cézanne*

CLAUDE MONET

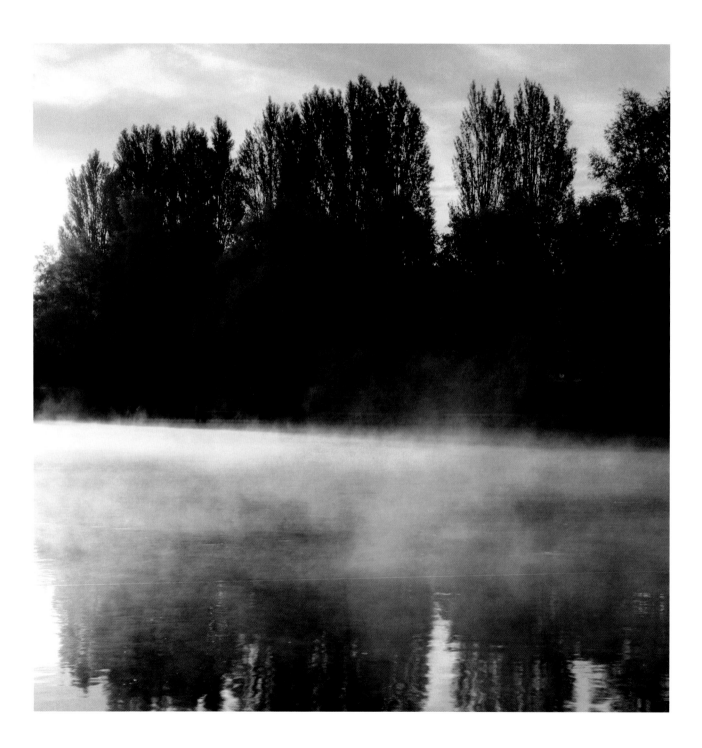

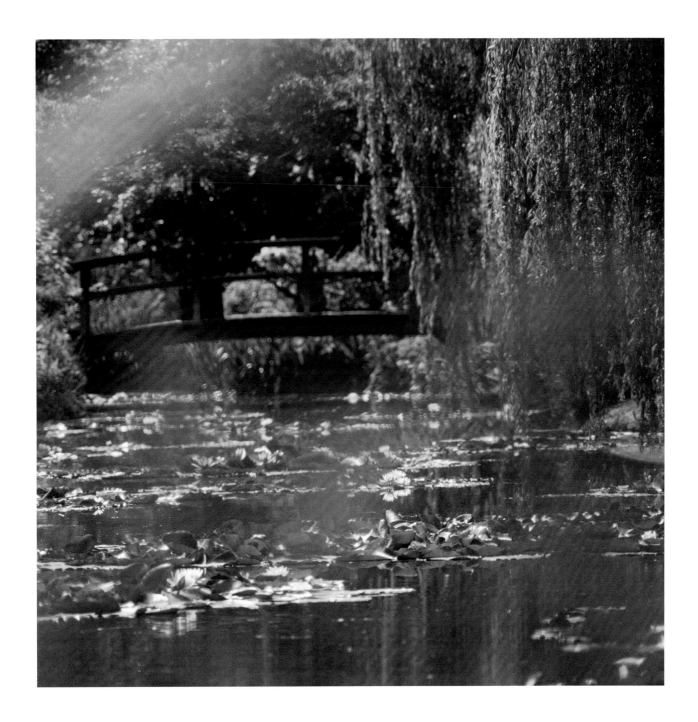

181　*Claude Monet*

183 *Claude Monet*

EDOUARD MANET

191 *Edouard Manet*

BERTHE MORISOT

203 *Berthe Morisot*

205 *Berthe Morisot*

PIERRE-AUGUSTE RENOIR

211 *Pierre-Auguste Renoir*

EDGAR DEGAS

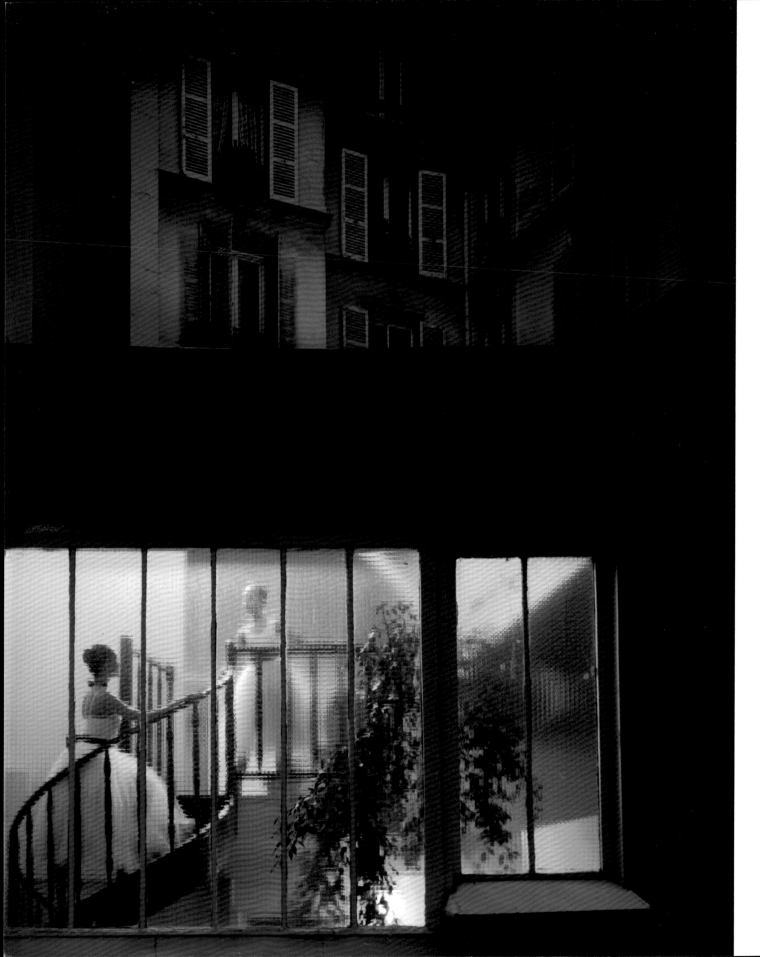

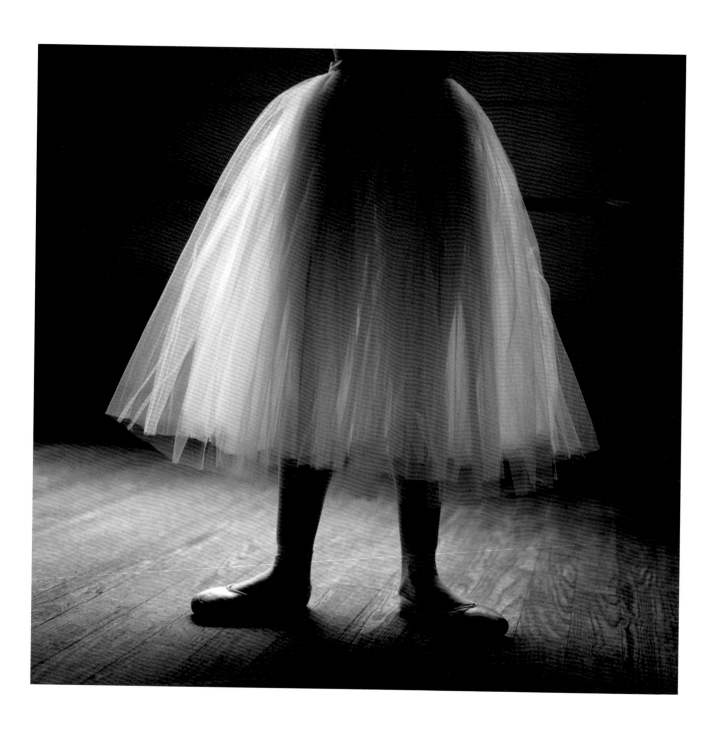

227 *Edgar Degas*

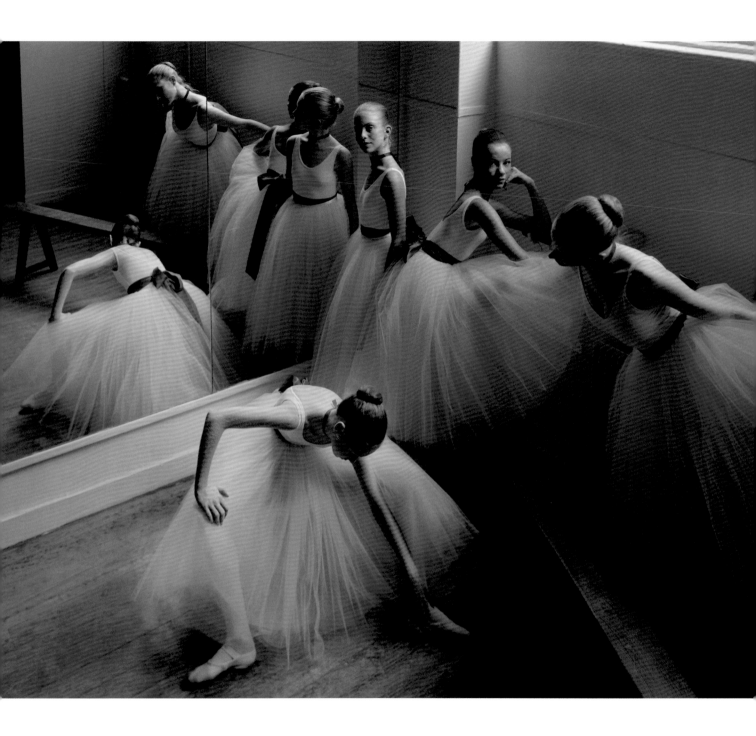

229 *Edgar Degas*

VINCENT VAN GOGH

235 *Vincent van Gogh*

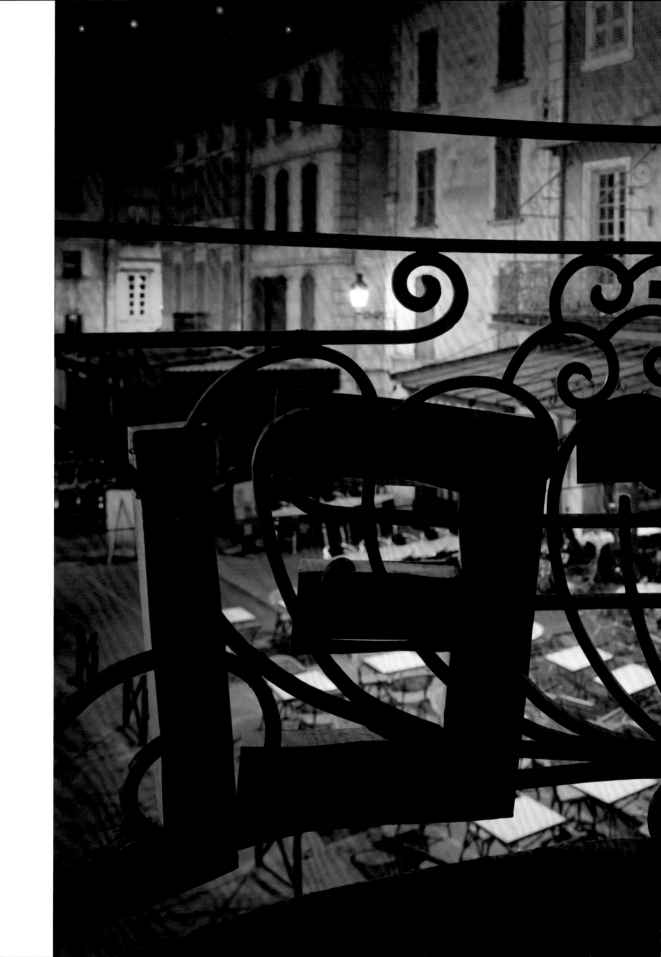

239 *Vincent van Gogh*

243 *Vincent van Gogh*

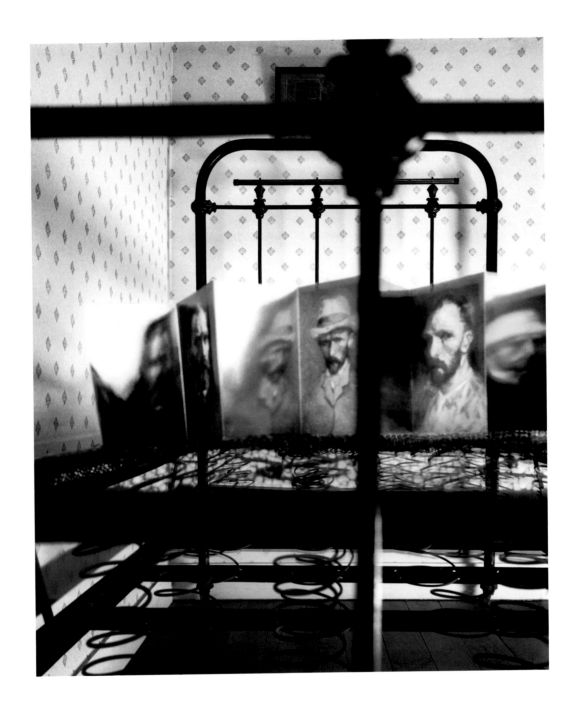

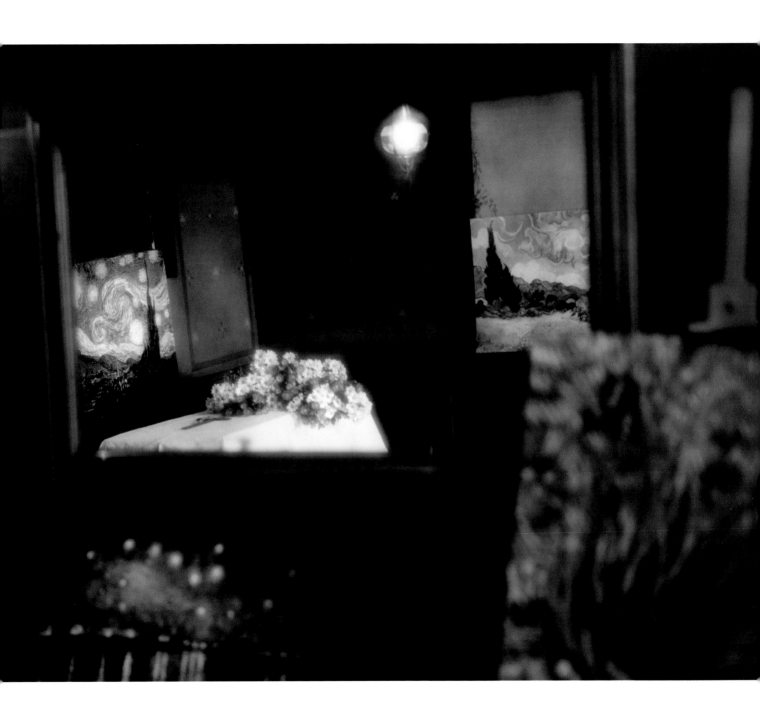

247 *Vincent van Gogh*

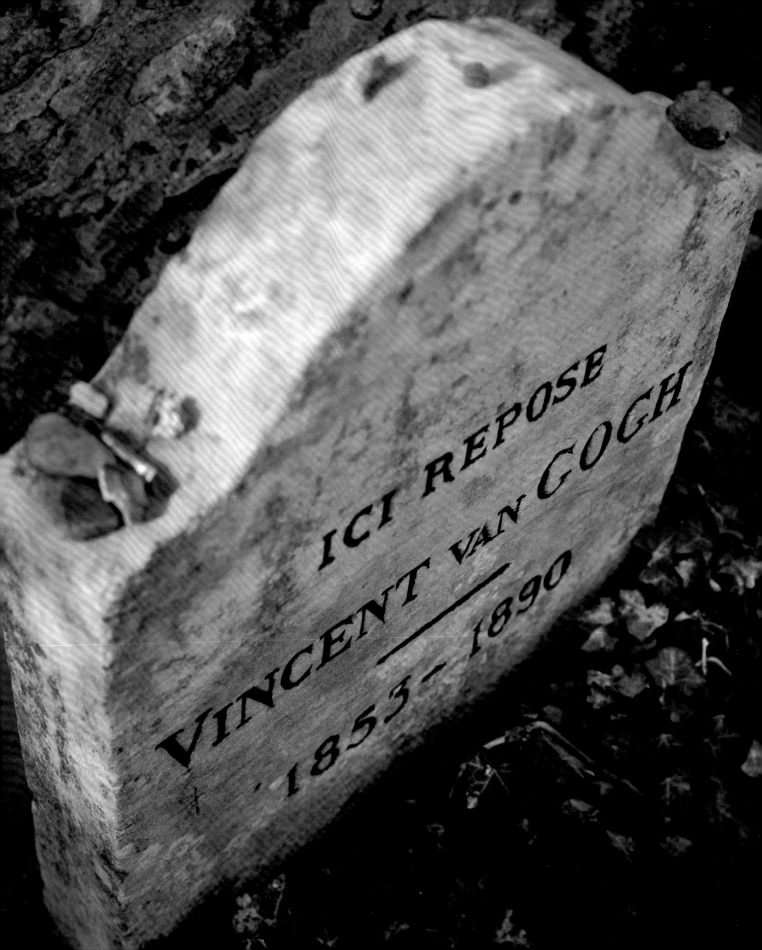

BY NEIL FOLBERG

CAMILLE PISSARRO

Pissarro was in many ways the "father figure" of the Impressionists: a precursor and champion of their work who had a strong rapport with most of the painters in the group. He had an extraordinarily keen eye for landscapes; his are often characterized by evocative roads and paths meandering between village and market town, gentle hills crowned by rows of trees, village scenes, quiet and dramatic skies. Early in his career, Pissarro supplemented his income by painting skies for other artists. The sky is the key in every landscape photograph I have made: it defines the horizon toward which we journey, and it determines the light that falls on the land as well.

Pissarro's was a direct gaze that did not romanticize. He took in the beauty of the French landscape along with the difficult life of the peasants who worked the land. Perhaps that is what is missing today and what makes it such a struggle to replicate the feel of Pissarro's landscape paintings: the hardness is gone; life seems easier. What remains is merely the charm of the countryside (where it's not yet spoiled). Today, it seems perhaps even a little too pretty: a landscape photograph made in the manner of Pissarro can easily have the simplistic feel of a picture postcard. It is pleasurable and beguiling, but lacks the depth of his paintings.

As a photographer who has spent many years making images of the wilderness, I was both charmed and somehow repelled by the very civilized river landscapes around Pontoise and Auvers-sur-Oise. Traveling through Pissarro's landscapes, I was always looking for a way to approach them that would capture the feel of his paintings, in which, it seems to me, the earth has the loudest voice.

So it was with some relief that I arrived with Lin at Pissarro's last home and atelier in Eragny-sur-Epte, where the beauty of the surroundings was less overt, and needed some coaxing out. Our guide and driver for much of this project was Laurent Olive, a delightful and brilliant man who doubled (not incidentally) as a psychoanalyst. He easily managed to charm Mireille Sutter, the woman who now owns the property; she opened the door to him and soon found herself receiving our entire entourage. As she showed us around the house, I quickly set up my equipment to photograph Pissarro's old atelier through the ancient glass of the window that looked out on the backyard. Eventually, Madame Sutter, Lin, and Laurent decided to go out for the standard two-hour lunch (a tradition for which I have little patience, especially when I'm working). I was left to explore and photograph the grounds and atelier peacefully on my own. By the time the group returned, I felt I had entered Pissarro's world; it was easier now for me to see this gentle land through his eyes and through his studio window, which seemed to frame the orchards beyond perfectly.

Driving through the countryside, I was constantly on the lookout for the combination of the right site and distribution of elements that characterize Pissarro's paintings. In his work, there is often an element in the foreground—perhaps a road or a vehicle—that invites the viewer into the composition, and the horizon line beckons in the distance under a sky glistening with clouds. I see in Pissarro's paintings a human approach to landscape: an open door, an extended hand.

PAUL CÉZANNE

Cézanne's studio near Aix-en-Provence is maintained today as if he were still working there. There are no plaques or signs announcing where you are or what you're looking at, and everything is pleasantly disordered. The studio contains many of the objects Cézanne used in his still lifes, and his cap and coat still hang there—a bit stiff and heavy with the years that have passed. There is truly a sense that the artist has just left the atelier and may come back at any moment.

On my first visit, I realized immediately that this was the correct place to start my exploration of Cézanne, and so I asked the curators for permission to come back with my lighting equipment and make photographs, for a period of several days or more. One of the many things I loved about the French throughout my work on this project was that they always seemed to reciprocate my seriousness of purpose and interest. Here—despite their initial pronouncements that I could touch nothing, that I could never work without a curator or guard present, that I had to leave when they went for lunch, and so on—the attendants kept an eye on me for about an hour and never troubled me again with rules and regulations. Once they saw that I truly cared for the subject, they were eager to help, providing information, taking me to visit the *sites cézanniens*, and pulling out John Rewald's lovely photographs of those same sites from the 1930s.

It was during one of these excursions, with Christine de la Forêt, a curator from the atelier, that I experienced a breakthrough. We were visiting the spot on the Arc River where Cézanne had played in his childhood, and where he later found inspiration for his series of Bathers. While I was photographing the play of dappled light on the path along the river, Christine walked into the frame—and everything about the image was changed. I suddenly knew that I could no longer avoid making photographs of people for this series.

I had never considered portraiture my strength; in fact, I had hardly touched it and was frankly somewhat afraid of it. I was very reluctant to start working with models and lights in a studio setting, yet it was clear that staging carefully arranged portraits would be an absolute necessity if I wanted to approach the work of Renoir, Manet, and Morisot in contemporary photographs. I marked this down in my notes, and mulled over the idea, as we continued our explorations, to the quarry at Bibemus where Cézanne painted his *Rocher Rouge* (among other scenes), and to the Pont des Trois Sautets.

When I returned to Cézanne's atelier, I carefully arranged onions and apples on one his worktables, a white cloth draped over the edge of the surface—trying to make a still life in the fashion of the artist—and then photographed it in black and white from above, as if I had walked in when Cézanne was working.

I followed the roads he had taken around Aix and spent a couple days walking around and up to the summit of Mont Sainte-Victoire. I don't know if Cézanne ever took that particular hike—he seems to have painted the mountain only from a distance—but I felt I needed to internalize the landscape that he knew so intimately, to make it my own somehow. I finally depicted the mountain from afar, as Cézanne did, for it is only from a distance that it takes on the sculptural look it has in his paintings, with the limestone cliffs rising above the land. Though one can easily recognize from the artworks the viewpoints from which Cézanne painted, he translated the landscape's form to accommodate the geometry of his mind. A photograph, unmanipulated, can never feel the same as his paintings. My photograph of the same subject is in this case more record than reinterpretation.

I found it relatively easy to call up Cézanne's spirit in the studio he left behind and along the water near Aix. The other artists in this series would require a different kind of effort from me. Still, the sense of kinship I felt with the work of Cézanne provided a wonderful moving-off point for the work to come.

CLAUDE MONET

When I first began making this series of photographs, I was certain that the color range of available photographic papers was incapable of recording the Impressionist palette in a worthy manner. I had for many years used a particularly expensive, proprietary four-color carbon-pigment process that

was produced by only one lab in the United States, and that lab had closed its doors. Their standard had spoiled me and I was not prepared to compromise now, when color was more important than ever. So—surprising even myself—I initially decided to explore the Impressionists through black-and-white photography.

Who could present more of a challenge to this approach than Monet, whose work *is* color in its purest form? I knew, though, that Monet was also profoundly interested in the ephemeral effects of light and atmosphere, of capturing the fleeting but transcendent moment that leaves a lasting impression. I sought these effects in some of the places where he had found them: on the Seine near the village of Vétheuil where Monet lived with his wife Camille, and of course in the landscape he created to delight himself at Giverny.

I wandered early one morning along the river in Vétheuil. There was a mist hovering over the water, blowing lightly in the wind, obscuring just a bit the landscape beyond and the trees on the other bank. I made a photograph, and soon a resident of a nearby home came to tell me two important things: first, that there was poison ivy along the river; and second, that Monet, who had lived some meters from where I was standing, had also depicted the river. The man's name was Stéfan Petit Halgatte, and we talked for a while on his patio overlooking the river. Little did I know how helpful Stéfan would prove to be nearly two years later, when I would find myself challenged by Renoir.

Within a few months, I gave up the notion of working with the Impressionists without color. There were many reasons for my change of heart, but chief among them were that it was simply too limiting, and that color had been so vitally important to them.

Photography in their era was of course only black and white, but today the medium can do so much more. In fact, new technologies were developing even as I worked on this project. I saw samples of photographs made with ink-jet printers that used pigment dyes to create long-lasting prints of exquisite color and depth. I ordered the newest large-format printer, and within a few weeks was making prints that rivaled those made with my beloved lost carbon-pigment process. Technology had moved

forward just as I needed it—in a way, as the Impressionist painters were propelled forward in their work by the advent of the railroads, allowing them to travel to the countryside at will, and by prepared oil paints that came in tubes and allowed them to paint on location.

On my next visit to Giverny, I felt as if color had just been discovered.

Somewhat later, near Gardanne, I saw a cloud of smoke rising from the chimney of a power plant, backlit by the setting sun, and it brought to mind Monet's steam train standing in the Gare Saint-Lazare. It seemed to me that this was a subject Monet would have been attracted to: the industrialization of the French countryside, depicted in a context that is neither negative nor positive, allowing the beauty of the moment to impart its reddish glow to the scene.

It was Monet who finally turned me to work in my studio, to make a photograph of a young woman in Japanese dress—after his playful painting of Camille in Japanese costume, complete with a fan. This was among the first of many staged photographs in this series that involved people.

EDOUARD MANET

I was at the Musée Marmottan Monet with Lin. Standing in the corridor, I fixed my gaze first on Manet's 1873 portrait of Berthe Morisot, and then on Morisot's 1885 self-portrait. Manet's painting is intensely sensual, and I found it almost impossible to take my eyes off it: the directness of Morisot's gaze and the rich, dark tonality are mesmerizing. Morisot's self-portrait reveals an older woman, with the intense look of an artist who is questioning the purpose of her work, but is nevertheless determined to pursue her calling. I looked back and forth between the two paintings, transfixed. I called Lin to look also—but of course, she had already discovered this spot in the corridor, for the same reason, on previous visits to the museum.

To evoke Manet through photographs was perhaps the greatest challenge for me. He was an unparalleled master of portraiture, of the gaze that pins the viewer right to the spot—

and again, portraits were something I had barely experimented with. Manet had left no studio behind, nor had he taken a great interest in landscape, the genre in which I had always felt most comfortable. So I was forced to come to grips with something new. I could no longer rely on the semi-documentary approach I'd adopted up until this point. I would have to deal with portraiture itself.

As I studied Manet's works, it was clear to me that the most interesting portraits were those of Morisot. There is so much tension, so much drama in them. They were very unlike, for example, the fleshy women of Renoir, who I felt lacked soul and individuality. Here is a woman with absolute presence— even through the painting's sensuousness, she emerges as a very powerful individual, easily Manet's equal, with challenge in her eyes.

I decided to evoke Manet's style in contemporary settings, and to conjure up what might be called the "psychological narrative" of his scenes and characters. I focused here on the relationship between painter and subject—specifically, between Manet and his subject and colleague (and later sister-in-law), Morisot.

Manet's famous 1868 *The Balcony* (which includes Morisot as a model) was made from an exterior perspective, looking at three people at a window, with a young boy deep in the interior of the room behind them, setting down a silver tray. I've created a continuation of Manet's story: a scene inside the room after the tray has been set, followed by an image titled *Don't Leave!*—the sequel, as it were, to the balcony scene: what might have happened after the moment shown in the painting.

Repose, a photograph of a young woman reclining, was inspired by several of Manet's portraits of Morisot. (The pose and attitude are also not far from that of his provocative 1863 odalisque *Olympia*.) Several of the photographs in this group were made at Morisot's country home on the outskirts of Juziers in Mesnil, including the portrait of Lucie Rouart, Morisot's great-great-granddaughter, after Manet's definitive *Portrait of Berthe Morisot with a Bouquet of Violets*.

BERTHE MORISOT

It was clear to me that the Château du Mesnil was the key not only to Morisot but to a more personal approach in this whole project. I saw that the house and yard would be suitable for staging a series of photographs in an evocative, authentic setting, and that including some of Morisot's family in the photographs would be a logical reflection of her own work, which was so focused upon home and family.

Lin and I set about contacting Yves Rouart, Berthe's great-grandson, in Paris. Once Lin had broken the ice, I went out to Mesnil to meet Yves and his family when they were there for a weekend, and made a few photographs on the spot. The house was full and lively: the bohemian spirit that had inspired Morisot has apparently been bequeathed to her descendants.

Two little girls were busy playing, and they posed for me as if they had been modeling every day of their lives for foreign photographers who lugged around enormous cameras and lighting equipment. They could not have been more natural. No one was annoyed or surprised to have me wandering around in the garden and interior—in fact, no one paid the slightest attention to me, other than to offer drinks. I had the feeling that had I wanted to remain there for a few days it would have been fine.

The French (and Parisians in particular) have a bad name among certain Americans, who have typecast them as somewhat impatient and unfriendly. In my own experience, though, the French are extraordinarily kind and generous. Yves Rouart was a perfect example of French hospitality: once he had an idea of our project, he agreed to lend us his home at Mesnil for a week, so that I could take my time making the kind of photographs I wanted. This was neither the first time nor the last that someone in France whom I barely knew would hand me the keys to his house.

And so I would re-create Morisot's world in her environment, at this house where she lived with her husband, Eugène Manet. I had the opportunity to work with some of her descendants—including a session with Lucie Rouart—and we hired models as well for our days of work at Mesnil. Morisot had depicted in her paintings mostly the world of women and

girls, and I followed her lead. As a male artist, I was challenged to avoid the kind of patent sensuality that the "male gaze" so often imparts to the female subject; I tried instead to evoke the self-awareness, introspection, and depth of character with which Morisot's subjects are portrayed.

Her well-known 1891 painting *The Cherry Pickers* finds an echo in my depiction of young women picking cherries from the tree in the yard—although my viewpoint is distinctly photographic (a painter would find it difficult to work from such a high perch in the cherry tree). In the house, a young woman brushes her hair while gazing in the mirror in Morisot's bedroom—a treatment very close to her *Before the Mirror* (1893), which had captivated me with its palette and light. The young women posing in the bedroom seem to have the same air of self-absorption that we see in many of Morisot's portraits of women and girls. And there are Morisot's own great-great-great-granddaughters, seated in a pose and setting reminiscent of one of her paintings.

As with the Manet series, the Morisot-inspired works take a narrative turn, as seen in the photographs of a little girl near her playhouse, being called to a Sunday afternoon party on a porch overlooking the Seine. The cast of characters in these two images was continued in my version of Renoir's *Luncheon of the Boating Party*—serving as a symbol of the personal friendship between Morisot and Renoir.

PIERRE-AUGUSTE RENOIR

I came to know Renoir toward the end of his life, since he had left the most visible signs of his presence among the olive trees on a hillside in Cagnes-sur-Mer, in the South of France, where he lived out his last years.

Lin and I had spent some time early in our travels walking among the now-crowded lanes of Montmartre in Paris, where Renoir had lived for a time in his youth; we had even visited his former home. But it was hard for me to integrate his personality and his paintings with that place—difficult to imagine that the cobbled streets of Montmartre were once almost bucolic lanes—and to conjure up an image of him there.

It was far easier for me to picture him among the olive groves in a place still filled with light and air, as Renoir's paintings are. His landscapes burst with light and color, and his portraits glow with the warmth of real flesh.

A simple experiment sufficed to demonstrate that it would not be simple to attain the depth of Renoir's flesh tones in a photograph. Standing as close as I could to one of his portraits, I made a little square frame with my fingers, and used that frame to isolate a section of a young girl's cheek. That small square, on its own, did not look like skin at all: the brushstrokes are of an amazing variety of colors, not all of them normally associated with human flesh. Yet the cumulative effect of those colors, from even a little distance, is of glowing, breathing skin.

The closest I was ever able to come to that quality of skin and flesh was in a close-up portrait of an adolescent girl, her blond hair luminous after repeated brushing by my wife, her blue eyes shining. This young girl had the full cheeks and her skin had the glow of one of Renoir's subjects. But my vantage point in the photograph is not one that Renoir would likely have taken: I was looking up at the girl from slightly below. I was certainly not convinced that anyone seeing the image out of context would have sensed Renoir in it.

This problem plagued me—the connection to Renoir's work seemed too oblique to me. I realized I would have to do something grand that could not be mistaken for anything but an evocation of Renoir.

Max and I had been to the porch overlooking the Seine where Renoir painted his *Luncheon of the Boating Party*, and he suggested we go back and have another look. The porch is still there, but the environs are somewhat more industrial-looking than they were in Renoir's day. To shoot there would have required working around that, and building scaffolding for the camera and lighting. It was then that I had a moment of inspiration, recalling Stéfan Petit Halgatte's lovely porch on the river in Vétheuil. Where better to set this scene? This had some other advantages: Stéfan, who is a set designer, might well have suggestions as to how to restage the piece. Furthermore, he and his family are extremely photogenic:

they would make perfect models and would, I hoped, be very comfortable and natural in their own home.

The Petit Halgattes also had a friend named Bénédicte Gerin, who had spent some years working for magazines arranging photo-shoots, and who had modeled herself. This was a project that would have to involve close to twenty people, including models, props, makeup and hair stylists, so we hired Bénédicte to manage the shoot.

My idea was to restage Renoir's *Luncheon of the Boating Party* in a contemporary mode, as a family gathering with friends and children on a Sunday afternoon—instead of trying to "re-create" the painting, which I felt would be pointless. I wrestled with the problem of animating such a large group. Renoir had made careful studies of the individual characters and only later composed the complete painting—meaning that he had not had to work with a great group of people at one time. I evaluated his lighting, colors, and composition—which seems quite simple until you look at the painting at length, in all its complexity. I wrote a sort of "script" for each of the characters, assigning to them a little story and a part to play, and we spent the better part of the morning of the shoot adjusting lights, going over the roles, and choreographing a range of movements, so the resulting photograph would not seem static.

After a wonderful lunch, which included liberal amounts of wine, everyone was in the right mood—relaxed and celebratory. The group moved into position, and I got behind the camera to begin shooting. Just as the sun was lowering itself over the river, it struck the glass decanter on the table, and there was a momentary shimmer. I caught the image, and that is the one that is included in these pages.

Next I returned to Renoir's hillside garden and home in Cagnes-sur-Mer (after a lengthy process of obtaining permission from the municipality and director to work there). Renoir purchased this large plot of land for its ancient olive trees, and built a house with a studio, more to satisfy his wife, Aline, than for himself. He preferred to paint outside in nice weather, in a glass pavilion in his yard. Sadly, the structure no longer exists, but it was from this spot—or my estimation of where it had been—that I chose to make the photograph of

the old olive trees beside the farmhouse, subjects that had so intrigued Renoir.

It seems that the urge to paint was stronger than anything else for Renoir: in his later years, he would have his wheelchair brought out into the yard, binding the paintbrush to his arthritic hands that could no longer hold a brush otherwise. The wheelchair now sits in the atelier inside his home, where I photographed it with his brushes and paints.

EDGAR DEGAS

Degas and I would not have been good friends. He was a known anti-Semite—as was clear from his sentiments during the Dreyfus affair. But at a distance of a couple generations, I have found much to love in his work.

We also share an involvement with photography, with which Degas experimented rather obsessively for about two years. He posed his friends by artificial light in their salons, ignoring their complaints about the tedious, lengthy sittings. He also made photographs of one of his most beloved subjects: dancers. I wondered at first if he had used the camera to record a pose of a dancer with her arm extended, but then recalled that he could sketch a scene more quickly and with less fuss—and did so, probably thousands of times. My image *Dancer, Arm Extended* looks very much like one of Degas's photographs of ballet dancers.

I spent much time at Paris's Musée d'Orsay looking at some of Degas's original glass plates and prints. The Orsay agreed to allow me to look at them at the light table. I was rather surprised when a curator began to *hand* me the fragile glass plates! If I were holding a drawing by Degas and it were to slip out of my fingers, nothing much would happen to it; but the risk of dropping a glass plate by Degas seemed a bit more serious—I politely declined and had the curator carry them to the light table.

Also at the Orsay, I was enchanted with a small room full of Degas's drawings and pastels, mostly of dancers. The rich, saturated colors of the pastels are positively seductive. I was inspired to go out and seek a ballet studio with a turn-of-the-century look in which to photograph dancers.

Laurent Olive and I spent a couple days driving around Paris, looking for a dance studio that had the right feel and would be available for a few days. After some searching, we discovered the studio of Mademoiselle Liane Daydé, a retired *étoile* of the Opéra Ballet de Paris, who took private students and rented out her studio on occasion to other dance teachers. We went to visit her in her quiet home on a little gated street in the sixteenth arrondissement. She was very friendly and pleasant, and we arranged a time to come to her studio. She also agreed to supply the dancers—some of her students—and costumes as well.

At the studio, Mademoiselle Daydé was expecting that we would be a little awkward with the dancers, and would not know how to work with them; she was prepared to help by teaching a class and letting us watch. My wife, Anna, who was a dancer and ballet teacher in San Francisco for many years, was with us. She quickly warmed to the subject and eventually took charge of the shoot, helping us pose the young models, and choreographing a series of movements that she thought would be interesting for the photographs. We spent three wonderful days with the young dancers, who were as pleasant to work with as they were beautiful to watch.

Despite some of the similar poses and lighting, you would not mistake my dancers for those of Degas. My subjects have a decidedly contemporary look: they direct their gazes toward the viewer, who is thus forced to acknowledge their identities; Degas generally kept his subjects further at bay. In *The Little Dancer Looks Back*, there are two views and impressions of one young dancer: both the "ideal" little ballerina and the real adolescent, echoing Degas's many studies of the dancer Maria, whose charming pose is an iconic image of a young ballet dancer.

Another of Degas's preferred subjects was of course racehorses. Dancers and horses are both trained for absolute grace and streamlined speed, and both require sweat, determination, and strength for their performance. I visited the racetrack at Chantilly, where I was given permission to visit the stables and training courses in order to watch and learn.

Later I photographed the Jockey Club race, and found a distinct visual irony in watching the young riders before the race, as they adjusted their stockings and boots in poses so reminiscent of Degas's dancers. And the horse owners in their top hats, bantering before the races, look uncannily like the bankers and brokers painted by Degas in his magnificent *At the Bourse* (1878–79).

VINCENT VAN GOGH

Though Van Gogh is generally regarded as a post-Impressionist, he was of course intimately connected with the Impressionists, their world, and their art.

I photographed a number of the places where Van Gogh worked and lived, among them the café at the Place du Forum in Arles, which he painted at night under the stars. I visited the asylum of Saint-Paul-de-Mausole near Saint-Rémy, where Van Gogh stayed for a year. There, I made photographs of the interior courtyard, which the artist found so depressing. On Pissarro's advice, Van Gogh then moved to Auvers-sur-Oise, where he was treated by Dr. Gachet, without success. In Auvers, Van Gogh lived at the Auberge Ravoux, in a tiny room in the inn's attic, taking his meals in the public room downstairs. I spent time also in Auvers, where the sites are remarkably unchanged from Van Gogh's times, as you can see in the images here.

Van Gogh's personal story is so compelling that, like Lin and her granddaughter Sarah, I found myself drawn to him. I studied his copious correspondences, which give a remarkable sense of who he was—a sensitive, thoughtful, and very sympathetic man. The Auberge Ravoux, where the artist passed his last days, has been restored with great care to its state in 1890, and so offered a perfect venue in which to capture Van Gogh's spirit. The Auberge's curator and owner, Dominique-Charles Janssens, offered me the keys to the place, known as the "Maison de Van Gogh," so that I could work there during a week when it would be closed.

I wanted to create photographs that would evoke the last days of Van Gogh's life and his death. Max and I began in one of the inn's two upstairs rooms, which still holds Van Gogh's deathbed. The springs on the bed were a perfect metaphor, I

thought, for the tension under which Van Gogh lived. I placed a little group of reproductions of his self-portraits on the springs.

Even the stairs to his room still seem haunted and melancholy; they speak of his loneliness and his personal demons. You can almost hear him tramping up them after a day in the field, or a visit to Gachet's nearby home, in the clumsy boots that are immortalized in one of his paintings. Van Gogh's chair is perched upside-down on a table downstairs at the Auberge café, where the sole patron seems to have just left.

Van Gogh's funeral service took place in this very room, the coffin giving off a horrible stench (according to a friend's account) amid the beauty of the canvases that the artist's brother, Theo, had tacked up on the walls. For one photograph, Max and I brought in flowers, and created a coffin out of a lighting-equipment case, covering it with a white cloth and placing it near an antique mirror that reflected the starlike pattern of the wallpaper. One of the ceiling lamps became a star—the star that Van Gogh had longed to reach.

Like Van Gogh, I am fascinated and awed by the celestial bodies. "When I look at the stars," he once wrote, "I always start dreaming." I, too, am transported by them to a place of contemplation, and find comfort under the infinite space of the night sky.

Van Gogh's story was so sad and potent. He knew that we would be looking again and again at his paintings. He knew that, like the stars, they reflect the soul of man.

I hope, as he did, that some will find pleasure and meaning in my images.

CAPTIONS

p. 2, p. 22
Neil Folberg (b. 1950)
Wheat Fields, Valmandois, 2001

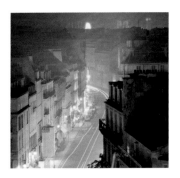

p. 4
Neil Folberg (b. 1950)
Faubourg Saint-Honoré at Night,
Paris, 2001

p. 7
Neil Folberg (b. 1950)
Arabesque, Paris, 2002

p. 14
Neil Folberg (b. 1950)
Les Calanques, Provence, 2003

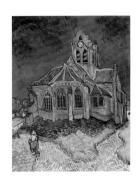

p. 21
Vincent van Gogh (1853–1890)
The Church at Auvers, June 1890
Oil on canvas, 37 x 29 in. (94 x 74 cm)
Musée d'Orsay, Paris

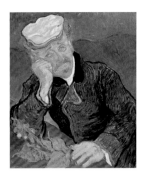

p. 24
Vincent van Gogh (1853–1890)
Dr. Paul Gachet, June 1890
Oil on canvas, 26 ³/₄ x 22 ³/₈ in. (68 x 57 cm)
Musée d'Orsay, Paris

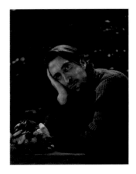

p. 25, p. 239
Neil Folberg (b. 1950)
*Dr. Gachet, After the Loss of His Friend and
Patient* (after Van Gogh), Paris, 2002

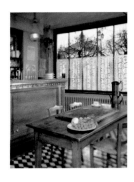

p. 28
Neil Folberg (b. 1950)
Dining Room, Auberge Ravoux,
Auvers-sur-Oise, 2002

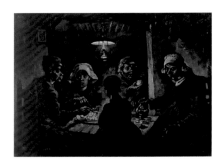

p. 31
Vincent van Gogh (1853–1890)
The Potato Eaters, 1885
Oil on canvas, 32 x 45 in. (81.5 x 114.5 cm)
Van Gogh Museum (Vincent van Gogh
Foundation), Amsterdam

p. 33, p. 238
Neil Folberg (b. 1950)
L'Arlésienne (after Van Gogh), Paris, 2003

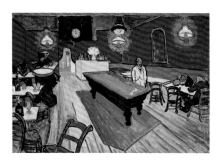

p. 34
Vincent van Gogh (1853–1890)
The Night Café in Arles, 1888
Watercolor, 17 ¹/₂ x 25 in. (44.4 x 63.2 cm)
Professor Hans R. Hahnloser Collection,
Bern, Switzerland

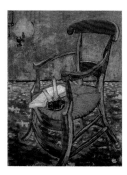

p. 41, left
Vincent van Gogh (1853–1890)
Gauguin's Armchair, 1888
Oil on canvas, 35 ¹/₂ x 28 ¹/₂ in. (90.5 x 72.5 cm)
Van Gogh Museum (Vincent van Gogh
Foundation), Amsterdam

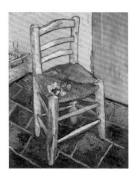

p. 41, right
Vincent van Gogh (1853–1890)
Van Gogh's Chair, 1888
Oil on canvas, 36 x 28 ¹/₂ in. (91.8 x 73 cm)
The National Gallery, London

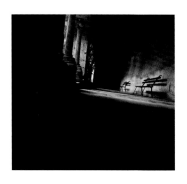

p. 44, pp. 244–45
Neil Folberg (b. 1950)
*Corridor at the Asylum of Saint-Paul-de-
Mausole*, Saint-Rémy-de-Provence, 2003

p. 45
Vincent van Gogh (1853–1890)
A Corridor in the Asylum, 1889
Black chalk and gouache on pink Ingres paper;
25 ⁵/₈ x 19 ³/₈ in. (65.1 x 49.1 cm)
The Metropolitan Museum of Art, New York;
Bequest of Abby Aldrich Rockefeller, 1948

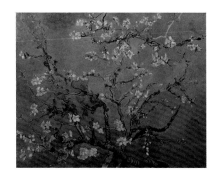

p. 46
Vincent van Gogh (1853–1890)
Branches of an Almond Tree in Blossom, 1890
Oil on canvas, 29 x 36 ¹/₈ in. (73.5 x 92 cm)
Van Gogh Museum (Vincent van Gogh
Foundation), Amsterdam

p. 47, p. 242
Neil Folberg (b. 1950)
*Courtyard at the Asylum of Saint-Paul-de-
Mausole*, Saint-Rémy-de-Provence, 2003

p. 50
Vincent van Gogh (1853–1890)
*Café-Terrace at Night
(Place du Forum in Arles)*, 1888
Oil on canvas, 31 x 24 ³/₄ in. (78.7 x 62.9 cm)
Rijksmuseum Kroeller-Mueller, Otterlo,
The Netherlands

p. 51
Neil Folberg (b. 1950)
Café at Night, Montmartre, Paris, 2001

p. 56
Neil Folberg (b. 1950)
Moret-sur-Loing, 2003

p. 58
Neil Folberg (b. 1950)
Atelier Pissarro, Eragny-sur-Epte, 2002

p. 59
Camille Pissarro (1830–1903)
View Through a Window, Eragny, 1888
Oil on canvas, 25 ¹/₂ x 32 in. (65 x 81 cm)
Ashmolean Museum, University of
Oxford, England

p. 62, p. 165
Neil Folberg (b. 1950)
Rural Road in Provence, 2001

p. 65
Camille Pissarro (1830–1903)
The Banks of the Marne in Winter, 1866
Oil on canvas, 36 ¹/₈ x 59 ¹/₈ in. (91.8 x 150.2 cm)
The Art Institute of Chicago; Mr. and Mrs. Lewis
Larned Coburn Memorial Collection

p. 68
Camille Pissarro (1830–1903)
Jalais Hill, Pontoise, 1867
Oil on canvas, 34 ¹/₄ x 45 ¹/₄ in. (87 x 114.9 cm)
The Metropolitan Museum of Art, New York;
Bequest of William Church Osborn, 1951

p. 69
Paul Cézanne (1839–1906)
Jalais Hill, Pontoise, c. 1879–81
Oil on canvas, 23 ¹/₂ x 30 in. (60 x 76 cm)
Private collection

p. 72
Edouard Manet (1832–1883)
Olympia, 1863
Oil on canvas, 51 ¹/₂ x 75 in.
(130.5 x 190 cm)
Musée d'Orsay, Paris

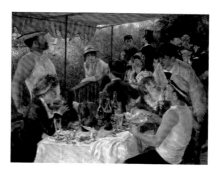

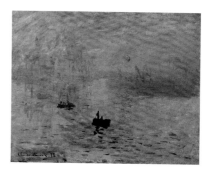

p. 74, pp. 216–17
Neil Folberg (b. 1950)
Luncheon of the Boating Party
(after Renoir), Vétheuil, 2003

p. 75
Pierre-Auguste Renoir (1841–1919)
Luncheon of the Boating Party, 1880–81
Oil on canvas, 51 1/4 x 69 1/8 in.
(130.2 x 175.6 cm)
The Phillips Collection, Washington, D.C.

p. 78
Claude Monet (1840–1926)
Impression, Sunrise, 1872
Oil on canvas, 119 x 25 in. (48 x 63 cm)
Musée Marmottan-Claude Monet, Paris

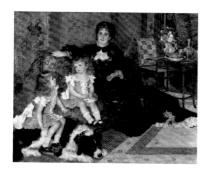

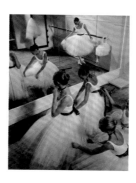

p. 83
Pierre-Auguste Renoir (1841–1919)
*Madame Georges Charpentier and Her Children,
Georgette-Berthe and Paul-Émile-Charles*, 1878
Oil on canvas, 60 1/2 x 74 7/8 in. (153.7 x 190.2 cm)
The Metropolitan Museum of Art, New York;
Catharine Lorillard Wolfe Collection, Wolfe Fund

p. 85
Neil Folberg (b. 1950)
Dancers Adjusting Their Skirts, Paris, 2002

p. 86
Edgar Degas (1834–1917)
Four Studies of a Dancer, 1878–79
Charcoal on paper, 19 1/4 x 12 1/2 in.
(49 x 31.7 cm)
Musée du Louvre, Paris

p. 87
Edgar Degas (1834–1917)
Blue Dancers, c. 1890
Oil on canvas, 33 1/2 x 29 3/4 in. (85 x 75.5 cm)
Musée d'Orsay, Paris; Gift of Dr. and Mrs.
Albert Charpentier, 1951

p. 88, p. 219
Neil Folberg (b. 1950)
Jockey and Trainer, Chantilly, 2004

p. 89
Edgar Degas (1834–1917)
Race Horses in front of the Stands, 1866–68
Oil on canvas, 18 x 24 in. (46 x 61 cm)
Musée d'Orsay, Paris

p. 92
Claude Monet (1840–1926)
Camille on Her Deathbed, 1879
Oil on canvas, 35 $^1/_2$ x 27 in. (90 x 68 cm)
Musée d'Orsay, Paris

p. 93
Neil Folberg (b. 1950)
Drowned (after Monet's portrait of his wife
Camille on her deathbed), 2006

p. 95, p. 179
Neil Folberg (b. 1950)
River Fog on the Seine, Vétheuil, 2001

p. 96, p. 209
Neil Folberg (b. 1950)
Young Girl, Paris, 2002

p. 100, p. 175
Neil Folberg (b. 1950)
Pont des Trois Sautets, on the Arc River,
Aix-en-Provence, 2002

p. 101
Paul Cézanne (1839–1906)
The Bridge of Maincy, near Melun, 1879–80
Oil on canvas, 23 x 28 $^1/_2$ in. (58.5 x 72.5 cm)
Musée d'Orsay, Paris

p. 102
Paul Cézanne (1839–1906)
*Mont Sainte-Victoire, above the
Tholonet Road*, 1896–98
Oil on canvas, 32 x 39 $^1/_2$ in. (81 x 100 cm)
Hermitage, St. Petersburg, Russia

p. 104, p. 211
Neil Folberg (b. 1950)
Renoir's Garden, Cagnes-sur-Mer, 2003

p. 106
Paul Cézanne (1839–1906)
Apples and Oranges, c. 1899
Oil on canvas, 29 x 36 $^1/_2$ in. (74 x 93 cm)
Musée d'Orsay, Paris

p. 107, p. 173
Neil Folberg (b. 1950)
Still Life with Apples and Onions,
Atelier Cézanne, Aix-en-Provence, 2002

p. 108
Neil Folberg (b. 1950)
Forest, Provence, 2002

p. 109
Paul Cézanne (1839–1906)
Chestnut Trees at Jas de Bouffan, c. 1885–86
Oil on canvas, 28 x 35 ¹/₂ in. (71.1 x 90.1 cm)
Minneapolis Institute of Arts; The William
Hood Dunwoody Fund

p. 110
Pierre-Auguste Renoir (1841–1919)
The Farm at Les Collettes, Cagnes, 1908–14
Oil on canvas, 21 ¹/₂ x 25 ³/₄ in. (54.6 x 65.4 cm)
The Metropolitan Museum of Art, New York;
Bequest of Charlotte Gina Abrams, in memory of
her husband, Lucien Abrams, 1961

p. 114, p. 183
Neil Folberg (b. 1950)
Monet's Home, Giverny, 2001

p. 115
Claude Monet (1840–1926)
The Artist's Garden at Giverny, 1900
Oil on canvas, 32 x 36 in. (81 x 92 cm)
Musée d'Orsay, Paris

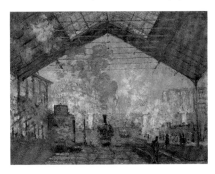

p. 119
Claude Monet (1840–1926)
Saint-Lazare Station, 1877
Oil on canvas, 29 ¹/₂ x 40 ⁷/₈ in. (75 x 104 cm)
Musée d'Orsay, Paris

p. 120
Claude Monet (1840–1926)
Water Lilies, 1916–22
Oil on canvas, 6 ft. 6 ³/₄ in. x
13 ft. 11 ³/₈ in. (2 x 4.25 m)
The National Gallery, London

p. 121
Neil Folberg (b. 1950)
Marine Landscape, Normandy, 2002

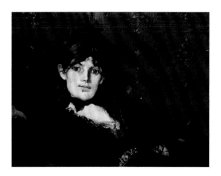

p. 122
Edouard Manet (1832–83)
Berthe Morisot Reclining, 1873
Oil on canvas, 10 x 13 ¹/₂ in. (26 x 34 cm)
Musée Marmottan-Claude Monet, Paris

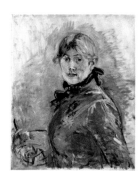

p. 125
Berthe Morisot (1841–1895)
Self-Portrait, 1885
Oil on canvas, 24 x 19 ¹/₂ in. (61 x 50 cm)
Musée Marmottan-Claude Monet, Paris

p. 126
Edouard Manet (1832–1883)
The Balcony, 1868
Oil on canvas, 67 x 49 in. (170 x 124.5 cm)
Musée d'Orsay, Paris

p. 127, p. 190
Neil Folberg (b. 1950)
The Balcony (after Manet),
Paris, 2002

p. 129
Berthe Morisot (1841–1895)
*Portrait of Madame Edma Pontillon, née
Edma Morisot, Sister of the Artist*, 1871
Pastel on paper, 31 ¹/₂ x 25 ¹/₄ in.
(80 x 64 cm)
Musée d'Orsay, Paris

p. 130
Berthe Morisot (1841–1895)
Young Girls at the Window, 1892
Oil on canvas, 25 ¹/₂ x 19 ¹/₄ in. (65 x 49 cm)
Galerie Daniel Malingue, Paris

p. 131, p. 205
Neil Folberg (b. 1950)
*Anna and Lou, Great-Great-Great-
Granddaughters of Berthe Morisot*,
Château du Mesnil, 2002

p. 135
Pierre-Auguste Renoir (1841–1919)
Berthe Morisot and Her Daughter, 1894
Pastel on paper, 32 x 25 ¹/₂ in. (81 x 65 cm)
Musée du Petit Palais, Paris

p. 136
Berthe Morisot (1841–1895)
Before the Mirror, 1893
Oil on canvas, 25 ¹/₂ x 21 in. (64.8 x 53.3 cm)
Private collection

p. 137, p. 203
Neil Folberg (b. 1950)
Before the Mirror (after Morisot),
Château du Mesnil, 2003

p. 140
Berthe Morisot (1841–1895)
The Cherry Pickers, 1891
Oil on canvas, 60 ¹/₂ x 33 in. (154 x 84 cm)
Private collection

p. 141, p. 197
Neil Folberg (b. 1950)
The Cherry Tree in Berthe Morisot's Yard,
Château du Mesnil, 2003

p. 142, pp. 200–201
Neil Folberg (b. 1950)
Young Women, Château du Mesnil, 2003

p. 144
Edouard Manet (1832–1883)
*Portrait of Berthe Morisot with a
Bouquet of Violets*, 1872
Oil on canvas, 21 ¹/₂ x 15 in. (55 x 38 cm)
Musée d'Orsay, Paris

p. 145, p. 193
Neil Folberg (b. 1950)
Lucie Rouart (after a portrait of
Berthe Morisot by Manet),
Château du Mesnil, 2003

p. 146
Edouard Manet (1832–1883)
Repose, c. 1870–71
Oil on canvas, 59 ¹/₈ x 44 ⁷/₈ in. (150 x 114 cm)
Museum of Art, Rhode Island School of Design,
Providence; Bequest of Mrs. Edith Stuyvesant
Vanderbilt Gerry

p. 147, pp. 194–95
Neil Folberg (b. 1950)
Repose (after portraits of Berthe Morisot
by Manet), 2002

p. 150
Neil Folberg (b. 1950)
Etretat and Arcturus, Normandy, 2003

p. 169
Mont Sainte-Victoire, 2003

p. 170
Atelier Cézanne, Aix-en-Provence, 2002

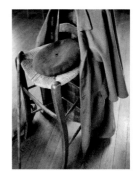

p. 171
Cane and Beret, Atelier Cézanne,
Aix-en-Provence, 2002

p. 172
Atelier Cézanne, with Apples,
Aix-en-Provence, 2002

p. 174
Red Rock, Quarry at Bibemus, 2003

pp. 176–77
Reflections, Arc River, 2002

p. 180
Japanese Bridge, Giverny, 2001

p. 181
Ripples on the Water-Lily Pond, Giverny,
2001

pp. 184–85
Water-Lily Pond, Giverny, 2001

p. 186
Steam Clouds and Setting Sun, Power Plant at Gardanne, 2002

p. 187
La Japonaise (after Monet), 2002

p. 189
Gaëlle and Camille, Château du Mesnil, 2003

p. 191
Don't Leave! (sequel to *The Balcony*), Paris, 2002

pp. 198–99
Young Woman in Blue, Château du Mesnil, 2003

p. 204
Young Girls Running, Château du Mesnil, 2003

p. 206
Eva in the Garden, Vétheuil, 2003

p. 207
Sunday in the Country, Vétheuil, 2003

p. 210
Atelier Renoir, Cagnes-sur-Mer, 2003

p. 213
After a portrait of Berthe Morisot and
Julie Manet by Renoir, Paris, 2003

pp. 214–15
Christine by the Arc River, 2003

p. 220
Race, Chantilly, 2004

p. 221
Prix de Bois Bourillon, Chantilly, 2004

pp. 222–23
Jockey Adjusting His Boot, Chantilly, 2004

p. 224–25
Dancer Adjusting Her Shoes, Paris, 2003

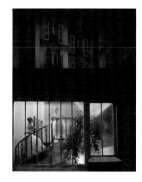

p. 226
The Ballet School, Paris, 2002

p. 227
Young Dancer Standing, Paris, 2002

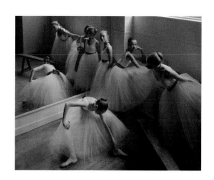

p. 228
Four Dancers, Paris, 2002

p. 229
Two Dancers and a Violinist (inspired by
Degas's sketches), Paris, 2003

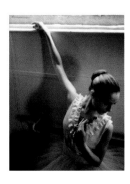

p. 230
Dancer, Arm Extended (after a photograph
by Degas), Paris, 2002

p. 231
The Little Dancer Looks Back, Paris, 2002

p. 233
Auvers-sur-Oise, 2001

p. 234
Vincent's Chair, Auberge Ravoux,
Auvers-sur-Oise, 2002

p. 235
*The Stairs to Vincent's Room, Auberge
Ravoux,* Auvers-sur-Oise, 2002

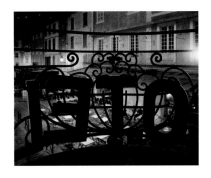

pp. 236–37
Café at Night in Arles, 2003

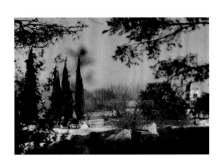

pp. 240–41
Cypresses and Saint-Paul-de-Mausole,
Saint-Rémy-de-Provence, 2003

p. 243
Columns, Saint-Paul-de-Mausole,
Saint-Rémy-de-Provence, 2003

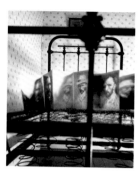

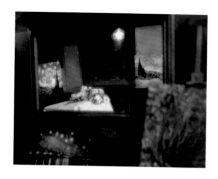

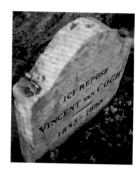

p. 246
Vincent's Deathbed, Auberge Ravoux,
Auvers-sur-Oise, 2002

p. 247
Vincent van Gogh's Funeral, Auberge
Ravoux, Auvers-sur-Oise, 2002

p. 249
Ici repose Vincent van Gogh,
Auvers-sur-Oise, 2002

ACKNOWLEDGMENTS

I know I speak for both Neil and myself when I say that there are two friends without whom our travels and research for this project, which took place over a period of six years, could not have happened as they did. Laurent Olive and Françoise Kinnoo were steadfast companions and helpers, locating corners of France that were previously unknown to us. Together, we formed a team of four whose common goal was to investigate deeply and directly the lives of the Impressionists and their work.

I spent countless hours driving from town to town with Laurent, who had a background as a psychoanalyst; our conversations were intense and wonderful, and immensely helpful to me. Laurent eventually developed his own interest in the Impressionists. At one point along the way, I was drawn to find a particular road by the stream in the town of Pontoise, where Camille Pissarro lived—but I was unable to locate it on any map. Laurent and I went to the regional archives, where, on our hands and knees (accompanied by a solicitous archive director), we scoured the ancient town maps together until we finally found the rivulet Saint-Antoine. And it was Laurent who came across Jacques Salomon's eyewitness account of Monet's final months and funeral, and translated it from French for me—a most helpful document in my research. Laurent passed away in 2006; I miss him, and am deeply sorry that he did not live to see the completion of this volume.

I could never have entered the Impressionists' private lives so fully were it not for Françoise, my extraordinary guide, who generously shared her love of these artists with me. Together, we followed their trail from Paris's Montmartre, where Françoise lived as a young girl, north to Auvers-sur-Oise, south to Arles, and to many spots in between. The travels that I've taken with Françoise have formed indelible memories, and I am eternally grateful to her for her brilliance and her companionship.

In the end, Laurent and Françoise took this project on as their own, and Neil and I are both thankful to have had them as our collaborators in its development and completion.

It took just a matter of hours to change my life, and that of my granddaughter Sarah as well. We arrived at Auvers-sur-Oise late one afternoon and discovered Vincent van Gogh's death chamber and the nearby wheat fields, golden in the July sun—the same fields Van Gogh had painted during the last months of his life. Without Sarah's compassionate tears during that visit to Auvers, this book might never have been written. Sarah pulled three sheaves of wheat from the fields and gave them to me. I keep them safely to mark this momentous occasion.

Later, when I returned to Auvers, I met Dominique-Charles Janssens, the visionary who returned Van Gogh's last home to its 1890 reality, down to the smallest detail: his wife, Françoise, even replicated the original white lace curtains in the windows. While in Auvers, I stayed for weeks at a time at La Ramure, whose proprietors, Sylvie and Thierry Amaniera, became my good friends. Joël and Corinne Boilleaut created the lovely Hostellerie du Nord in Auvers, where I have stayed on subsequent visits; the hotel and its superb restaurant are a very pleasant find in this tiny village.

My thanks go to many people who opened the doors of houses and studios of the Impressionists to me. Mireille Sutter, the owner of Camille Pissarro's home in Eragny-sur-Epte, was both hospitable and kind. I am certain that when she looks at Neil's extraordinary photographs taken on her property, she will be glad that she invited our whole team in. Berthe Morisot and Eugène Manet spent some summers in the town of Mézy; their house is now owned by Michel Fargier and his wife Patricia, who allowed me in and showed me Berthe's studio. I would also like to mention the Dormy House in Etretat, from which I looked over Monet's beloved motifs: the Porte d'Aval and Needle Rock.

I am grateful to Paddy Nichols, whose XO Travel made all the arrangements for my voyages, and who helped with my research about Cézanne. I am indebted to Jean-Jacques Pousthomis, Maître d'ouvrage at the Musée Granet in Arles, who in 2006 enabled me to get into the museum to see the exhibition *Cézanne in Provence*, and to Denis Coutagne, the Granet's director and present curator.

There are many books that were helpful to me in my research, but the catalog for the 2002 exhibition *Van Gogh and Gauguin: The Studio of the South* at the Art Institute of Chicago, by Douglas W. Druick and Peter Kort Zegers, was invaluable. And without Anne Higonnet's books, guidance—and commiseration—during my Morisot investigations, I might never have come to understand and love this artist as I do, or to encounter her remarkable family.

Yves Rouart and Jean-Marie Rouart allowed me to explore some of the mysteries of Morisot's life. Yves's daughter, Lucie Rouart, whose arresting eyes gaze at you from the cover of our book, has become this project's icon. My thanks also to Joachim Pissarro, for his support of our project. It is as if his great-grandfather, Camille Pissarro, has blessed us.

My sister, Abbey Lovenburg Peruzzi, translated into English all the information at Saint-Paul-de-Mausole about epilepsy and its treatment (or lack thereof), shedding light on Van Gogh's physical and mental state.

My thanks to Jeff Latham for creating such phenomenal floral interiors—truly a contemporary Giverny—at the Four Seasons/George V in Paris.

Without the help of many friends, this book would not have happened. My deepest gratitude goes to Allen Hoffman, a wise editor and dear friend. Gila Fachler has been there throughout the writing of both my books, and has patiently helped me through many pitfalls. Thanks also to Valerie Solti, who visited Auvers with me and fell in love with the Auberge Ravoux. It was Edith Krygier who many years ago gave me Neil's book *And I Shall Dwell Among Them*: this was the catalyst for a long and fruitful collaboration.

My two personal assistants, Tracey Corwin in Miami and Avital Moses in Israel, have taken this project to their hearts, and have smoothed the way for its birth. There is no way this book would have taken shape without them.

My thanks go to Diana C. Stoll, editor; Michelle Dunn Marsh, designer; and Stevan Baron, production, who, along with Abbeville's team—particularly Leanna Petronella, working with Misha Beletsky, Louise Kurtz, and Austin Allen—have delivered a book that will "stand up and sing," as Neil has often said. And to Bob Abrams: profoundest thanks for having faith in this project. We are determined to do you proud.

—*L.A.*

Without Lin Arison and her inspiring vision, these photographs would never have been made. The confidence she placed in me gave me the ability to see and photograph in new ways. My horizons have expanded in directions that I could never have imagined . . . and I am a happier man for it.

During the course of producing this book, our friend Laurent Olive passed away. For me, he had been a guide, driver, mobile encyclopedia of French art and history, as well as adviser about customs, food, wine, and psychoanalysis. We spent so much time laughing together during our adventures that it's a wonder I managed to find time to photograph. I will miss him and remember him always.

I would like once again to thank Max Richardson for his creativity and expertise in lighting. Nathalie Arfi, who moved to Israel from France, was my assistant in Jerusalem during the entire project. She walked in my door before Lin came to me with this idea, and seemed to bring France with her from the moment she began to work with me.

I met Bénédicte Gerin toward the end of the project, when she became my production assistant, and we have since continued our work together. She is a talented artist and a good friend—and her assistance in organizing props, models, studios, hair and makeup stylists, and more, has been invaluable.

Quentin Bajac, former curator at the Musée d'Orsay, kindly provided access to the collections of the museum and some valuable background material. Baudoin Lebon also gave me assistance and information about photography of the nineteenth century.

I am grateful to the following people and organizations for allowing me access to photograph: Mireille Sutter at Pissarro's home in Eragny-sur-Epte; Dominique-Charles Janssens at the Auberge Ravoux (Maison de Van Gogh), Auvers-sur-Oise; Stéfan and Nina Petit Halgatte at their home and yard, Vétheuil; Yves Rouart and his family at the Château du Mesnil in Juziers; Liane Daydé in her ballet studio, Paris; Bernard Bégouin at the Musée and Atelier Renoir, Cagnes-sur-Mer; Christine de la Forêt and Michel Fraisset at the Atelier de Cézanne, Aix-en-Provence; the Fondation Claude Monet at Giverny; France Galop, for access to the facilities at Chantilly and for permission to photograph the Prix du Jockey Club race; and Gabrielle Hirn at the Hotel Le Bristol, Paris.

It was my pleasure to work with a remarkable group of dancers, actors, and models who were all animated and creative and who contributed greatly to the making of the photographs. Camille Proust, a student of Liane Daydé, was particularly helpful. I was also fortunate to work on numerous occasions with Sonia Zonenberg and Gaëlle Pouliquen. Lucie Rouart is at the heart of this book and on its cover, in her very distinctive role as both model and descendant of Berthe Morisot.

Finally, I have once again had the privilege of working with Bob Abrams, Stevan Baron, Michelle Dunn Marsh, and Diana C. Stoll. Bob published my very first book in 1986, and now this one, providing a lovely feeling of continuity in life and work. Stevan, who has produced two previous books for me, is both a fine person and a master of his craft. Michelle designed *Celestial Nights* and has once again brought amazing order and grace to a difficult book. Diana first worked with me as an editor on *And I Shall Dwell Among Them*; for this project, I have had the additional pleasure of spending time with her. I am also indebted to the staff at Abbeville Press, particularly Leanna Petronella, who has played a major role in organizing the book's production.

Allen Hoffman's assistance and critiques during the progress of this work have been invaluable; he, too, came into my life at the time of my first book and has remained a friend ever since.

Anna, my wife, played a very professional role in this production, as a choreographer and ballet mistress. It has been very special to be able to work together.

So many people have been involved in this work that I will surely not be able to mention every one of them. My deepest thanks to all.

—N.F.

BIBLIOGRAPHY

GENERAL

Baudelaire, Charles. *Selected Letters of Charles Baudelaire*. Rosemary Floyd, ed. and trans. Chicago: University of Chicago Press, 1986.

Chevreul, M. E. *The Principles of Harmony and Contrast of Colors and Their Application to the Arts*. West Chester, Penn.: Schiffer, 1987 (based on first English edition, 1854, as trans. by Charles Martel from original French, *De la loi du contraste simultané des couleurs et de l'assortiment des objets colorés*, 1839).

The Impressionists, 1999. Produced by Kulturvideo, Long Branch, N.J. Six-part DVD series, 300 minutes, color.

The Impressionists: The Other French Revolution, 2001. Directed by Bruce Alfred for the Arts and Entertainment Network, New York. Four-part DVD series, 200 minutes, color.

Manet, Julie. *Growing Up with the Impressionists: The Diary of Julie Manet*. Rosalind de Boland Roberts and Jane Roberts, eds. and trans. London, New York: Philip Wilson/Sotheby's, 1987.

Moore, George. *Reminiscences of the Impressionist Painters*. Dublin: Maunsel, 1951.

The Post-Impressionists, 2001. Produced by Kulturvideo, Long Branch, N.J. Six-part DVD series, 300 minutes, color.

Rewald, John. *The History of Impressionism*. New York: Museum of Modern Art, 1946.

Roe, Sue. *The Private Lives of the Impressionists*. New York, London: HarperCollins/Chatto and Windus, 2006.

Roque, Georges. *Art et science de la couleur: Chevreul et les peintres de Delacroix à l'abstraction*. (Privately translated to English by Dee Klein Braig.) Nîmes: Jacqueline Chambon, 1997.

Seigel, Jerrold. *Bohemian Paris: Culture, Politics, and the Boundaries of Bourgeois Life, 1830–1930*. New York: Viking Penguin, 1986.

PAUL CÉZANNE

Boyer, Jean, et al. *Jas de Bouffan: Cézanne*. Aix-en-Provence: Société Paul Cézanne, 2004.

Consibee, Philip, and Denis Coutagne. *Cézanne in Provence*. Judith Terry, trans. London, New Haven: National Gallery of Art/Yale University Press, 2006.

Pissarro, Joachim. *Cézanne and Pissarro: Pioneering Modern Painting, 1865–1885*. New York: Museum of Modern Art, 2005.

Rewald, John. *Cézanne*. New York: Abrams, 1986.

Rewald, John, ed. *Paul Cézanne: Letters*. Seymour Hacker, trans. New York: Hacker, 1984.

Rilke, Rainer-Maria. *Letters on Cézanne*. Joel Agee, trans. New York: Fromm International, 1985.

Schroeder, Klaus Albrecht, et al. *Cézanne: Finished-Unfinished*. Isobel Feder, et al., trans. Ostfildern-Ruit, Germany: Hatje Cantz, 2000.

EDGAR DEGAS

Daniel, Malcolm, with Eugenia Parry and Theodore Reff. *Edgar Degas, Photographer*. New York: Metropolitan Museum of Art, 1999.

DeVonyar, Jill, and Richard Kendall. *Degas and the Dance*. New York: Abrams, 2002.

Halevy, Daniel. *My Friend Degas*, Mina Curtiss, ed. and trans. Middletown, Conn.: Wesleyan University Press, 1964.

Kendall, Richard, ed. *Degas by Himself*. London: Macdonald, 1987.

EDOUARD MANET

Friedrich, Otto. *Olympia: Paris in the Age of Manet*. New York: HarperCollins, 1992.

Lipton, Eunice. *Alias Olympia: A Woman's Search for Manet's Notorious Model and Her Own Desire*. New York: Scribner's, 1992.

CLAUDE MONET

Gerdts, William H. *Monet's Giverny: An Impressionist Colony*. New York: Abbeville, 1993.

Green, Pauline, ed. *Monet and Japan*. Canberra: National Gallery of Australia, 2001.

Hoog, Michel. *The Nympheas of Claude Monet*. Jean-Marie Clarke, trans. Paris: Réunion des Musées Nationaux, 1990.

Joyes, Claire. *Monet's Table: The Cooking Journals of Claude Monet*. Josephine Bacon, trans. New York: Simon and Schuster, 1989.

Kendall, Richard, ed. *Monet by Himself*. London: Macdonald, 1989.

Koja, Stephan. *Monet*. John Broenjohn, trans. Munich, New York: Prestel, 1996.

Lochnan, Katharine. *Turner Whistler Monet*. London: Tate, 2004.

Michels, Heide. *Monet's House: An Impressionist Interior*. Helen Ivor, trans. London: Frances Lincoln, 1997.

Patin, Sylvie. *Monet: The Ultimate Impressionist*. Paris, London, New York:

Gallimard/Réunion des Musées Nationaux/Thames and Hudson/Abrams, 1991.

Pissarro, Joachim. *Monet and the Mediterranean*. New York: Rizzoli, 1997.

Potts, Vanessa. *Essential Monet*. London: Parragon, 2001.

Russell, Vivian. *Monet's Garden: Through the Seasons at Giverny*. New York: Stewart, Tabori and Chang, 1995.

Swiler, Champa Kermit, and Dianne W. Pitman. *Monet and Bazille: A Collaboration*. New York: High Museum of Art/Abrams, 1998.

Tucker, Paul Hayes. *Monet in the 90's*. Boston: Museum of Fine Arts, 1989.

Wildenstein, Daniel. *Monet's Years at Giverny: Beyond Impressionism*. New York: Metropolitan Museum of Art, 1978.

BERTHE MORISOT

Au coeur de l'impressionisme: La famille Rouart. (Privately translated to English.) Paris: Musée de la Vie Romantique/Paris Musées, 2004.

Bona, Dominique, et al. Papers presented at the colloquium "Berthe Morisot and the Painters and Writers of Impressionism" held October 25, 2002 at the Singer-Polignac Foundation, Paris (Jean-Marie

Rouart, chair). Fabrice di Giovanni, trans. Paris: Editions de la Bouteille à la Mer.

Clairet, Alain, with Delphine Montalant and Yves Rouart. *Berthe Morisot, 1841–1895: Catalogue raisonné de l'oeuvre peint.* Jean-Alice Coyner, trans. London: Percy Lund, Humphries, 1957.

Edelstein, T. J., ed. *Perspectives on Morisot.* New York: Hudson Hills/Mount Holyoke College Art Museum, 1990.

Higonnet, Anne. *Berthe Morisot.* Berkeley, Cal.: University of California, 1990.

———. *Berthe Morisot's Images of Women.* Cambridge, Mass.: Harvard University Press, 1992.

Morisot, Berthe. *Berthe Morisot Correspondences.* London: Moyer Bell and Cambden, 1987.

Rouart, Jean-Marie. *Une famille dans l'impressionisme.* (Privately translated to English.) Paris: Gallimard, 2001.

———. *Une jeunesse à l'ombre de la lumière.* (Privately translated to English.) Paris: Gallimard, 2000.

Shennan, Margaret. *Berthe Morisot: The First Lady of Impressionism.* Stroud, U.K.: Sutton, 1996.

Stuckey, Charles F., and William P. Scott. *Berthe Morisot, Impressionist.* New York: Hudson Hills, 1987.

CAMILLE PISSARRO

Pissarro, Joachim. *Camille Pissarro.* New York: Abrams, 1993.

———. *Cézanne and Pissarro: Pioneering Modern Painting, 1865–1885.* New York: Museum of Modern Art, 2005.

Rewald, John, ed. *Camille Pissarro: Letters to His Son Lucien.* Cambridge, U.K.: Cambridge University Press, 1944.

Rewald, John. *Pissarro.* New York: Abrams, 1986.

Stone, Irving. *Depths of Glory: A Biographical Novel of Camille Pissarro.* Franklin Center, Penn.: Franklin Library, 1985.

PIERRE-AUGUSTE RENOIR

Bailey, Colin B. *Renoir's Portraits, Impressions of an Age.* New Haven: Yale University Press, 1997.

Renoir, Jean. *Renoir, My Father.* Randolph and Dorothy Weaver, trans. Boston, Toronto: Little, Brown, 1958.

White, Barbara Ehrlich. *Renoir: His Life, Art and Letters.* John Shepley and Claude Choquet, trans. New York: Abrams, 1984.

VINCENT VAN GOGH

Druick, Douglas W., and Peter Kort Zegers. *Van Gogh and Gauguin: The Studio of the South.* New York, Chicago: Thames and Hudson/Art Institute of Chicago, 2001.

Gayford, Martin. *The Yellow House: Van Gogh, Gauguin, and Nine Turbulent Weeks in Arles.* New York: Little, Brown, 2006.

Graetz, H. R. *The Symbolic Language of Vincent van Gogh.* New York, Toronto, London: McGraw-Hill, 1963.

Leaf, Alexandra, and Fred Leeman. *Van Gogh's Table.* New York: Artisan (Workman), 2001.

Redolfi, Marco. *La pittura nascosta di Van Gogh.* (Privately translated to English.) Venice: Litto Immagine-Rodeano, 2000.

Schapiro, Meyer. *Vincent van Gogh.* New York: Abrams, 1983 (reissued 2000).

Van Gogh, Theo, and Jo Bonger. *Brief Happiness: The Correspondence of Theo van Gogh and Jo Bonger.* Zwolle, Amsterdam: Waanders/Van Gogh Museum, 1999.

Van Gogh, Vincent. *The Complete Letters of Vincent van Gogh,* 3 vols. Boston, New York, London: Little, Brown/Bulfinch, 1958.

Welsh-Ovcharov, Bogomila. *Van Gogh in Provence and Auvers.* New York: Hugh Lauter Levin, 1999.

PHOTO CREDITS

p. 8:
Map by Robert C. Forget

pp. 34, 59, 69, 122, 130:
The Bridgeman Art Library

p. 45:
The Metropolitan Museum of Art,
New York, Bequest of Abby Aldrich
Rockefeller, 1948 (48.190.2). Photograph
© 1998 The Metropolitan Museum of Art

pp. 50, 78:
Erich Lessing / Art Resource, NY

p. 65:
The Art Institute of Chicago, Mr. and
Mrs. Lewis Larned Coburn Memorial
Collection, 1957.306. Photography © The
Art Institute of Chicago

p. 68:
The Metropolitan Museum of Art, New
York, Bequest of William Church Osborn,
1951 (51.30.2). Photograph © 1993 The
Metropolitan Museum of Art

pp. 72, 86, 92, 101, 126, 144, back cover:
Réunion des Musées Nationaux / Art
Resource, NY

p. 83:
The Metropolitan Museum of Art,
New York, Catharine Lorillard Wolfe
Collection, Wolfe Fund, 1907 (07.122).
Photograph © 1992 The Metropolitan
Museum of Art

p. 110:
The Metropolitan Museum of Art, New
York, Bequest of Charlotte Gina Abrams,
in memory of her husband, Lucien
Abrams, 1961 (61.190). Photograph ©
1984 The Metropolitan Museum of Art

pp. 125, 135, 140:
Giraudon / Art Resource, NY

p. 136:
Private collection, courtesy
Galerie Hopkins-Custot

p. 146:
Museum of Art, Rhode Island School
of Design, Providence, Bequest of Mrs.
Edith Stuyvesant Vanderbilt Gerry.
Photography by Erik Gould

INDEX

(Page references in *italic* refer to illustrations.)

FRONT COVER:
Neil Folberg (b. 1950)
Lucie Rouart (after a portrait of Berthe Morisot by Manet),
Château du Mesnil, 2003

BACK COVER:
Edouard Manet (1832–1883)
Portrait of Berthe Morisot with a Bouquet of Violets, 1872
Oil on canvas, 21 ¹/₂ x 15 in. (55 x 38 cm)
Musée d'Orsay, Paris

FRONTISPIECE:
Neil Folberg (b. 1950)
Wheat Fields, Valmandois, 2001

Editor: Diana C. Stoll
Designer: Michelle Dunn Marsh
Production Manager: Stevan A. Baron
Project Managers: Leanna Petronella
and Austin Allen

First published in the United States of America in
2007 by Abbeville Press, 137 Varick Street, New York,
NY 10013.

This book was typeset in Fournier; the display type is
Cézanne, a font based on the artist's handwriting.
Printed and bound in China.

*A limited-edition portfolio of six photographs by
Neil Folberg from* Travels with Van Gogh and the
Impressionists *is available through Vision Gallery.*

*The portfolio edition is limited to 40 numbered
sets and 10 artist's proof sets; each print is 33.8
by 43.2 cm (sheet size), signed and numbered by
the photographer. For more information, please
visit www.visiongallery.com.*

First Edition
10 9 8 7 6 5 4 3 2 1

ISBN-13: 978-0-7892-0932-0
ISBN-10: 0-7892-0932-2

Library of Congress Cataloging-in-Publication Data

Arison, Lin.
 Travels with Van Gogh and the impressionists :
discovering the connections / text by Lin Arison ;
photographs by Neil Folberg.— 1st ed.
 284 pp., 25.4 cm x 21.6 cm.
 ISBN-13: 978-0-7892-0932-0
 ISBN-10: 0-7892-0932-2
 1. Impressionism (Art)—France. 2. Painting, French—
19th century. 3. Impressionist artists—Homes and
haunts—France. I. Folberg, Neil. II. Title.

ND547.5.I4A57 2007
759.4—dc22

 2006103157

Visit Abbeville Press online at
www.abbeville.com